KASHMIR

SCARS OF PELLET GUN

KASHMIR
Scars of Pellet Gun

THE BRUTAL FACE OF SUPPRESSION

MANNAN BUKHARI

PARTRIDGE
A Penguin Random House Company

To order additional copies of this book, contact
Partridge India
000 800 10062 62
orders.india@partridgepublishing.com

www.partridgepublishing.com/india

Index

Acknowledgements

I express my profound acknowledgement to all those without who's active support the compilation of this volume would not have been possible. I barely find the words to express my gratitude to Chairman A.P.H.C. Mirwaiz Dr. Mohmmad Umar Farooq for his enormous encouragement and support in this endeavour.

It may be most appropriate to mention my deep gratitude and profound thanks to Mr. Gautam Navlakha who took out time from his busy schedule to write 'Foreword' of this book.

I am highly grateful to Advocate Abdul Majid Banday who gave me the idea to compile this book. As a mentor and loving brother he was very generous in sharing his time and knowledge with me in making this project a success.

I owe my deepest gratitude to all those who's articles and works have been included in this volume, because their contribution is of great value and central to the objective of compiling this volume.

Tassaduq Hussain Baba deserves the deepest gratitude for designing the cover page of this volume.

Also I must mention my deep sense of appreciation and sincere thanks to the victims and their families for their outright cooperation.

Finally I express my special thanks to Mir Imran, Bilal Bashir Bhat, Yaseen Hassan, Shabir Ahmad, Bilal Zaid and Javaid Ahmad for their help and cooperation.

Foreword

It is an axiomatic truth by now that in Kashmir one can pick any issue and its links to the main dispute over Jammu and Kashmir, becomes poignantly clear. It is by now a given fact that every act of brutality massacre, rape, torture, disappearances, impunity enjoyed by security forces, all and more are the result of a deliberate and institutionalized suppression of a democratic demand for right to self-determination. In this military suppression 'catch and kill', 'shoot to kill', remained the norm for all these years and still does. It was incentivized and promoted through cash grants and career advancement. When popular opprobrium finally forced the Indian State to shift to use of "non-lethal weapons" to deal with public protests against those throwing stones, it soon showed that a predatory force can turn even "non-lethal" weapons, if there is such a thing, into lethal tool by deliberately targeting the youth by firing at their eyes, stomach, head or other vulnerable spots to cause fatal injuries or even cause death. Let's remember the use of tear gas shells to kill in 2010.

The book **Kashmir – Scars of Pellet Gun compiled, edited and also written by Mannan Bukhari,** is coming out at a time when the Inspector General of Police (Kashmir) Javaid Geelani recently justified blinding of 16 year old Hamid by rhetorically asking "How (else) can a deterrent be set then? How are stones-throwers to be stopped?". The brazenness of the statement is symptomatic of a much larger problem which confronts people in Kashmir. The fact that IG of Police in May 2015 finds blindings acceptable, should remind us of the old adage that it is not guns that kill it is man who kills. Even air guns can turn fatal if the man wielding is ordered to believe that it is alright to maim or kill protestors.

The significance of the book, therefore, lies in collection and collating of data acquired through RTI as well as based on medical practitioners own experience and observations on pellet caused injuries and fatalities. It is stories of some of the survivors, accounts of family members and others that recalls real life happenings as they unfold and their aftermath. It is the everydayness of this happening, the real events and those involved. It is told simply and lucidly.

But in the end it is much more than that. It tells you, records and documents, what befell people at the hands of Indian occupation forces, when the military forces turned "non-lethal". And in so doing it further lends credence to the body of literature about the hideous aspect of 'War to win Hearts', where not just hearts but minds are target of attack.

Gautam Navlakha
New Delhi, 28th May 2015

Preface

My endeavour was to work for a cause which is about a subject that shaked my conscience and which, after going through this book, I am sure would shake yours too. This volume includes true stories of Pellet gun fire victims, articles on the subject published in various news papers, RTI Reports, collection of Medical Research Articles and the Glimpse of the Victim's lives as came to my knowledge while working on this project.

In this humble effort I have tried my best to arrange the contents in a simple manner, so as to aware the reader about the use of pellet gun and its devastating impact on the human life in the strife torn Valley of Kashmir.

Mannan Bukhari

Dedicated to

Pellet Gun Fire Victims

Of Kashmir

The Alarming Pellets

Kashmir -- a symbol of unfulfilled promises, dreams, commitments and one of the oldest unresolved disputes in the world. The brutal behaviour of the Government of India has turned once a beautiful valley of Kashmir into a terrible place of death, destruction, rapes, fake encounters, disappearances, unmarked graves, orphans, widows, half widows and torture. Here every eye is moist, every heart bleeds, souls are wounded and sentiments bruised.

Since 1947 India has been adopting a military approach to crush the inalienable right to self-determination of Kashmiris. The approach of the Indian state has been and continues to be neo-imperial and aggressively militaristic. Subjugation, Suppression and Oppression are nothing new to Kashmiris. The human dignity and rights of Kashmiris were always trampled with impunity.

In 1990's due to the initiation of a powerful armed struggle coupled with a mass uprising against the Indian Occupation, Jammu and Kashmir was declared a disturbed area by the Government and draconian laws like AFSPA, TADA and PSA were imposed, providing full protection to Government forces to kill, torture, rape, maim and incarcerate people with impunity.

For the last two and a half decades India has maintained the presence of more than 6.00,000 troops, making the region one of the most heavily militarised zone in the world. For an Area whose total population is not more than ten million, the roughly ratio of deployment is one soldier for every fifteen persons. There are reportedly 671 camps of

Indian forces in Jammu and Kashmir occupying 3.5 lakh acres of land (Excluding Jammu, Akhnoor, Udhampur, Kargil and Leh) and 1635 buildings are under occupation of forces. As per the Landmine report 2007 about 160 square kilometres of land in Jammu and 1730 square kilometres in Kashmir were land mined.

Since 1989, more than 70,000 persons have been killed, around 8,000 have gone missing, there are thousands of unmarked graves, several hundred thousand have been maimed, thousands of women have been raped, tens of thousands widowed, countless orphaned and around 250,000 displaced. Since 1990, Kashmir's economy has incurred a reported loss of more than 1, 88,000 million Indian rupees (40.4 billion dollars). About 19 percent of Kashmiris suffer from depression. Nearly 16 percent have post-traumatic stress disorder. Kashmiris are not allowed to protest, and are denied freedom of assembly. Due to the presence of huge military deployment, black laws and denial of basic human rights, nearly every inhabitant of the Valley has been touched by the violence and the discourse of Human Rights remained always unknown to them. Human rights and human values are mere concepts found only in books in this part of the world.

Civilian killings, torture, rapes etc are going on since 1989 but the public agitation of 2010, the third consecutive summer of large scale public uprising was an obstinate nightmare for the government of India. The civilian killings by the hands of Government forces started with the killing of Inayat – ullah – Khan of Dalgate Srinagar on January 08, subsequently four

other civilians including Wamiq Farooq were also killed in the month of January by the government forces. Later after the killings of teenagers Zahid Farooq, Tufail Matoo and the revelation of Machil fake encounter in which three civilians namely Mohmmad Shafi, Shehzad Ahmad and Riyaz Ahmad were killed by the Indian Army, the agitation gathered momentum. Every death at the hands of Government forces catalysed more angry demonstrations and pro-freedom protests and the cycle of intense protests – killings – more protests – more deaths – violence continued throughout the summer. A summer of massive pro – freedom protests, killings, shutdowns, curfews, violence and civilian unrest sweeping the valley with a new generation of Kashmiris pressing their call for an end to Indian rule. This new generation of Kashmiris whose lives have been shaped by the violence of militarization, suppression and subjugation and everything that two –decade-long conflict had thrown their way, were in thousands demonstrating in the streets, challenging the military might of India. Unlike their previous generation, who picked AK-47, these young Kashmiris made stones and rocks a weapon of choice against India's armed forces. With their powerful voice, they continue to speak out – through facebook, YouTube, photographs, poetry, art and street protests.

As hundreds of thousands of people joined rallies and marches against the Indian authority in 2010 and tens of thousands of young men confronted the government forces, authorities clamped curfews and used brute force to quell the pro freedom demonstrations and to suppress the public agitation.

More than 3500 youth were arrested while 120 people were detained under the controversial Public Safety Act during the summer unrest in the Valley. Around 100 among the killed in 2010 were under the age group of 30 years with 37 students including 4 kids of 8 – 12 years of age. They include Milad Ahmad Dar (8) of Wanpora, Khudwani Kulgam, Sameer Ahmad Rah (9) of Batmaloo Srinagar, Asif Hussain Rather (10) of Delina Baramulla and Adil Ramzan (12) of Palhallan Pattan. Around 60% of the executed persons were students. The victims also include 5 women and a 60–years-old person. One Police man was also killed during the unrest.

Since 1990, the large scale pro freedom protests and rallies of Kashmiris were crushed by brutal use of force including indiscriminate firing on the protesting processions which at times turned into massacres which are imprinted on the collective conscience of the people of Kashmir. So far around forty massacres have been recorded which includes Gow Kadal, Hawal, Sopore, Handwara II, Kupwara, Bijbehara, Zakoora, Tengpora, Khanyar, Pathribal, Brackpora and other massacres, where people were killed at wholesale level by the trigger happy cops.

Meanwhile, after the worldwide acrimony over the high number of fatalities during protests in 2008, 2009 and 2010, pellet gun was introduced in Kashmir as a "non-lethal" alternative to bullets against the protestors. But since the Government introduced pellet gun as non-lethal alternative to quell pro freedom demonstrations and to minimize the chance of casualty during street protests in the Valley, it failed to produce the desired results. It has proved deadly

at many times leading to deaths and fatal injuries including significant "collateral damage" to people who were running to fetch milk, heading towards their homes, going somewhere or simply chatting with the neighbours.

The pellet guns were hailed then as effective non-lethal weapons and authorities claimed that they will rarely harm the target. But these pellet guns created havoc in the Valley and have increasingly drawn sharp criticism from various quarters for debilitating injuries on civilians. A single shot fired can explode into innumerable pellets and can penetrate into body at several places like abdomen, eyes, intestines, legs, back, or head and can cause severe damage. A pellet cartridge holds around 500 little iron balls in it and when shot, they scatter in the air, hitting anyone in the range and doctors say, at times it can perform more dangerous than bullets. Surgeries of the pellet wounded, as per the medicos, are so complicated that it not only takes several hours more as compared to bullet injuries, but requires presence of multiple super – specialists. And according to the experts it is the most deadly weapon among the "non-lethal" weapons.

It is pertinent to mention herein that according to experts some of the injuries associated with Pellet Guns (Air Guns) are as:

Eye Injury: Pellet guns injuries to the eye can inflict permanent damage. A 1997 American Academy of Pediatrics' study on air-gun-related eye injuries found that 66 percent of victims suffered permanent partial vision loss or blindness. A 2008 British study, supported by the Charitable Trusts for the United

Bristol Hospitals' Medical Research Committee, found similar results: 65 percent of victims suffered vision loss or blindness.

Skin Injuries: Any projectile can injure the skin; especially one that travels over 200 mph. These guns can cause severe bruising, skin lacerations and deep puncture wounds. Pellets can become embedded in the skin, where they increase infection risk and may require minor surgery to be removed.

Infection: The nature of pellet gun wounds makes them prone to infection. Like other puncture wounds, such as stepping on a nail, the pellets can drive bacteria deep into a wound, increasing infection risk. In one extreme incident in 1992, a Philadelphia man died from a bacterial infection after a BB lodged in his brain.

Fatalities: The U.S. Consumer Safety Commission estimates that BB guns and pellet guns cause four deaths annually in the United States. The chances of death from a BB gun wound, while statistically low, increase at close range. According to the "Orange County Register," a Laguna Hills, California, teenage boy died in 2009 after being shot through the temple with a BB gun. In 2008, a six-year-old Detroit boy died when shot point blank with a BB gun.

Since 2010, hundreds of Kashmiris have been disabled by the use of pump action pellet guns used by the government forces and number of deaths are also associated with this deadly weapon. But since then these pellet guns are being used by the government forces as main crowd control weapon against civilian protestors.

A study conducted at the SK Institute of Medical Sciences, Soura Srinagar, has revealed that pellet guns have caused death of at least six persons and injuries to 198 others during four months of 2010. Five persons, according to it, have also lost their eyesight following pellet injuries.

The study was conducted between June 2010 and September 2010. "A total of 634 patients were received at the Emergency Reception (of SKIMS). 325 (had) sustaincd firearm injuries 88 bullet injuries, 39 tear-gas shell injuries and 198 pellet gun injuries, 98 were injured by stone pelting and another 211 by alleged beating by security forces," the study says.

The study, which has been published in 'Turkish Journal of Trauma and Emergency Surgery', has focused on the pellet injuries only. It has found that 72.7 percent of patients were aged between 16 to 25 years and the percentage of body extremities (limbs) hit was 47.percent.

"Of 80 patients admitted to the hospital for their injuries, 43 (53.7%) required an operative procedure," the study said. "Six deaths (3.03 %) were observed."

"Mortality occurred in six patients (3.03%)," says the study. "Five of these patients died either in the emergency OT or in the immediate postoperative period. One died of septesis on the 7th day."

The study titled "Pellet gunfire injuries among agitated mobs in Kashmir" was jointly conducted by a team of doctors.

"Seven of the 11 patients with injuries to their eyes required operative intervention. "A total of five patients were blinded in the involved eye," said the

study. "One patient had pellet injuries in both eyes, rendering him completely blind."

The study has found that the youngest patient was a six-year-old boy and the oldest was 54 years old, "with pellet wounds in the face and abdomen, respectively."

Of the 198 patients there were six women too. "Most patients sustained multiple wounds, with up to 70 small wounds reported in one of them," the study said. "Injuries to any of these sites were associated with a significant number of injuries involving other parts of the body."

A total of 118 (59.5%) patients were found to have minor injuries and were discharged from the emergency department. Of the remaining 80 (40.4%) patients, 43 required surgery due to viscera damaged. "The most common sites of injuries requiring hospitalization or operative intervention were the abdomen, chest and eyes."

About pellet gun, the study says, "the weapon is a pump action shotgun or pellet gun and its single shot fires numerous pellets that can hit multiple targets at once."

The study says such guns can generate muzzle velocities of 200 to 900 foot-pounds per second. "Skin penetration requires only 120 foot-pounds per second, while ocular penetration can occur at velocities as low as 130 ft/second," it says.

"While the pellet wound itself may seem trivial, if not appreciated for the potential for tissue disruption and injuries to the head, chest, and abdomen, there can be catastrophic results," it further states.

The study compares the pellet injuries similar to bullet injuries. "Pellets should be evaluated and managed in the same way as those sustaining bullet injuries."

Another study titled 'Profile and Outcome of Violence Related Injuries of Patients during Civilian Unrest in a Conflict Zone' has noted that attending doctors grappled with patients who had suffered injuries due to use of controversial pellet guns by the police and paramilitary troops. "An individual shotgun pellet is comparatively small, though victims are usually hit by large numbers of pellets simultaneously; the degree of injury is severe, particularly when the wound is inflicted at close range. The patients present with multiple pellets, sometimes hundreds causing diagnostic difficulties to the treating clinicians "the study says.

According to a study titled 'Pattern of ocular injuries in stone pelters in Kashmir valley' 18 patients with grave pellet injuries caused by the pellet guns were admitted in the hospital during 4 months of 2010. According to the study "the injuries due to pellets are mostly perforating and pellets IOFB (Intra Ocular Foreign Body) and both tend to have very poor prognosis. OTS can be used to estimate visual prognosis."

The study was conducted on the pattern of eye injuries in 60 cases, which were referred to the department of Ophthalmology, Government Medical College Srinagar between 11th June 2010 to September 2010. A total number of 60 patients who received different types of eye injuries were assessed and admitted in the hospital and managed accordingly.

A perspective study of patients with features of vascular injuries due to pellets and rubber bullets from June 2010 to November 2010 was conducted by the Department of Cardiovascular and Thoracic Surgery, S.K. Institute of Medical Sciences, Soura Srinagar, the only Tertiary Care Centre in the State of J & K for the management of such injuries.

All patients with features of Vascular Injuries due to Pellet and Rubber bullets were included in the study. However Vascular Injuries caused by other cases were excluded.

"A total of 35 patients presented with features of vascular injury during this period were studied. All of them were males. The mean age was 22years. Fifteen patients were revascularized primarily, 19 patients needed reverse saphenous vein graft and, in one, patient lateral repair was done. There were two mortalities in our series. Wound infection was the most common complication. The amputation rate was around 6%." The study says.

Doctors have observed a pattern in some of the injured, as vital veins and arteries of some of the victims had been torn beyond repair leading to amputations.

The study titled 'Pattern, presentation and management of vascular injuries due to pellets and rubber bullets in a conflict zone' has found that Pellets and rubber bullets can cause serious life-threatening injuries. Vascular injury caused by these weapons need no different approach than other vascular injuries and early revascularization and prompt resuscitation prevent the loss of limb or life.

It is pertinent to mention herein that using these pellet guns for disbursing protesters as a crowd dispersal technique is alien in the civilised societies of the world and its use on unarmed civilian populations is generally considered a transgression of human rights. Where as it continues to be used exclusively in Kashmir valley as "non-lethal" weapon to quell the public demonstrations.

Such crowd dispersal techniques have never been used outside Kashmir, in India or in any other democratic setup, instead lathicharge, Water Cannons, Teargas etc are generally used to disperse the mob. However, in Kashmir these deadly pellet guns are being used frequently by the Police and CRPF personnel directly on civilian protesters, targeting their vital parts viz eyes, chest, head, back abdomen etc which not only deprives the victims of their eye sight but also deprives them of their lives.

Assuming for the sake of arguments that the persons injured or killed by these pump action Pellet guns were the part of unlawful assembly, nevertheless no law empowers the police and CRPF to take law into their own hands by misusing their position, as, the protests cannot be retaliated by virtue of Pump Action Pellet gun fires indiscriminately upon the human beings which omissions and commissions on the part of the men in uniform amount to the violation of Articles 21 of the constitution of India and basic human rights values.

It is noteworthy to mention herein that there is the set procedure given under **chapter IX of Criminal Procedure Code. Svt 1989, for dealing with "unlawful assemblies"** under sections 127, 128,

129, 130, 131 and 132 Cr.P.C. The Executive Magistrate or Officer in charge of police station is empowered under section 127 Cr.P.C, may command any unlawful assembly, of five or more persons likely to cause a disturbance of the public peace, to disperse and there upon be the duty of the members of such assembly to disperse accordingly. And if such assembly does not disperse, the Executive Magistrate or Officer in charge of police station may under section 128 Cr.P.C, by force disperse such assembly and if necessary, to arrest and confine the persons who form part of it and may be punished according to law. The force word appended to the section above stated has not been shown and interpreted as using of excessive force in terms of using of lethal weapons like pellet guns. Therefore the provisions of section 128 Cr.P.C are being violated by the law enforcing agencies. The procedure to disperse the unlawful assemblies is to arrest and confine the persons involved in unlawful assemblies, if necessary, but the police or paramilitary force is no where given license to kill or to cause grievous injuries by cluster of pellet gun-fires. More so under sub section 2 of section 130 Cr.P.C, every commissioned or non-commissioned officer in command to disperse such assembly, shall obey the requisition of the Executive Magistrate in such manner as he thinks fit, but in so doing, he shall use as little force, and do as little injury to person and property, as may be consistent with dispersing the assembly and arresting and detaining such persons, but in the cases of pellet gun fires as stated herein above, the procedure which needs to be adopted and adhered to, is not being complied with, hence the acts by the paramilitary forces or by the police in the garb

of their uniform amounts to violation of the above stated sub section 2 of section 130 Cr.P.C.

Even the Jammu and Kashmir State Human Rights Commission has expressed its great concern over the excessive use of Pellet Gun by the government forces, which according to it is a threat to life. After taking into account the adverse effects of the use of Pellet gun by the law enforcing agencies which is Prima Facie case of human rights violation and according to the State Human rights Commission the law enforcing agencies were bound to strictly follow the Standard Operation Procedure (SOP) and adhere to the use of non-lethal methods of mob control in order to prevent causalities, it further observed that the law enforcement agencies must use minimum force which will not cause any causalities or serious injuries.

The use of deadly pellet guns has also echoed in J&K legislative Assembly on 11 March 2013 when a few members from the then opposition party expressed resentment over the use of pellet guns by the government forces. "The use of pellets by the security personnel while dealing with the protesters is adversely affecting People's health. People are being injured and killed by the pellet Guns." PDP President Mehbooba Mufti had said.

On Feb 16, 2014 the then opposition PDP walked out of the Jammu and Kashmir Assembly to protest against the use of Pellet guns on protestors. They criticised the government over the use of "Harmful Weapons on Public" and sought a reply. "Two youth-Tariq Ahmad and Ghulam Mohidin were injured after Pellet guns were used on protesters. They have

suffered severe injuries in their eyes and doctors have to refer them to Amritsar for treatment," Mehbooba Mufti said.

The opposition alleged that State government's use of Pellet guns against civilian protestors, left many youth deprived of their vision. It has caused loss and impairment of Vision to many in Kashmir. A ban on the use of Pellet Guns and Chilli grenades in Kashmir valley as well as compensation for the injured youth for their medical bills and treatment was demanded.

However, since they have taken over the reins of power at least three persons have suffered fatal pellet injuries at the hands of the men in uniform. On 17 April 2015, Aquib Ayub Bhat son of Mohmmad Ayub Bhat of Zonimar, Srinagar and Bilal Ahmad Lone son of Ab. Rahman Lone of Syed Pora, Eid Gah, Srinagar received pellet hits in their eyes, resulting in serious damage to their vision. On May 21, 2015, Sixteen-year-old Hamid Ahmad, a student of class X of Palhallan, Pattan, North Kashmir also became the victim of fatal pellet injuries during the P.D.P and B.J.P collation rule. The brutal cops fired directly on Hamid and he was hit by a rain of pellets in his skull, forehead and face. The attack was so serious in nature that the number of pellets in his entire skull was more than 100. The unconscionable way in which pellet guns are used in the Kashmir is continuity of the suppressive military approach of New Delhi through which it wants to control Kashmir, eliminate its youth in a different way so that the genuine voice of the Kashmiris gets muted.

It is also of paramount importance to mention here that the victims of these Pellet guns have suffered not only in terms of their health but they also had to incur

huge amounts for their treatment besides the loss to their financial capacity as they became incapacitated and unable to work. It has been observed that a majority of victims are from very poor families having hardly any source of Income.

According to Press Trust of India (PTI) the weapon was first time put to use on 14 August 2010 against a 3000-strong mob at Seelo Sopore in north Kashmir and a few people were injured but no one was killed in the forces action. However, according to information obtained through Right to Information (RTI) Act from District Hospital Baramulla, on 31 July 2010 a patient namely Iqbal Ahmad Rather son of Ghulam Nabi Rather of Sangrama who was injured at Baramulla was having bullet injuries on his back and his X-Ray showed pellets in chest. He was referred to Srinagar. As per the same information one more person namely Gh.Qadir Shayir of Seelo Sopore who was injured at Baramulla on 14 August 2010 had pellets on his chest and his minor pellet injuries were treated at the District Hospital.

In fact, shortly as this deadly weapon was introduced, Kashmir saw its first casualty. On 19 August 2010, Para military CRPF personnel fired cluster of pellets in Sopore and Soura on protestors in which Mudasir Nazir, Danish Ahmad Sheikh, Lateef Ahmad Changa, Feroz Ahmad, Muhammad Umar War and Nisar Ahmad Malla were critically injured.

Twenty years old Mudasir Nazir Hajam son of Nazir Ahmad Hajam of Aram Pora Sopore, is the first person who lost his life due to these deadly Pellets. He along with Danish Ahmad Sheikh and Latief Ahmad Changa received cluster of Pellets when CRPF

personnel who were boarded in a Bunker Vehicle without any provocation fired Pellets indiscriminately on civilians near Chinkipora Sopore. Mudasir was rushed to SKIMS (S.K. Institute of Medical Sciences) Soura Srinagar and was admitted under MRD No:6624431 dated 19-08-2010. Due to Pellet firing almost whole small intestine of Mudasir was perforated with massive gangrene. He succumbed to his injuries on 20-08-2010 (12:45 am) at SKIMS in Soura Srinagar.

Another Victim Danish Ahmad Sheikh son of Muhammad Ramzan Sheikh of Tarzoo Sopore aged about 15 years, a student of Government School Takiyabal received multiple injuries on head, scapular region, back and one pellet in orbit. He was referred from SKIMS (emergency Card No: 824669 dated 19-08-2010) to Ophthalmology Department of SMHS Hospital Srinagar (OPD ticket No: 600660 dated 20-08-2010) as he had received grave injury in his left eye.

Regarding the death of Mudasir Ahmad a CRPF spokesman was quoted by a New Delhi based television network as saying that Assistant Commandant S.K Das of the 177 Battalion fired two rounds from a pellet gun in self defence and Mudasir Ahmad Hajam was hit in the abdomen.

It is worth mentioning here that the Jammu and Kashmir State Human Rights Commission in one of its judgments dated 23-10-2013 regarding a complaint (File No: SHRC/137/2010, date of institution 04-10- 2010) says, "After going through the report of the Police chief of the State there remains nothing substantial to be adjudicated in the matter. The DGP J&K has frankly admitted in

his report that CRPF personnel who were boarded in a banker vehicle fired indiscriminately on civilians as a result of which three persons sustained injuries out of whom one Mudasir Nazir Hajam succumbed to his injuries and the present subject has sustained 30% visual impairment permanently. From the report, **it is clear that the deceased and the injured were completely innocent civilians but for the misadventure and unbridled powers exercised by CRPF personnel a precious life has been lost** and the present subject has sustained permanent disability. The incident is an example which shows that many innocent civilians have unnecessarily lost their lives only because the Security forces had run amok and were not subjected to any command or control."

Hon'ble member of the J & K State Human Rights Commission, Mr. Javaid Kawos in his judgement (regarding the victim Danish Ahmad Sheikh) further says "Though this is clearly a black spot on the face of a civilized society which is run by "Rule of Law" and equality before laws. I personally feel shocked that such unaccounted incident has taken place and the Investigating Officer/Police concerned is still unable to get the nominal roll of CRPF personnel from the Force. There is nothing on record to show that the CRPF high ups have even ordered a court of enquiry or any departmental enquiry against the erring personnel who resorted to indiscriminate firing on peaceful civilians without any provocation. I say so because there is report of Police Chief of the State before me."

Like Mudasir Ahmad Hajam, Irshad Ahmad Parray, Yasir Rafiq Sheikh and Abdul Gani Goji there

are number of victims who lost their lives to deadly pellets. Leaving aside the death, these pellets have also lead to complete vision disability among the victims like Amir Kabir Beigh, Hayat Ashraf Dar, Farooq Ahmad Malla and Muhammad Sidiq Chotta. Besides there are hundreds of victims who have lost one eye or have got partial visual disability due to these pellets fired by the law enforcing agencies. These traumatised souls are the unnoticed victims of the Kashmir Conflict. They are alive and do not make it to the statistics of the dead but their future has been darkened forever, they are living the lives of the dead and helpless.

Such highly condemnable acts are reminiscent of the Roman gladiator's shows and the barbaric Mongol rulers who gauged eyes of their adversaries for a sport. Hardly any modern society can reconcile with the use of such a brute and wanton force against the voices of dissent. Even beasts have rules of game but it seems that in Kashmir the oppressor has no rules at all.

The indiscriminate use of pellet guns and the deadly injuries suffered by the victims are alarming. Many of these victims have little hope and economical means to get proper treatment. Fearing police and other government agencies, most of the victims don't want to apply for government compensation or relief. On the other hand social relations of these victims also get negatively affected. If pellets are sprayed on victims body, it look like he has been stung by hundreds of bees or flood of needles are pierced in his body and the marks get permanently imprinted on the skin. Thus pellets piercing the body change the cosmetic appearance of the body. In some cases

it is impossible to take all the pellets out of the body because of their small size.

All the heartrending cases of pellet Gun victims of Kashmir show the miseries they suffer and the atrocities, suppression as well as oppression committed upon them by the men in uniform. Only victims and their families know how life becomes hellish for them. Their dreams are shattered, they are maimed for life and they are half dead.

The figure of pellet gun fire victims is much higher but exact figures are impossible to compile as many victims do not register themselves in the health care centres, for being charged with rioting. Families of most of the victims with pellet injuries prefer to treat the injured at private clinics and hospitals. They avoid visiting government hospitals due to the fear of police spies and agencies posted there. These spies and agencies present in the hospitals check hospital records and watch the patients to arrest the pellet gun victims. Number of victims with serious injuries and pellets present in their eyes were operated in the private clinics and hospitals in and outside the Valley. These victims and their families do not cooperate with the Media fraternity and Rights activists. They try to avoid them because of the fear of police and other government agencies. There are scores of victims who have been treated at private clinics, chemist shops or at homes because their injuries happened to be minor. Hospital authorities also didn't cooperate fully regarding the details of deaths, surgeries and the number of patients admitted etc due to pellets fired upon them by the government forces. The applications filed under Right to Information (RTI) Act were

also not responded positively and delay tactics were adopted by the concerned authorities. However I was able to get some information from the hospitals and other concerned authorities. But the figures provided are not complete and contradict with the figures about the number of patients present in the studies conducted by the doctors of the concerned departments of leading hospitals. But still the figures provided under RTI Act by the concerned authorities are shocking and horrible.

Despite of these shortcomings I was able to compile a comprehensive data and document the cases regarding these pellet victims through the information obtained under RTI Act and by visiting some victims and their families personally or through Media and other sources. Due to some reasons the details about most of the victims could not be mentioned here but details regarding few victims are being shared in this publication with the aim and objective to aware global leadership, international human rights organisations, global civil society and people, so that they take serious note of this crime against humanity committed by the men in uniform in the Kashmir valley. They must intervene and call on Indian authorities and authorities in Jammu and Kashmir to protect the Right to Life in accordance with the International Law – including the International Covenant on Civil and Political Rights, to which India is a signatory and a state party. It is high time for the government of India to recognise the fact that use of pellet gun constitutes violation of human rights covenants and a 'threat to life'. In this regard International Standards, in particular the United Nations Basic Principle on

the Use of Force and Firearms by Law Enforcement Officials and the code of conduct for Law Enforcement Officials must be strictly followed. The use of pellet guns as crowd control weapons should be immediately banned and steps for rehabilitating the victims and sufferers of pellet injuries must be initiated.

International Humanitarian Organisations bear a responsibility to impress upon India to immediately halt the use of Lethal Weapons by Government forces against the civilian protestors in Kashmir. An impartial and effective investigation regarding the use of this deadly weapon against civilians in Kashmir is must. All deaths or serious injuries caused by it must be investigated and all suspects, including those with command responsibility, must be prosecuted in a competent, independent and impartial court. For this purpose the International Human Rights Organisations must initiate an International and transparent investigation in all such cases of pellet victims and all other Human rights violations in Kashmir. The perpetrators must be punished. Justice is must.

A Glimpse
On
Victims

Mudasir Nazir

(The first person who lost his life to deadly Pellet Guns)

"Where are you my son? Why didn't I stop you from visiting mosque on that fateful day? You were my first child. You were my Hope. Your death has shattered our dreams", screams Naseema. Every tear drop that rolls down her face is revealing the account of gruesome killing of her son Mudasir Nazir Hajam who became victim of newly introduced pellet guns at Arampora Sopore in north Kashmir.

On 19th August, at the peak of 2010 public agitation, 20 years old Mudasir Nazir Hajam, student of 12th standard in Hajam Mohalla Arampora Sopore left home to offer the evening prayers at a local mosque. It was the Holy month of Ramadan, Mudasir's mother Naseema and two younger sisters insisted him to break his fast with the family but Mudasir insisted that he will break his fast in the mosque. He promised that after offering evening prayers he will join the family and will accompany them at dinner. Mudasir's father Nazir Ahmad Hajam an ordinary hair cutting saloon owner was not feeling well and he along with his wife Naseema and two daughters broke their fast at home. After offering evening prayers Naseema started preparations for dinner. Her younger daughter laid the dining sheet on the floor and suddenly they heard the sound of gun fire from outside.

It was Mudasir who along with two other persons namely Danish Ahmad Sheikh and Latief Ahmad

Changa were critically injured when CRPF personnel boarded in a Bunker Vehicle going towards Adipora village fired pellets indiscriminately on the people without any provocation. Mudasir was hit by cluster of pellets and received multiple Pellet injuries in abdomen chest and thighs respectively. Mudasir was rushed to state's premier territory–care hospital, SK Institute of Medical Sciences (SKIMS), Soura Srinagar, and was admitted there under MRD No: 6624431.

Due to Pellet injuries almost whole small intestine of Mudasir was perforated with massive gangrene. Doctors faced lot of problems while operating Mudasir who had got multiple pellet injuries in multiple organs. A senior doctor attending Mudasir said that he had never seen such condition of patients and was aghast over the use of newly introduced pellet guns. "We tried our outmost to save his life but the pellets have damaged his whole gut" he said.

Mudasir is the only son of his parents who are now left with two daughters. He succumbed to injuries on 20-08-2010 (12:45 am) at SKIMS Soura Srinagar and is the first person who lost his life to newly introduced Pump Action Pellet Guns in Kashmir.

It is pertinent to mention here that regarding the pellet firing by CRPF at Armpora Sopore in which Mudasir lost his life and two others were injured, an FIR No 414 of 2010 stands registered in Police Station Sopore for offences punishable under section 307 RPC. Regarding the incident a judgement of Jammu and Kashmir State Human Rights Commission which was obtained through Right To Information Act.(RTI Act), is annexed with the second victim's case study.

Danish Ahmad Sheikh

15-year-old Danish Ahmad Sheikh of Tarzoo Sopore was hit by scores of Pellets fired by the Para military CRPF personnel at Armpora Sopore in North Kashmir.

A student of Government School Takiabal Sopore, Danish has been living with his maternal grandparents at Armpora Sopore since his Childhood. In his early childhood he often remained sick and complaint of some gastric problems at his home Tarzo Sopore. Because of his health problems his grandparents took him to Armpora Sopore and admitted him in Government School Takibal, since then Danish used to live with his grandparents.

Relatives and neighbours near his maternal home Armpora Sopore stated that Danish is a sensitive boy and vouch for his honesty, gentleness and his careful nature. The first child of Muhammad Ramzan Sheikh, Danish often used to visit his home at Tarzoo Sopore, to see his four younger sisters, two younger brothers and his mother.

"Danish was never part of protests and never hurled a stone at Police or Para military CRPF. I had virtually banned him from venturing out since the Sopore town along with the whole valley witnessed pro-freedom demonstrations and clashes between protestors and troopers during 2010 public agitation," says his maternal uncle Ashiq Ahmad Malla.

On August 19, Danish broke his fast at his maternal home and moved towards mosque to offer evening prayers. Para Military CRPF personnel boarded in a

bunker vehicle going towards Aadipora Sopore were firing pellets indiscriminately on people moving around without any provocation. Danish who was near the mosque got hit by the pellets and sustained multiple injuries in left eye, head, neck, forehead, chest and arms respectively.

Danish along with Mudasir Ahmad Hajam and Latief Ahmad Changa who were also critically injured by the pellet firing were rushed to SK Institute of Medical Science (SKIMS), Soura Srinagar. Where Mudasir Nazir Hajam succumbed to his injuries and Latief Ahmad Changa was discharged after treatment, while as Danish who was admitted in the Emergency Department of SKIMS under No: 824669 Dated 19-08-2010, after proper treatment was discharged on 20-08-2010 MRD No: 62448 and was referred to Ophthalmology Department of SMHS Hospital Srinagar for further treatment of grave pellet injury in his left eye.

On August 20, 2010 Danish was taken to SMHS Hospital and was treated under No.600660. Lying in bed No 16 of Ophthalmology ward of SMHS Hospital, Danish, who's left eye was damaged was hopeful that he will regain his eye sight but his hopes were smashed and nothing happened.

BEFORE JAMMU AND KASHMIR STATE HUMAN RIGHTS COMMISSION
DAWN BUILDING, DALGATE, SRINAGAR.

Before:	Javaid Kawos.	Member
File No. SHRC/137/2010	Date of Institution 04/10/2010	Date of Decision 23/10/2013

Complaint from Deirdre O'Reilly, M.Ed. and Rosalina Costa, Human Rights Advocate Hotline Human Rights Bangladesh.

V/S

J&K State.

JUDGMENT

Nemo for the complainant.
Gh. Rasool for CPO.

During the turmoil of year 2010 many precious lives were lost and many more sustained permanent disabilities and thereby have been left to suffer for whole of their lives. In the present case, the plight of one Danish Ahmad Sheikh aged about 15 years, a student of Government School Takiabal District Baramulla has shaken the conscience of many Rights Activists across the globe and they through their e-mails have approached this Commission for justice to be done in the matter. Deirdre O'Reilly from Glassgow, UK and Rasalina Costa from Bangladesh have highlighted the case of subject Danish Ahmad Sheikh. Both the Rights Activists have shown their serious concern that on 19 August, 2010 CRPF personnel while on patrol duty at Tarzoo Sopore fired indiscriminately at civilians in order to force them to remain indoors and during this indiscriminate and unprovoked firing the subject who was simply returning home from a local mosque was hit by pelletilets on his forehead, two on his back and one in his left eye. It has been agitated that though he was rushed to SKIMS but the subject has lost eyesight of his left eye permanently. They have shows their concern and requested for proper investigation because the Security agencies have been resorting to firing at civilians at random and injuring them without any accountablility.

Both these e-mails were clubbed and registered as a complaint in which initially reports were sought from Financial Commissioner Secretary Home, Director General of Police, J&K and Dy. Commissioner Baramulla. Police chief of the State is the only authority who responded to the communications of the Commission and submitted a detailed report regarding the incident. The copy of the report was initially forwarded to both the complainants for their rejoinder / further presentation, but later on it was observed that it was not possible for the the actual complainants who hail from UK and Bangladesh to send their rejoinders because the Commission was never sure whether the copies of the report submitted by the Police chief of the State have actually been delivered to them. It was, therefore, thought proper that the actual victim and his nearest next of kin be called so that they can pursue the matter before the Commission. The actual victim Danish Ahmad Sheikh alongwith his father Mohammad Ramzan Sheikh

Police chief of the State, in his report dated 10.03.2011, has admitted that on 19.08.2010 a group of people alongwith subject Danish Ahmad Sheikh approached Police Station Sopore where they reported that CRPF personnel boarded in a banker vehicle were going to Adipora started firing upon the people without any provocation as a result of which at Hajam Mohalla Sopore three youth got injured and in this backdrop a case FIR No. 414 of 2010 was registered in P/S Sopore for offences punishable u/s 307 RPC. The report further reads that during investigation it was ascertained that Danish Ahmad Sheikh alongwith two other youth Mudasir Nazir Hajam and Latief Ahmad Changa had also got injured during the firing and all of them were rushed to SKIMS Soura Srinagar by the locals where one of the injured Mudasir Nazir Hajam succumbed to his injuries and the present subject sustained bodily injuries. The Police chief of the State has further reported that though during the investigation the Investigating Officer tried his level best to get the nominal roll of CRPF personnel deployed at the location on the said date, but till date he has not been able to get the same due to the ill response from CRPF as a result of which investigation of the case is still pending

The report being all favourable to the interests of the subject, so no rejoinder /further presentation was filed. The subject and his father were only directed to file permanent disability certificate which they filed in original and is available on the file. The Disability Certificate shows that the subject Danish Ahmad Sheikh was examined by a Medical Board who have opined that he suffers 30 % visual impairment and the disability is permanent.

I have considered the matter and have perused the entire record available on the file.

Actually, after going through the report of the Police chief of the State there remains nothing substantial to be adjudicated in the matter. The DGP J&K has frankly admitted in his report that CRPF personnel who were boarded in a banker vehicle fired indiscriminately on civilians as a result of which three persons sustained injuries out of whom one Mudasir Nazir Hajam succumbed to his injuries and the present subject has sustained 30 % visual impairment permanently. From the report, it is clear that the deceased and the injured were completely innocent civilians but for the misadventure and unbridled powers exercised by CRPF personnel a precious life has been lost and the present subject has sustained permanent disability. This incident is an example which shows that many innocent civilians have unnecessarily lost their lives only because the Security Forces had run amok and were not subjected to any command or control. Though Rosalina Costa has addressed her concern directly to Honorable Chief Minister of J&K, but I feel that either the e-mail has not gone to his table or same has been treated in a routine manner. Though this is clearly a black spot on the face of a civilized society which is run by "Rule of Law" and equality before laws. I personally feel shocked that such unaccounted incident has taken place and the Investigating Officer / Police concerned is still unable to get the nominal roll of CRPF personnel from the Force. There is nothing on record to show that the CRPF high ups have even ordered a court of enquiry or any departmental enquiry against the erring personnel who resorted to indiscriminate firing on peaceful civilians without any provocation. I say so because there is report of Police chief of the State before me.

Considering all that what has been discussed herein above, it is recommended that the victim Danish Ahmad Sheikh S/O Mohd. Ramzan Sheikh R/O Tarzoo, Sopore be given ex-gratia relief of Rs. 75,000/- for sustaining permanent disability and further District Social Welfare Officer Baramulla will pay monthly financial assistance as envisaged under scheme 20 of Social Welfare Department Schemes in J&K. The Dy. Commissioner Baramulla will ensure that the District Social Welfare Officer Baramulla sanctions and pays the due monthly amount to the subject. Further, it is hereby recommended that Director General CRPF shall ensure submission of nominal roll of the erring officers / officials who resorted to indiscriminate firing on 19 August, 2010, to DGP J&K so that investigation of FIR No. 414 of 2010 of P/S Sopore is taken to logical end.

Copies of this judgment be forwarded to the State government / District Administration through Chief Secretary of the State, Director General CRPF C/O 56 APO, Dy. Commissioner, Baramulla and District Social Welfare Officer Baramulla for reporting action taken report (ATR) / proposed action taken report (PATR) within the prescribed time frame as provided under the act.

A copy of this order be also forwarded to both the complainants as also to subject Danish Ahmad Sheikh S/O Mohd. Ramzan Sheikh R/O Tarzoo Sopore under registered post free of cost for their information. The original disability certificate be returned to the subject personally against proper receipt after retaining photocopy of the same for records.

The file after due completion be consigned to records.

23.10.2013

Javaid Kawos
Member J&K SHRC.

Announced:
23/10/2013

Irshad Ahmad Parray

Studying in the 8th standard, Irshad Ahmad Parray, a brilliant student of Government Middle School Mehman Mohalla Anantnag, was only 14, when hundreds of pellets were fired upon him by the Police personnel near Sher Bagh Anantnag, in South Kashmir.

"On 29 August 2010, in the holy month of Ramadan, Irshad despite not feeling well, woke up for Sehri (dawn meals) and insisted that he will keep fast. Around at 4 pm before leaving home for afternoon prayers, Irshad had a bath and put on new clothes," says Irshad's father Mohammad Ashraf Parray, an auto driver and a resident of Old Idd Gah Lal Chowk Anantnag.

After offering afternoon prayers in a local mosque Irshad went to Cheeni Chowk and Sher Bagh area to watch pro freedom protests which were going on in the area.

Irshad, while fasting, was watching the protesters on a roadside near Sher Bagh at 5 pm, when he got caught in between protesters and cops after clashes broke out and was hit by cluster of pellets fired by the police. Irshad fell down amid pool of blood. He received multiple pellet injuries on whole body and was rushed to the M.M.A.B Hospital Anantnag where doctors referred him to SKIMS/SMHS Hospital Srinagar. Irshad was received in surgical casualty theatre of SMHS Hospital Srinagar with multiple pellet injuries involving (L) side of Abdomen, Chest and (R) Arm, but he was having no Vital Signs and

was declared brought dead under OPD No. 60868, Dated 30-8-2010.

Irshad Ahmad Parray is the second person who lost his life to Pellet gun firing in Kashmir and is survived by his parents, younger sister studying in 5th standard and elder brother studying in 10th standard.

Death Certificate issued by the Ragistrar SU-II

<u>S.M.H.S.Hospital Srinagar</u>

Certified that irshad Ashraf Parray S/O Mohd Ashraf Parray

aged approximately 14years R/O Old idgah Lal Chowck Anantnag

was received in Surgical Casualaty theatre with multiple

pellet injuries involving (L) side of abdomen/Chest/(R)

arm on 30-08-2010 at 7pm.He was having no vital signs and

was declared brought dead.This is as per the records available

in this hospital with the deceased bearing OPD NO:-60868

dated:-30-08-2010.

Sd/-

Ragistrar SU-II

GOVERNMENT S.M.H.S.HOSPITAL SRINAGAR

NO:-MS|Misc/2592 Dated:- 5/0-2010

Copy to the:-

1. Mohd.Ashraf Parray R/O Old Idgah Lal Chowck Anantnag for

 information.This is inref.to his application on:/file/

Dy.Medical Superintendent,
S.M.S.Hospital Srinagar.

Yasir Rafiq Sheikh

28 years old, shopkeeper Yasir Rafiq Sheikh son of Rafiq Ahmad Sheikh of Maisuma Srinagar, was among five other persons namely Ashfaq Ahmad, 18; Sajid Mushtaq, 19; Aquib Ahmad, 17 and Feroz Ahmad Dar, 40 who were critically injured in the unprovoked pellet gun firing by police on a group of youth who were playing carom on a street outside their houses at Misuma Srinagar on 30 August 2010 around 10 in the morning.

All the injured persons were admitted in the surgical ward of the SMHS Hospital, a major hospital in Srinagar. As the injured were writhing in pain, their family members, relatives and neighbours were highly disturbed and emotional scenes were witnessed as all the injured hailed from Maisuma locality. The inconsolable families were screaming and shouting "They were not raising slogans, they were not protesting, they were not pelting stone, for what crime the brutal cops fired pellets on them from point blank range? They were playing carom, why did they fire upon them?"

Four other victims recovered after a few days of treatment at the SMHS Hospital but Yasir had received cluster of pellets in abdomen and his intestines were badly damaged. Around 20 cm of his intestines were cut by the pellets and were removed. He was given around 20 pints of blood because he had lost most of his blood by the time he was brought to the hospital.

But his condition continued to be critical after surgery and many days of treatment.

After 10 days Yasir was moved to Apollo Hospital New Delhi for better and advanced treatment. On 16 September, the doctors treating him at New Delhi's Apollo Hospital gave up their efforts to save him and Yasir succumbed.

Yasir Rafiq Sheikh is the third person who lost his life after being hit by a cluster of pellets. He left behind younger sister, parents and immortal memory of separation.

Feroz Ahmad Kandoo

On August 19, 2010, around one kilometre from SK Institute of Medical Sciences, Soura Sgrinagar, in Jinab Sahab Soura area, a large number of people including children and women from Anchar and Jinab Sahab locality took to streets and staged a pro-freedom demonstration. They were peacefully protesting against the civilian killing in valley by the govt forces.

A huge contingement of police and Para military CRPF reached on the spot and without any provocation started teargas shelling and fired bullets to disperse the peaceful protesters. In police action at least 10 persons were injured. Four of them were from one family and three had bullet injures.

The incident brought more people onto streets who raised pro-freedom slogans and protested against the brutal action of the govt troops. Police and Para military CRPF men resorted to teargas shelling and used pellet guns to disperse the unarmed protesters. Several people sustained injuries due to forces action.

20-year-old, Feroz Ahmad S/o Mohammad Shafi Kandoo of Anchar Soura was hit by scores of pellets fired by the men in uniform. Feroz was admitted in the SMHS Hospital under MRD No 493562 dated 19-08-2010. He had received grave pellet injury in his left eye and was operated upon in the Ophthalmology department unit 1st of the same Hospital.

A driver by profession, Feroz Ahmad, one of the early victims of pellet guns in Kashmir, was discharged from the hospital on 26-08-2010 and his life goes on with the damaged left eye.

Owais Amin Dentho

In Kashmir the indiscriminate use of pellet guns and the fatal injuries suffered by numerous youth are alarming. Most of the youth who fell prey to this deadly weapon are students and numerous lost their eyesight or are visually impaired by one eye. The future of these students has been smashed and their career ruined forever.

Thirteen-year-old Owais Amin Dentho of Chattabal area of Srinagar is one of those young students who sustained life changing pellet injury at the hands of Government forces. He became the victim of pellet fire on September 8, 2010 when he was heading towards his tuition centre. As he was on way towards his destination, there was no disturbance in the area. But as he reached the main road, all of a sudden clashes erupted between protesters and troopers. Owais was hit by a pellet in his right eye and his eye suffered significant damage.

He was admitted in the Ophthalmology department of SMHS Hospital Srinagar, but finally doctors referred him outside the state for specialized treatment. His father Mohammad Amin Dentho who runs a modest business, took him to AIIMS Delhi, where he had two emergency surgeries. But the doctors treating him were not hopeful that his eyesight will be restored. Later on he was also taken to a private hospital in Amritsar but, the eye sight in his damaged eye could not be restored. Till now the family has spent more than five lac rupees and have

sold some family ornaments and other valuables for the high costs of his treatment.

The brutal pellet injury has partially snatched his eyesight and suddenly, the life for this teenager has changed forever. After the pellet attack, traumatized and visually impaired Owais was not able to reconcile with the abrupt change in his life but slowly, he has found ways to accept the hard reality. Now Owais doesn't want his family to spend more money on his treatment because the high amount his family has incurred on his highly expensive treatment has left him sullen. He is not able to achieve academic excellence as this tragedy has taken a severe toll on this psyche. Now he cannot concentrate properly on his studies for more than an hour as he feels pain in his both eyes and this uncertainty has over shadowed the prospects of his future.

The incident has almost devastated the family and left them speechless. "I was working hard to feed my family and for the better education of my children. I was keen to see Owais as highly educated but these pellets have not only snatched my son's eyesight but smashed the hopes of our family as well. This gruesome incident has pushed our family in an endless journey of miseries and sufferings," says his father Mohammad Amin in a mournful tune.

After pellet injury which left Owais and many other youth like him impaired, their social relations have changed. The negative physiological impact of the tragedy has changed the behaviour of many pellet survivors. Their cosmetic appearances have changed because of the visible injury marks. They feel shy in maintaining eye contact because of the change in

physical appearance. The barbarous approach of the state and the high handedness adopted by the government forces has shattered dreams of many students like Owais. The perilous pellets have not only made them disabled but their lives have also been spoiled badly. Due to state inflicted violence their career has vanished in the roars of pellet gun fires and the number of victims of such fatal injuries due to pellet guns continue to surge as the use of pellet guns by the government forces in Kashmir hasn't stopped.

Sohail Ahmad Khan

On 21 May 2013 afternoon, Sohail Ahmad Khan, 20 year-old young boy from Soura Srinagar was returning home on a bike after visiting his relatives at Gopal Pora, when police personnel fired cluster of pellets on him at Rajouri Kadal Srinagar after there was some incident of Stone Pelting in the area.

A commerce student of Islamia College Srinagar, Sohail Ahmad Khan after being hit by pellets from a very close range fell from the bike and was ruthlessly beaten by the men in uniform. Sohail was lying in a pool of blood at the road and was rushed to S. K. Institute of Medical Sciences (SKIMS) Soura, by some locals. His family came to know about the gruesome incident at around 8:30pm when he was already admitted in the SKIMS under MRD No 754397 at 6.00 pm. Sohail had received multiple Pellet injuries in abdomen, arm, back, head, chest and legs and was operated on the same day.

Sohail's father 48 years old Abdul Majeed Khan, a hard working carpet weaver with limited sources of income had never thought that such a horrible thing would happen to his son, who was never involved in pelting stones on the government forces. It was impossible for him to manage the crises and its expenses on his own but at that desperate time his neighbours and management of his local mosque came forward and lent a helping hand.

"I was shocked with the behaviour of some government officials who offered me Rs 2000 in the hospital and asked me to remain silent about the

issue. I don't know from which department they were but it was shocking and very unfortunate. It shows the situation that prevails in Kashmir," alleged Sohail's father Abdul Majeed Khan.

Sohail, a very sensitive and a hard working boy was aware of his father's financial conditions and was trying his best to complete his bachelor's degree in commerce with flying colours. Besides his studies Sohail was doing a part time job with a businessman from old city of Srinagar and was managing his accounts as Sohail is a brilliant commerce student with accounts as one of his main subjects. Thus Sohail was providing financial support to his family and was managing the expenses of his studies on his own as he was aiming to become a Charted Accountant.

Injured Sohail battled for his life at Surgical Intensive Care Unit (ICU) of SKIMS for many days and underwent different consecutive surgeries there. Even months after his discharge from SKIMS on 01-06-2013, Sohail is unable to concentrate on his books for more than an hour as he suffers from headaches, low blood pressure problem and feels laziness. The brute pellet attack has badly affected his studies. His back still bears pellet injury marks, as if he has been stung by hundreds of bees. The mark of grave wound on his arm is so clear and visible even after the months of treatment and plastic surgery. Sohail is still visiting the Department of General Surgeries, Department of Plastic Surgery and Department of CVTS at SKIMS for treatment and regular checkups. The family is barely managing the huge costs of his treatment and is still suffering silently.

Muzamil Qayoom

During public protests against the execution of Mohmmad Afzal Guru, the 2001 Indian Parliament Attack Convict who was executed inside Tihar Jail in Delhi on 9 February 2013, India's paramilitary, police and military resorted to extreme use of Pellet Guns to quell unarmed civilian protests against the execution.

On 12, February 2013 a large procession of people from adjoining villages of Sheeri Baramulla were protesting against this execution. As the procession was about to reach the main market in Sheeri, a large number of paramilitary troops and police deployed in the market fired rubber bullets and resorted to heavy teargas shelling to disperse the unarmed civilian protesters and make passage for a Cabinet Minister who was on a tour in the area. In forces action, number of persons including Tariq Ahmad Malik of Zandafaran and Abid Rashid of Heewan Sheeri received severe rubber bullet injuries. They were rushed to SKIMS Soura, where they underwent through an operative procedure.

Muzamil Qayoom Rather of Sheeri, 15 – years – old boy, leaned out of the window of his home to watch the protests taking place in the street below, the forces personnel deployed in the market spotted and aimed at him. They fired at Muzamil and he was hit by pellets in his left eye.

Muzamil was taken to a local Dispensary were from he was referred to District Hospital Baramulla. Doctors at District Hospital referred him to SMHS

Hospital Srinagar. He was admitted in SMHS Hospital under MRD No. 81789 were he had an emergency surgery.

According to Muzamil's father Abdul Qayoom Rather a bus driver "doctors treating Muzamil at SMHS Hospital Srinagar said that Muzamil had suffered extensive damage to his left eye and might lose eyesight. So we took him outside the state and approached Dr. Daljit Singh Eye Hospital in Amritsar Punjab for better treatment."

Since then, Muzamil has been taken to Dr.Singh's Eye Hospital, a number of times where he has been operated twice and the doctors are trying hard to get his vision back.

The family has spent huge amount on his treatment and have not lost hope but a bright student Muzamil who's aim was to become a doctor has not still regained his eyesight. The incident has left him speechless and his dreams shattered.

Sajad Ahmad Darzi

13 years old Sajad Ahmad Darzi, a rag picker from Babteng Pattan became the victim of pellet gun fires during a protest in August 2010. Around two years later Sajad died silently and unheard on 19 May 2012.

During the summer agitation of 2010, Sajad went to buy some bread for the family from nearby Pattan market. He inadvertently got caught in a public protest which was in progress in the market and was about to find his way out when police and paramilitary troops reached the spot. Sajad got caught in between protesters and the government forces after clashes broke out. Forces personnel fired teargas shells and pellets to disperse the protesters and Sajad got hit by pellets in his right hand and had several minor wounds on right side of his body. He along with some other boys took hide in a baker's shop till he found it safe to leave. Taking the pellet injury as a minor injury he looked alright and ran home along with the bread.

Next morning, his father Ali Mohammad Darzi a 65 yrs old labourer took him to a nearby health care center where his wound was dressed. Sajad apparently looked alright and he along with his mother Saleema as usual, went out every morning to collect trash in a cycle cart. He carried on with his life and everything looked normal. Due to lack of proper medical attention things started worsening for the poor family and around three months later, Sajad complained of swelling in his right hand and his father Ali Mohammad Darzi took him to Local Health Centre

where doctors suggested them to visit SKIMS Medical College Hospital, Bemina Srinagar.

It is of great importance to mention herein that the nature of pellet gun wounds makes them prone to infections. Like other Puncture Wounds, such as stepping on a nail, the pellet can drive bacteria deep into a wound, increasing infection risk.

Ali Mohammad Darzi took his son to SKIMS Medical College Hospital, Bemina Srinagar, where doctors after performing some important tests diagnosed that they had found cancer in Sajad's right hand bone. His father Ali Mohammad Darzi a labourer, who owns no land and struggles hard to feed his family, it was not easy for him to manage huge expenses of the treatment.

"When I took Sajad to a private diagnostic centre at Karan Nagar, Srinagar for MRI test, I had no money. So I along with his mother Saleema begged on streets to collect 7500 Rupees for MRI" says Sajad's father Ali Mohmad Darzi.

Sajad's right hand swelled and he was shifted to Government Bone and Joint Hospital Barzulla, Srinagar, where doctors amputated his right hand and Sajad returned home with the amputated hand but he was continuously complaining of pain. Family approached doctors again who informed them that the infection in the hand had spread to upper area. Doctors amputated his forearm but this didn't help and then they amputated his upper arm.

"It was not easy for us to manage huge expenses. We took him to all major hospitals of Srinagar. We even took him to Kolkata for treatment. We were

penny less but we made all possible attempts to save our son" says Saleema in a tearful voice.

Within the rough walls of a dark room of their dilapidated house with clear signs of abject poverty, Sajad's parents narrate their struggle and painful story, their daughters squeeze themselves in a corner of the room, with their eyes moist. While their elder daughter Nusrat is holding the picture of his brother in her lap and is putting his remaining medical records back in a polythene bag. Sajad's cycle cart which he used to pull with his mother to collect trash lies outside the room and Ali Mohammad Darzi's younger son Faisal is playing with it. Who seems innocent of what has happened and what is going on inside the room.

With no source of income Ali Mohmmad Darzi struggled a lot to save his son's life. According to him he approached district administration for the help but nothing happened. "No one from any political party, no leader and no one from the local administration visited us in these two years. At that desperate time the Community Fund (*Baitulmaal*) of the local mosque lent a helping hand and some people from Srinagar collected money for his treatment. Doctors at SK Institute of Medical Sciences, Soura Srinagar, also lent their support and helped a lot," he says.

Finally doctors at SKIMS, Soura Srinagar, started therapy on Sajad. But his condition started to worsen. After three consecutive surgeries Sajad developed swelling in the rib cage and it was continuously increasing in size. The infection soon spread to his lungs and on 19-05-2012 at 6.30pm he breathed his last breath in his hospital bed.

"Before his death when his condition was critical, he whispered something. I took my ear close to his face and told him that my son tell me what you want? He asked for an ice-cream. I knew that my son was going to die so I decided to give him Ice-Cream but I didn't have a single penny even to buy an ice cream for him. But I arranged some money and fulfilled the last wish of my dying son," says Saleema while wiping her tears.

(Due to lack of education and awareness the family has not preserved the relevant documents about the injury and treatment of the victim. However, the above stated statements were deposed by the family which are collaborated by media reports as well)

Waheed Ahmad

21-years-old Waheed Ahmad lives in a grand but, old wooden and stone house in Nawakadal area of old Srinagar city. Built by his great grandfather around 100 years back, the house depicts the rich architectural past. (Actual name and address withheld at the request of the victim)

Sitting in a corner of a room, Waheed a science student says stone pelting is a part of resistance against oppression. "We hurl stones on government forces to reflect our urge for freedom and it conveys a strong message. The summer agitation of 2010 is the only instance when Government of India was really nervous viz-a-viz Kashmir. For the first time Government of India sent a High Profile All Party Parliamentary delegation to meet resistance leaders in Kashmir and this credit goes to the people of Kashmir especially the youth who were protesting against the Indian rule with stones in their hands", says young Waheed.

Waheed was hit by volley of pellets, when according to him paramilitary CRPF personnel fired cluster of pellets directly on pro-freedom protesters with Waheed one among them near Saraf Kadal Srinagar on March 10, 2013.

The medical records of Waheed reveal that he had received multiple pellet injuries on whole body and his right eye was badly damaged in the pellet gun firing. He was admitted in SMHS Hospital Srinagar, on the same date and had an emergency surgery there. But

doctors advised his parents to take him outside the state for better and advanced treatment.

Recalling that fateful day when he was shot at and injured Waheed said, "CRPF personnel fired pellet shot directly at me targeting the upper part of my body. At that time it felt like someone was piercing hot iron needles in my body."

According to his medical records, besides SMHS Hospital he was also operated for his injured eye at a private nursing home of the valley. Later on he was also taken to Amritsar and was operated at Dr.OM PARAKASH EYE INSTITUTE (P) Ltd. Despite making all possible efforts he was not able to regain his eye sight.

"We are not against Indians we are not even against the forces personnel – they are also humans. Stone pelting has not resulted in death of a single man in uniform. We are against the occupation. We want freedom. By killing us and making us disabled, the motive of state seems simply to convey the oppressed Kashmiris to desist from registering our protests against the suppression, but this act will surely lift the popular sentiment in the area," said Waheed.

While returning back after meeting Waheed, the biblical story of David and Goliath came to my mind, in which David killed the giant named Goliath with a stone slingshot. The story proves that stones have been the weapon of the weak since very outset of the social life. People, who are oppressed beyond tolerance, resist the forces of oppression by whatever means including stones.

Stone pelting locally know as *Kani-jung* is nothing new to Kashmiris. It has been more than eight

decades since the Kashmiri youth first pelted stones on the streets of Srinagar in 1931 and expressed their anger. Now after eight decades the expression and the quantum of the anger of the youth can still be seen in the identical form on the streets of Kashmir. People of Kashmir who have lost their freedom of speech, freedom of assembly, freedom of travel, independence of the judiciary and what not, want to protest against the oppression and the subjugation. But when normal outlets of human expression are blocked, catharsis finds its likely ways-either through protests or slogans or stone pelting. And the new generation of Kashmiris who were born amid two-decade-long conflict, made stones their weapon of choice. Stone an easily accessible and defenseless weapon.

According to a Kashmir based senior journalist Parvaiz Bukhari, "The summer of 2010, witnessed a convulsion in the world's most militarized zone, the Indian-controlled part of Kashmir, an unprecedented and deadly civil unrest that is beginning to change a few things on the ground. The vast state intelligence establishment, backbone of the region's government, almost lost its grip over a rebelling population. Little–known and relatively anonymous resistance activists emerged, organising an unarmed agitation more fierce than the armed rebellion against Indian rule two decades earlier. And apparently aware of the post-9/11 world, young Kashmiris, children of the conflict, made stones and rocks a weapon of choice against government armed forces, side stepping the tag of a terrorist movement linked with Pakistan. The unrest represents a conscious transition to an unarmed mass movement, one that poses a moral challenge to New

Delhi's military domination over the region." (Jane's Intelligence Review, December 2010)

Although, I am not at all in favour of stone pelting and I think no human being deserves to be hit by the stone. I also believe that Kashmiris also do not deserve bullets, pellets and other fire arms simply for a slogan or a protest or a procession. Stone pelting can be described as a "non-violent protest" when compared to the indiscriminate use of bullets, pellet guns and other firearms on unarmed civilian protestors.

Farooq Ahmad Katoo

On 13 September 2010, Farooq Ahmad Katoo son of Habibullah Katoo, a 28-years-old, street vendor from Anchar Soura was at his home when he heard shouting of slogans from outside. As the whole Kashmir was witnessing pro-freedom protests, shutdowns and curfews, the people of his locality were peacefully protesting against the high handedness of troops in the area and against the civilian killings in the valley. Farooq couldn't resist and he along with other persons in the locality took to streets to participate in the protest.

"I couldn't control my emotions and my sentiments. I took to streets to protest against the brutality of government forces and to raise voice against the oppression. But as we reached near the Holy Shrine of Jinab Sahab, the police and Paramilitary CRPF personnel present there without giving any warnings rained pellets on us. After scores of pellets hit me, I fell on the street," says Farooq Ahmad.

"After being hit by the volley of pellets, Farooq fell on the ground and the forces personnel dragged him and beat him up ruthlessly. Blood was continuously oozing from his body. We were watching from a distance helplessly but when forces left we picked him up and took him to SK Institute of Medical Sciences (SKIMS)," says Ubaid Yousf an eye witness and a close relative of Farooq.

Farooq was admitted in the SKIMS vide MRD NO. 627954 dated 13-9-2010 and had an emergency

surgery there. His discharge summary reveals multiple pellets seen in chest and abdominal wall, 2-pellets seen in peritoneal cavity, few pellets seen in the Inguinal canal and perineal muscles, multiple pellet injury with Jujenal perforation and multiple pellets over body.

Fearing the police and other government agencies, Farooq doesn't want to apply for the compensation or government relief. "The cops visited my house number of times to enquire about me and other things related with the incident. Due to the fear of getting arrested, I am now working as a labourer within my locality and I avoid going out of this area, because anything is possible in Kashmir," says Farooq who is the lone bread earner in his family. Besides others he has to support his aged mother.

The last thing he said to me is that "Are slogans answered by pellet fires and sentiments bruised by the brute and wanton force."

Waseem Nabi Dar

Children are the future of nation and their role is vital in nation building, so their protection and welfare ought to be the prime duty of state. The UN Convention on the Rights of Child (UNCRC) to which India is a signatory, has obligated state parties to take all appropriate measures to promote physical, psychological, social reintegration of a child who are victim in any form of neglect, exploitation, torture as well as of 'Armed conflict' and such measures shall be taken in an environment that ensure the health, self respect and dignity of a child. Moreover, as per the Constitution of Jammu and Kashmir it is the state's responsibility to secure and ensure all the children, the right to have a happy childhood with an adequate medical care and attention.

However, besides these lawful aspects and other similar Acts children in conflict ridden Jammu and Kashmir are exposed to different kinds of vulnerabilities and are the worst sufferers of conflict so the state must have to obligate itself for their proper care and attention. But ironically, Kashmir has been overloaded by orphans and half orphans.

According to a report, around 600,000 children are orphans in the state and the failure of state has forced 80% of orphans in the valley to quit their studies after matriculation due to extreme poverty, family pressure and lack of quality education in charitable orphanages. The increasing depression has

led 55.3 % children to extremely depressive conditions whereas 54.25 % can't sleep properly.

A study "Social Impact of Militancy" conducted by renowned sociologist of the valley B. A. Dabla reveals that in Kashmir, six prominent groups of children have emerged - Orphaned children estimated number 97, 800, disabled children 2000 - 3000, Mentally deranged and physically diseased children about 3, 000, children of compromised surrendered militants 6,000 - 10, 000, children of imprisoned - LOC youth 4, 500 - 5, 000 and child victims of violence in thousands. According to Mr. Dabla, these children are the "prime victims of violence".

Children of this lawless land continue to be the victims of torture. The use of Public Safety Act to arrest hundreds of children, oppressive system, corruptions, huge presence of military with impunity, impotent Juvenile Justice system and the denial of their basic rights have deteriorated and will further worsen the overall situation for the children in this part of the world.

During the summer unrest of 2010 among other persons, four kids of 8 – 12 years of age were also killed by the government forces. They include Milad Ahmad Dar (8) of Wanpora, Khudwani Kulgam, Sameer Ahmad Rah (9) of Batmaloo Srinagar, Asif Hussain Rather (10) of Delina Baramulla and Adil Ramzan (12) of Palhallan Pattan. The number of children who were injured during that period is also alarming.

However the widespread and indiscriminate use of pellet guns by the government forces have made a large number of juveniles mentally traumatized and physically maimed forever, a few of them lost their

life to these so called "non-lethal" pellet guns. The juveniles who have survived pellet attacks have lost their childhood forever and who's eye sight has been snatched with these pellets, have lost their innocence as well as their hope in the humanity. Their intense desire to see the world with their both eyes is a dream which will be never fulfilled.

Fourteen-year-old Waseem Nabi Dar from Naik Mohalla Palhallan of North Kashmir is one of the victims of state inflicted violence. He was hit by pellets on 20-9-2013 when he was returning home from his school.

"On that fateful day the situation in the area was normal after few days of unrest schools had opened. Waseem also went to school, Savera Model Public School Palhallan, which is around 400 meters away from our house. It was Friday and his school closes at 1 pm, and at the same time clashes started in the area. Waseem who was returning home from his school was caught in skirmish between stone pelting youth and forces and was hit with number of pellets on his left eye, nose and head," says his father Ghulam Nabi Dar while recalling the events of the fateful day.

Living in abject poverty Ghulam Nabi Dar, is a labourer doing everything to make his both ends meet. Showing the X- Rays and medical records he narrates the ordeal of struggle innocent Waseem and his family had to undergo because of fatal pellet injury.

After injury Waseem was taken away by some locals to a nearby ground in unconscious condition and his parents were informed. "Our son was badly injured and unfortunately we were short of money. We had no money neither for his treatment nor to pay for

the ambulance or a private vehicle so that we could take him to hospital. We arranged some money but the forces didn't allow any vehicle to move in the area. We pleaded before them that we need to take our injured son to hospital but they refused. Blood was oozing out from his wounds. A government ambulance which took some other route reached near the spot and we took him to Sub District Hospital Pattan were from he was referred to SMHS Hospital Srinagar," Waseem's mother Nassema narrates and sobs.

Waseem was treated at SMHS Hospital Srinagar under MRD No.118576 and was operated upon there for his Open Globe Injury to his left eye. Doctors treating him were not hopeful that his vision will be restored and referred him to PGI Chandigarh or AIIMS Delhi for Vitreo-Retinal Consultation.

The sole bread earner of his family Ghulam Nabi didn't lose hope and despite limited sources of income he took Waseem to AIIMS Delhi for treatment and since then he has travelled extensively between Delhi and Kashmir for his treatment. "I am managing on loans and I owe more than two lac rupees to some well wishers who lent a helping hand," says Ghulam Nabi.

The treatment of AIIMS Delhi has shown some positive results and visually impaired Waseem has returned to school. He has passed his 8th standard but his grades have slumped. He is not able to concentrate on his books for more than an hour and sometimes he suffers from severe headaches. Now he is not able to play with his friends. The child within him has vanished in the screams of his own soul. His physical appearance has changed which has made physiologically negative impacts on him and still many

questions are haunting him. "I didn't pelt stones, I was not part of the protest, I was just returning home from my school. What was my crime? Why was I victimized?" asks Waseem in a distressing voice while sitting besides his father.

Nelson Mandela once said, "Safety and security don't just happen, they are the result of collective consensus and public investment. We owe our children, the most vulnerable citizens in our society, a life free of violence and fear."

There is a need of looking into the matters relating to children in Kashmir conflict. The global saviours of human rights and those who are working for protecting basic rights of the children must intervene for the effective implementation of UN Convention on the Rights of Child (UNCRC) and UN Human Rights laws in a zone of world's largest military presence.

The bitter experiences of inhumane approach children like Waseem have encountered by the pellet attacks will deeply affect their approach and behaviour in the future. When ambiance is marred by violence and children like Waseem get directly exposed to the violence, it adds up to their fear and anxiety. It ruffles up their delicate disposition bringing strange and nuanced changes in their behaviour and attitude. The mental stress among the children could have a severe impact on their academic performance.

Sociologists believe that the psychological distress among the children besides leading them to multiple health and mental problems could also have serious social impacts. A continuous exposure to violence could lead to increased depression and anxiety which often give way to antisocial behaviour, social

incompetence or even moral disengagement. Children are like dividends with good returns to its stakeholders in future. It is an investment in building the edifice of humanity. If not properly invested and taken care, they, perhaps, will give bad results, losses and these neglected, suppressed, oppressed and subjugated angels have the potential to paint the entire world with extreme colours of violence.

Sahil Ahmad War

While passing through the lanes of Kanidiwar Hawal Srinagar, where I was supposed to meet one of the youngest pellet victims of Kashmir conflict, I was in a fix what to do? And was wondering whether the family of the victim will cooperate with me or not.

The residence of Nayeema a 38-years-old housewife and mother of three children wears a gloomy ambience. The people living in the house had encountered a tragedy. Nayeema's youngest son 13-year-old Sahil Ahmad, studying in 9th standard at Islamia Higher Secondary School Rajouri Kadal fell victim to volley of pellets fired by the Indian Paramilitary CRPF personnel near Bachi Darwaza, Baha ud din Sahib Hawal. Sahil overcame this tragedy and returned home after spending many days at SMHS Hospital Srinagar.

Nayeema who originally hails from Rafiabad Sopore and her husband Bashir Ahmad War, who is a native of Kalaroos Kupwara have sold their whole property at their native place and settled here at Kanidiwar Hawal Srinagar.

On 30 April 2014, the polling day of Srinagar Parliamentary Constituency, general strike was being observed in the valley for the boycott of elections and usually on such strike days people in Kashmir prefer to remain indoors. Sahil's father Bashir Ahmad War a street vendor along with his elder son Aarif Ahmad preferred to do some domestic work, as some construction work was going on in their house. Sahil

also helped them during the whole day and at around 6 pm, Sahil and his elder brother, who were in the courtyard told their mother Nayeema to serve them food as they were feeling hungry.

Nayeema went inside, prepared food, while Sahil's elder sister Neelofer laid the dining sheet. Nayeema put Sahil's and Aarif's plates down on the said sheet, started waiting for them to come inside and have the food. In the courtyard Sahil asked his elder Aarif for some money to buy a notebook so that he could do his homework and could put up the same before the teacher next morning. Aarif who works as a labourer and makes both ends meet with his family paid 40 Rupees to Sahil, 20 for purchase of notebook and to recharge his cell phone with Rs.20 respectively. Sahil with his Brother's phone in his pocket went to nearby market near Bachi Darwaza, Baha ud din Sahib. As he was coming home back with his new notebook, clashes between pro-freedom demonstrators and Paramilitary CRPF broke out in the area and Sahil got caught in the clashes.

"I tried to hide under a wall in a lane and was trying to find a way out but suddenly I was hit by something and blood started oozing out from my body. I walked a few steps and fell on the ground and after that I didn't know anything as I was unconscious" says innocent Sahil with a sea of sadness in his eyes.

Hit by rain of pellets fired by CRPF personnel, Sahil with his new notebook in his hand was lying in a pool of blood at the ground. He was rushed to JLNM Hospital Rainawari by some locals who also informed his brother Aarif through his cell phone which was lying with injured Sahil at that time. Aarif without

telling his mother rushed to the JLNM Hospital Rainawari. Sahil had sustained multiple serious pellet injuries on his whole body including abdomen and doctors at JLNM Hospital Rainawari without wasting any time referred him to SMHS Hospital Srinager.

Recalling that fateful day Nayeema says "I was waiting for my kids to come inside to take food, a lady from our neighbourhood called me outside, as I went outside she enquired about Sahil. I told her that my Kids are at home and they might be watching T.V, but meanwhile some more neighbours came and whispers were going on. I felt that something wrong has happened". With big tear drops in her eyes she says "As I found Sahil and Aarif missing at home my husband Bashir Ahmad told me that Sahail has been injured and we both rushed to SMHS Hospital."

Sahil was admitted in SMHS Hospital under MRD No. 154781 dated 30-4-2014 and underwent two major surgeries there. The discharge summary of Sahil reveals that he had pellet injuries on Chest and Abdomen with RIGHT SIDED HAEMOTHORAX with MULTIPLE GUT PERFORATIONS. As per the C.T Scan of chest and abdomen, besides other parts pellets were seen in Lungs and anterior chest wall. Multiple pellets were seen in both the lobes of Liver and in anterior Abdominal and Bowel Loops. However a pellet was seen anterior to Bladder. After battling for his recovery in Intensive Care Unit and Ward no.18 of SMHS Hospital, Sahil was discharged from Hospital on 8-5-2014.

"After 10 days I served Sahil some soft diet in the same plate in which I was about to serve him food

on the fateful day of his injury" says Nayeema while wiping her tears.

Doctors at SMHS Hospital have advised Sahil's parents to be very careful about his regular medical check-ups and to keep him away from dust, they have also advised him not to jump or run fast. Even months after that fateful incident, Sahil along with his mother is still visiting the Hospital for treatment and regular check-ups. This has badly affected his school attendance and the poor family is somehow hardly managing the high costs of his treatment.

Due to the life changing wounds inflicted by the pellet gun, Sahil has lost his childhood. This gruesome pellet incident has put deleterious impact on him. His studies have suffered badly as he is unable to concentrate properly on his studies because of the weakness of his health and the psychological impact of the tragedy he has survived. His visible injury marks clearly indicate the barbarous and brutal approach being adopted by the government forces even against juveniles in Kashmir.

Musaib Ahmad

A well macadamised ten kilometres road from Baramulla in north Kashmir leads to Achabal Chowk of Rafiabad and then two kilometres to the right of this highway – with lush green apple orchards around and a beautiful pond in the middle of it is a hamlet known as Chotipora. The serenity of the place for a while makes you forget everything.

In this apple rich hamlet a fruit grower namely Ghulam Rasool Lone, sitting outside his single storied house is worried about the fate of his 15-year-old son Musaib Ahmad Lone who is sitting beside his father.

On 12 February 2013 a large procession of people was protesting against the execution of Afzal Guru in the area. Troopers deployed there opened fire in the air and used all other means of force to quell the unarmed civilian protesters. Musaib who was returning home from tuition centre in Doabgah, a nearby village was hit by pellets fired by CRPF personnel, near Alsafa Colony Doabgah.

Musaib was hit by pellets in his right eye, he was taken to District Hospital Baramulla in an ambulance provided by the local Health Centre, but the police deployed on Azad Gunj bridge in Baramulla didn't allow the ambulance to proceed. Musaib and one more wounded person namely Aabid Ahmad accompanied by some relatives left the ambulance and started moving on foot towards the hospital but the cops arrested both the injured boys and put them in the lockup of police station Baramulla.

"Instead of being in hospital we landed in police lockup and the brutal cops didn't allow us to reach hospital for treatment. In police lockup, we were requesting for medical help but instead of that we received slaps and kicks. Blood was oozing out of my eye and I was in great pain. I begged them for medical help but they didn't pay any heed to my woes. With pellet inside my eye, I was put behind the bars in a dark and dirty lockup. Next day only a pain killer injection was given to me on the name of medical treatment" said young Musaib with a deep breath.

A brilliant student of Sheikh-ul-Aalam High School, Achabal, young Musaib who had passed 9th standard in November last year and was preparing for the 10th standard exams, experienced the brutalities, atrocities and lawlessness a Kashmiri can face at the hands of law enforcing agencies in the name of maintaining law and order.

The hapless family pleaded before the police to let Musaib go for treatment or provide him appropriate medical help but their requests were brushed aside by the cops.

It is of great importance to mention herein that the Law doesn't allow in custody torture or denial of appropriate medical help. Even if it's a terror suspect but in Musaib's case the police not only blatantly violated the law but their inhuman approach put his health at great risk.

On 14 February, 2 days after injury, Musaib's condition started worsening and Police took him to District Hospital Baramulla were doctors protested against the denial of treatment to him. Doctors told the police to shift him immediately to SKIMS

Medical College Bemina or SMHS Hospital Srinagar, as the denial of medical treatment during his illegal detention has damaged his eye badly and has caused severe perforation in his eye.

"The worried cops framed him in a frivolous case after two days of illegal detention and booked him on charges of stone pelting and rioting under sections 148,149,336,188,332 & 307 RPC. He was presented in the court of Judicial Magistrate Baramulla on 14 February, which granted him interim bail and we rushed to SMHS Hospital for his treatment," said his father Ghulam Rasool.

Musaib was admitted at SMHS Hospital under MRD NO. 82127 and was operated upon there. "Doctors treating him told us that his eye injured with pellet had suffered extensive damage due to the delay in treatment and this might lead to the loss of vision in his eye. On 18-2-2013 he was discharged from the hospital and doctors advised us to take him to PGI Chandigarh or AIIMS Delhi for advanced treatment but we took him to a private Hospital in Amritsar," said his father.

He was treated at Dr.OM PARKASH EYE INSTITUTE (P) LTD. Amritsar under MR. No – 14120, File No – 1213029037 and was twice operated there. Since then he has been taken to Amritsar more than six times and still the doctors are not able to restore his vision. Ghulam Rasool is running short of money but somehow manages the high costs of treatment and huge travel expenses.

An ardent cricket fan, Musaib had a fascination of watching matches. He was a good cricketer but now everything has changed for him. "Now I am not able

to play cricket because now I am only able to see from one eye. Since then I feel uncomfortable, I think my life has changed completely. Although I am preparing again for my class X examination but I don't think my dreams will be fulfilled. I was not part of the protests but still I have paid a lot," said visibly shaken and psychologically traumatised Musaib.

Parvaiz Ahmad Kaloo

On 21 April 2014, a 28-year-old street hawker Parvaiz Ahmad Kaloo of Ganie Hamam, Old Town Baramulla was hit by a pellet in his left eye.

Recalling that fateful day Parvaiz says, "The entire town was peaceful. It was Friday and the market was swarmed with shoppers. At around 12 noon Police and Paramilitary CRPF blocked the SRTC Bridge for unknown reasons, concertina wire was laid down and no one was allowed to cross the bridge. I was at home because I don't go for work on Fridays. My wife Jamsheeda told me to bring back our kids 8-years-old Wamiq and 6-years-old daughter Aiman, from Noorul Islam, public school near District Hospital Baramulla, on the other side of the besieged bridge where they study. When I reached near the bridge, I saw people including women who had gathered on the spot, pleading before the forces to let them go so that they can bring their children home who where in the school. Some elderly persons were also requesting the forces to allow them to move towards other side; besides them some patients were also stranded there. The men in uniform not only refused but they started abusing the women. This enraged youth and other people present on the spot and they started raising slogans. Government forces used brute force and fired teargas canisters and pellets to disperse the mob. In forces action a pellet hit my left eye."

Parvaiz was taken to a local medical practitioner who referred him to District Hospital as the pellet was

inside his eye. After examining his injury doctors at District Hospital Baramulla referred him to SMHS Hospital Srinagar where he was admitted under MRD NO.153083 and was immediately shifted to Operation theatre at around 8.30 pm. senior doctors were called and after giving emergency operative treatment, he was shifted to Ward no. 8 at around 10 pm.

"At around 11.30 pm a police party from Baramulla police station barged into the hospital and searched for pellet injured Parvaiz. They entered into the ward no.8 and dragged Parvaiz from his bed and tried to take him away. The patients, their attendants, hospital staff and doctors protested against their high handedness and didn't allow them to frisk him away. After the intervention of doctors and sensing trouble, cops allowed him to be in the Hospital but he was arrested and an officer accompanying them deployed a police party there who handcuffed traumatized Parvaiz. He was not allowed to move from his bed as the handcuffs were locked with the bed and the cops were also present there. Whenever he needed to go to washroom, he was allowed to move handcuffed with its other end in the hands of cops accompanying him. During four days of his treatment at Hospital, his handcuffs were never unlocked and it seemed that India's most wanted terror suspect was admitted in the hospital," said his wife Jamsheeda in a tearful voice.

Keeping all the Human and Legal Rights aside police treated traumatised Parvaiz in a degrading and inhumane manner by handcuffing him on his hospital bed. By this harsh attitude of police the injured Parvaiz underwent physical and mental torture, which violates the guidelines laid down by the Supreme

Court of India besides amounting to infringement of basic Human Rights.

In Kashmir where it is normal for law enforcing agencies to slap, kick, beat, arrest without reason or kill anyone in broad day light under the protection of laws like AFSPA which provides them impunity from prosecution, the inhumane approach adopted with Parvaiz is nothing new in this part of the world. The new generation of Kashmiri's born into this conflict amid such a callous and cruel approach adopted as with Parvaiz and many other youth like him were on the roads during 2010 public agitation. This new generation's weapon of choice is the stone, the sense of grievance is intense and the anger towards Indian repressive authority is deeply rooted in their hearts and minds.

To suppress the 2010 public agitation of Kashmiris, more than 3500 youth were arrested while 120 people were detained under the controversial Public Safety Act. Shockingly, many of the incriminated youth were booked under harsh laws like 302 RPC (murder) and 307 RPC (attempt to murder). Other charges like 436 RPC and 13 Unlawful Activities Act were also levelled. Parvaiz who actively participated in these protests was detained in police station Baramulla, PSA was slapped on him and he was lodged in District Jail Udhampur. The PSA was later quashed by High Court after seven months of his detention but immediately after his release from district jail Udhampur he was re-arrested and logged in sub Jail Baramulla, where from he was released after a month.

After his release from eight months of detention Parvaiz never participated in protests and realised

how his family suffered during his detention. But he was again arrested and was falsely implicated in couple of cases. Denying the charges levelled against him Parvaiz says, "Whenever public protests erupt in our town I prefer to remain indoors and avoid such things, but still police implicated me falsely in a couple of cases. Whenever there is law and order problem or there is any apprehension of protests in the town, the police summon me along with many other youth against whom cases are pending before courts and we are kept in detention and sometimes they falsely book us in frivolous cases."

After many days of treatment and no signs of improvement, Doctors at SMHS Hospital referred Parvaiz to AIIMS-Delhi or PGI-Chandigarh for specialised treatment and discharged him. But immediately after being discharged from the hospital Police took him to Police Station Baramulla and detained him there.

After 10 days of his detention he was released after getting bail from a local court at Baramulla and soon after his release Parvaiz arranged some money and went to Doctor Dalgit Singh Eye Hospital, Amritsar, where two surgeries were performed upon him.

Since his injury, Parvaiz has taken loan from his relatives and friends and visited Amritsar more than ten times for his treatment. The local Community Fund *(Baitulmaal)* also lent a helping hand and Parvaiz is somehow managing the high costs of his treatment. He has not regained his eye sight fully but his family has suffered a lot.

Sajad Ahmad Malla

Palhallan Pattan in North Kashmir which is famously called Gaza Strip of Kashmir witnessed the highest number of human loss during 2010 public agitation. People were shot dead without provocation and their houses ransacked and looted by the men in uniform. The area was also under curfew for almost 40 consecutive days. But still the residents of this village are always at the forefront of protests against killings or human rights violations in any part of Kashmir.

Since 2010, people of the area are being constantly threatened and harassed. They are summoned to local Army camp and the concerned Police Station. Though there is no permanent deployment of troops in interior areas of Palhallan, but the entire village has been put under constant surveillance. During the summer unrest of 2010, around 8 unarmed civilians were killed by government forces in different firing incidents and since then number of youth of this village had sustained serious pellet injuries. Eyes of more than eight youth have been either partially or completely damaged by deadly pellets fired by police and CRPF personnel. Fear is so evident among the residents of this village that most of them avoid registering any complaint against the atrocities and rights violations committed against them by the government forces. Due to fear of reprisal from the government agencies most of the victims avoid media persons and human rights activists.

"Police and intelligence agencies maintain a close vigil on the village, they monitor our phone calls and many youth have been falsely implicated in cases. Please don't mention my name anywhere or I will have to face dire consequences at the hands of government agencies", said a pellet victim of Palhallan, wishing not to be named.

In Raipora mohalla of Palhallan, a single storied house with very little signs of refurbishing, is the house of Sajad Ahmad Malla, a 19-year-old youth who is extremely perturbed since he survived a deadly pellet attack.

Due to abject poverty, Sajad left his studies couple of years ago and started working as a labourer. He used to do menial jobs in orchards and paddy fields of the area to support his family, so that his three younger siblings could continue their studies. On 12 April 2014 Sajad was returning home after labour work at New Court Complex in Srinagar, when he reached Palhallan and started walking towards home, he was hit with a number of pellets on his chest and legs. A protest had broken out there and Sajad fell prey to pellets.

While showing his medical records and discharge certificate of SKIMS Soura Srinagar vide MRD No. 7979, Sajad is worried about the pellets still present inside his body, particularly the pellets which are present near his lung. He doesn't know what will happen to the pellets present inside his body. His discharge summary revels that multiple pellets were seen in lung parenchyma and one pellet near pericardium (very close to heart).

"Doctors didn't operate upon him but advised me that if any time he feels pain in his chest or any problem happens then he should be immediately rushed to CVTS department of the Hospital" said his father Abdul Majeed Malla who is also a labourer.

The main cause of concern for Sajad is that doctors have prescribed him costly medicines and his father is struggling to bear his treatment cost. They have also advised him not to run fast and to refrain from doing any hard work. So after his survival from pellet attack he thinks his life has been ruined and he will not be able to live a normal life.

Momin Bilal Kinu

Walking through the lanes of Mahraj Gung an important business centre of old city Srinagar is a by lane known as Banday Koucha, and here a two-storey house of Ghulam Mohammad Kinu is home to 16-year-old Momin Bilal Kinu, his grandson who looks no different from other teenage boys of his age. An 8th class dropout, Momin worked as a salesman at a dry fruit shop in Mahraj Gung Srinagar to support his family.

On April 30, 2014 at around 6.15pm Momin became victim of pellets fired by the Para Military CRPF in the vicinity of Mahraj Gung, near Gani Memorial Stadium Rajouri Kadal. His both hands were severely injured by pellets and he was admitted in Government Hospital for Bone and Joint Surgery, Barzulla Srinagar under MRD No: 1-255, where amputation of his left hand index figure and corresponding amputation of left 2nd MC and amputation of right middle figure at DP level was done on May 01, 2014. His father Bilal Ahmad Kinu, an auto driver buried his amputated fingers at their ancestral grave yard at Saraf Kadal in old city, at a stone's throw from his residence.

"Momin didn't respond properly at the end of surgery," says his father Bilal Ahmad showing his medical records. As per the medical records, after surgery Momin didn't have any respiratory effort, he was unconscious and didn't respond to painful stimuli and had very sluggish response to light. Post-Operative ventilation was continued and doctors wasted no time

in shifting him to SMHS Hospital, Srinagar under SU-1, MRD No: 154846 and was put on ventilator in the Hospital.

Medicos treating him at Intensive Care Unit (ICU) of SMHS Hospital kept their fingers crossed as he according to them was in Unexplained Shock. Inside ICU, Momim, was in Comma and outside the ICU his whole family, relatives, neighbours and friends were praying for his recovery.

"Nobody was saying what was wrong with my son. We were not able to eat or sleep during those fateful days. We were speechless. My son was in ICU for three days," says his father Bilal Ahmad.

Momin battled for life on ventilator for 72 hours in the ICU of SMHS Hospital and after improvement in his condition, he was shifted to the ward and was finally discharged from the Hospital on 09-03-2014.

Farooq Ahmad Malla

In one of the corners, near the window, 22-years-old Farooq Ahmad Malla is tucked inside a blanket and a mattress spread out in the kitchen of his dilapidated house in Chaki Hakbara of Hajin Sonawari. He looked in the direction of the voice as I greeted him. I shook his warm hand and seated close to him. As I introduced myself, Farooq moved his unshaven gloomy face towards me and removed his dark glasses which he uses to cover his ailing and vision less eyes. I could see his severally traumatized eyes. They lacked any activity. He has lost his vision and his future has been darkened forever.

His tale of sufferings began on March 17, 2014, when he along with his cousin Lateef Ahmad Malla, ventured out to take an evening stroll at around 7:00 pm. The entire area was tense those days. There were demonstrations, firing and the clashes going on in between police and the youth after the killing of a young boy in the neighbouring Naidkhai Village.

Barely after walking few meters from their houses, both the cousins got hit by pellets fired by the forces to quell a public demonstration near Hajin Hakbara Bridge.

The injuries inflicted upon both of them were severe and blood was oozing out of their eyes. Farooq's both eyes were hit by pellets while as his cousin Lateef who was also hit by pellets in his eyes, sustained serious injury to his one eye. They were ferried to Srinagar for the treatment.

At state's premier territory – care hospital, SKIMS in Srinagar, doctors diagnosed Farooq with pellet injury in both eyes, with pellets seen in the scalp, pellets seen in right orbit, multiple pellets seen in left orbit, with loss of vision and bleeding. (MRD No.794142)

The medical faculty present in the hospital referred him to Ophthalmology Department of SKIMS in Bemina, where he had two surgeries. But there was no improvement and his vision was not restored. Later on he was referred outside the state for specialized treatment.

"As we were in the Hospital, his arms were still under his *pheran* (a traditional Kashmiri winter wear resembling a gown) and he was unconscious. He was not part of any protest, he didn't throw stones and then why did they fired pellets on him. Eye sight is the most precious gift bestowed to humans by Almighty Allah. But they ruined his life by snatching his eye sight," says his mother Hajira in a tearful voice.

It is here worth mentioning that on March 18, the day after Farooq and Latief were injured in pellet attack, in the same vicinity two more youth Ishfaq Ahmad Parray and Aijaz Ahmad Parray of Parray mohalla Hajin also fell prey to pellets near Danger Mohalla Hajin. Both Ishfaq and Aijaz got pellet hits in their right eyes, affecting their eye sight.

On March 22, Farooq was taken to Dr. Daljit Singh Eye Hospital Amritsar and was treated there under Reg. No.40258. "After initial examination, doctors were doubtful about getting back my eye sight. They didn't give us any assurance about regaining my eyesight. They operated me and removed a few pellets," says Farooq.

The youngest among four siblings, Farooq was the sole bread earner for his family who used to take care of his old aged parents after his elder brothers left the parents to live a separate life. Farooq was working at a small Band Saw machine and was trying hard to make both ends meet. Now it is extremely difficult for the family to bear the high costs of his treatment. "We have to ferry him to Amritsar and the costs of treatment are beyond our reach. We sold our only cow and other family possessions. Now we have nothing left with which we can manage his medical expenses," says Hajira with visible marks of worry on her forehead and tear drops rolling down her eyes.

Farooq was taken to Amritsar several times for treatment but there are no signs of recovery and all the efforts to restore his vision have failed so far but the treatment of his cousin Lateef has shown improvement and the vision of his eye is improving.

"I can't see my old aged father in such an agony. He is running pillar to post to manage the high costs of my treatment", says Farooq in a mournful tune. Farooq showed me the costly medicines which doctors have prescribed him and told me that despite several surgeries pellet is still there in his right eye.

"Everything has turned black for me, now I am not able to see the flowing waters of river Jehlum which is at a stone's throw from my house. Darkness has become my world and I am caged in this lightless prison. I have to live this lightless life. Now I don't move out of this kitchen. I need my mother's help even to go to washroom---," Farooq says and wails.

His mother, Hajira, who was sitting near the cooking side of the kitchen, came near and while

wiping Farooq's tears she says, "Now I don't visit relatives and neighbours. I hardly go out of my house because he is totally dependent on me. My social relations are changing fast but I have to be present here. My son needs my help."

Farooq's case is not an isolated one. Like Amir Kabir, Mohammad Sidiq Chotta, Hayat Ashraf Dar, and Farooq there are number of such persons who have become victims of state inflicted violence and their future has been ruined by snatching their eye sight.

I ended up this heartrending conversation with Farooq and winded up. He shook my hand and I left. While moving towards Srinagar I noticed several hoarding near Indian paramilitary CRPF camp, "Public service is our only mission" was written on one of the hoardings and "Our Ultimate Aim is Your Well Being (CRPF)" was inscribed on a barricade near the camp. I was not able to understand whether to cry or laugh, because the words inscribed on the hoarding and the barricade, appear too powerful regarding cooperation and friendly relations. However, Farooq's brutalized and traumatized vision less eyes not only make fun of these words but clearly indicate the inhumane and barbaric approach adopted by the men in uniform against the civilians and the voices of dissent. The gloomy face of Farooq and his hushed voice indicate the extent of the ruthlessness and brutality that a Kashmiri can face at the hands of the government forces.

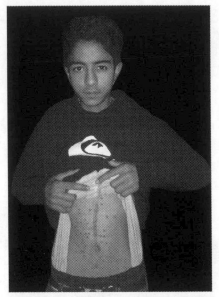

Sahil Ahmad War - Scars of Pellet

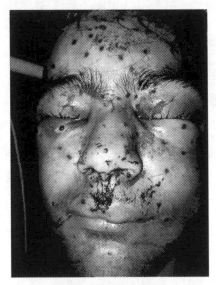

Hamid Ahmad Bhat

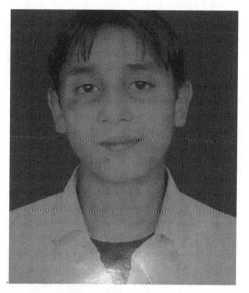

Deceased - Irshad Ahmad Parray

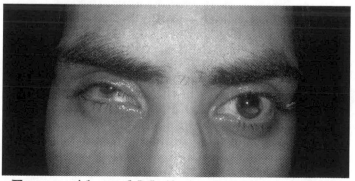

Farooq Ahmad Malla (Complete Vision Loss)

Pellets-N-Pain

(Articles)

Unleashing non-lethal terror

Nawaz Gul Qanungo

New Delhi's cruel obsession with the argument of lethal vs non-lethal methods of crowd control in Kashmir does not mean that it has failed to identify the ever-growing political nature of the conflict. It is just that it chooses not to acknowledge what it knows is staring it in the face. Sadly, India's persistence with its law-and-order theory means that a worse phase of turmoil in the valley is never too far away. For, any non-political method of "control" in Kashmir will ultimately prove lethal

Late last month, the chiefs of Indian state police, central paramilitary forces and intelligence officials met for an annual conference in New Delhi. "We are concerned that we have not been able to stop the vicious cycle in which the state is caught," the Indian home minister, P Chidambaram, told the gathering while referring to the ongoing turmoil in Kashmir. "I am afraid Jammu and Kashmir is now caught in a vicious cycle of stone pelting, lathicharge, teargassing and firing, leading to casualties and resulting in more stone pelting."

"The security forces have been instructed to act with great restraint," the minister told his men. It was Wednesday. And while the minister was busy talking in New Delhi, three young sisters were mourning the death of their only brother in the Soura locality of Srinagar. His name was Omar Qayoom Bhat. He was 17.

Omar was among the hundreds of young boys randomly picked up by the local police in order to break the spell of the current unrest. While in custody, he was beaten up severely enough to die in the hospital two days after he was released on bail. He was a class XI student.

The very next day, it was the turn of the Indian Prime Minister, Manmohan Singh, to talk to the security top brass. "I would like to pay tribute to the officers and men of our security forces who have made the supreme sacrifice in fighting Naxalism and other anti-social elements," he told them. "I would also like to repeat what I said in my speech on Independence Day. We recognize that the Naxalites are our own people and are ready to talk to them provided they abjure the path of violence." He next went on to deliberate up on the situation in Kashmir where "despite the curtailment of militant activities, the public order dimension had become a cause for serious concern."

"...The experience begun successfully by the Rapid Action Force for non-lethal crowd control needs to be examined for being followed by other police forces as well." He went on to conclude: "We need to revisit standard operating procedures and crowd control measures to deal with public agitations with non-lethal, yet effective and more focused measures." Four days later, a protest in Anantnag was fired up on by the police and paramilitary forces. Irshad Ahmad Parray was killed. Like Omar Bhat, he had no bullets in his body. "He had received a volley of pellets in his chest and abdomen," doctors in a Srinagar hospital said. "We received him dead."

Obviously, the world that Dr Singh and his home minister lives in doesn't seem to be the one where Kashmiris are killed in cold blood, day in and day out. Irshad was nine years old. Standard operating procedures and crowd control measures have certainly been revisited. They don't waste their bullets anymore.

The term "vicious" added to "cycle of violence" vis a vis the recent protests in Kashmir is a phrase that has been repeated countless times by the Indian establishment. Its media has been more than willing to lap up. An impression has been created in India wherein the act of demonstration by protesting Kashmiris has somehow been brought on a par with, or even worse than, that of the police and security forces, who have been on a killing spree in the valley since three months now. Not less than sixty-five unarmed protesters and bystanders, mostly children and young boys and girls, have been killed since June 11*. Not a single death among the police or paramilitary, not even a serious injury. A few teeth, as the Indian media informs of them, have been broken or lost.

A newspaper report during the current turmoil simply compared the "violence" in Kashmir with that of Andhra, Uttar Pradesh and Maharashtra. It mentioned: "Police in Uttar Pradesh killed 104 civilians and injured 145 in 608 incidents of police firing in 2008. Maharashtra reported 47 civilian deaths in 89 incidents of police firing."

"Fatalities caused by police firing in Jammu and Kashmir," the reported said citing figures published by the Indian home ministry's National Crime Records Bureau, "have been far fewer than in many other States less threatened by large-scale protests." The nature

and purpose of protests in Kashmir doesn't seem to be an issue for the analysis. "Indian police forces," the report quoted an "expert", "used to be internationally regarded for their crowd control skills." Part of the problem, it added, lies in deteriorating riot-control skills. Riot?

Interestingly, a crowd control method that wouldn't kill could not only encourage more protests, but also encourage more people to join such protests. Parents may not only stop being anxious about their children going out to protest, but feel persuaded to join the people on the streets themselves. People who avoid joining protests due to the physical risks it involves may join as well. In effect, it is not unlikely that truly non-lethal methods could lead to more and bigger protests.

However, as has been proved by the experience of the debility the so called non-lethal pellet guns have caused to the injured and the horror it has left among the doctors who have been operating up on such injured people, the idea is not merely to minimize killings. Rather, it is an easy method of crippling young men and women so that they are not on the streets for months. What's more shocking is even if the injured recover later on, they are not able to lead a normal life.

A statement of a police official quoted by a local newspaper points precisely at this: "In a single fire of a non-lethal weapon, we can target dozens in a mob and neutralize them for months." (Emphasis added). One is forced to recall Manmohan Singh's words: "We need to revisit standard operating procedures and crowd control measures to deal with public agitations with non-lethal, yet effective and more focused measures."

A tag of NLW (non-lethal weapon) placed on the weapon is all that's needed to unleash an effective non-lethal terror. The police has not even been trained in the use of these weapons. At any rate, all the talk of water cannons and pepper guns has proved not just futile but evidently deceptive. While in opposition, the person who spoke about these devices in 2008 was none other than the current chief minister himself. Today, the very idea of "crowd control" is essentially a denial of Kashmiris' right to assemble, let alone protest.

A RECENT ANALYSIS in The Economist argued that "the cycle of protests [in Kashmir] will resume [even after the current protests abate]... [but] at some point they will become so big that they can only be contained by killing more of its citizens than a democracy can stand." The mood on Kashmir's streets today suggests that indeed the protests may get bigger with time. The fact that both New Delhi and the local administration led by the National Conference have decided not to utilize any political acumen to tackle the crisis only bolsters this possibility. Looking at the past, however, the largest democracy of the world doesn't give much of a bother on whether there's a limit on how many more killings 'it can stand' in Kashmir.

Of course, the very idea of perceiving protest in Kashmir as a problem of law and order is flawed. And to control it with lethal or non lethal methods won't have as much an effect on the ground situation as a simple admission of the fact that the problem in Kashmir is political and needs a political approach towards a possible resolution. The core of the matter

remains that any non-political method of "control" in Kashmir is, by its very essence, a lethal one.

However, to say that the Indian establishment and the state administration is so blatantly incompetent and removed from reality in Kashmir that it doesn't know this reality would not merely be an underestimation of their intelligence and information but to think so would be an outright naivety. Of course, New Delhi knows what it faces in Kashmir and what it would take to genuinely tackle the issue. The truth is New Delhi does not want to acknowledge that reality. It pretends that it is lost in the crowd in Kashmir when certainly it is not.

Nawaz Gul Qanungo is a Srinagar based journalist. His work has appeared in Tehelka, Business Standard, Down to Earth, Rediff.com, The Kashmir Times and several other News Papers and websites. This article first appeared in the Kashmir Times, September 8, 2010.

The lost vision of life

Wasim Khalid

When I entered the partially lit room, it appeared Amir Kabir, 19, silently conversed with the God.

Alone, he squatted in one of the corners near the wooden window, his face towards the tall poplars in front of the sun-bleached mountains which host a picket of Indian troops. I constantly watched his lip sync, as if waiting for a saint to profess, while he moved his right thumb over the prayer beads.

Amir did not turn towards me for a while and we kept watching in the cold room where a silence of desolation loomed large. Then his mother, Jahanara Begum, entered the room, breaking the silence that was becoming suffocating. "The presswallas have come to meet you my son," she said almost like a murmur.

He looked in the direction of the voice as she spoke. Moments later I greeted him and he moved his head towards me. I asked: "How are you Amir?"

"I am fine, Alhamdulillah," he replied in a feeble voice, and then went on to add, instantly, "Things for me have changed forever."

I could easily make out the "change" he was speaking about. As he greeted us, he kept groping as if in dark. We shook his warm hand and moved closer to him. I could see his eyes almost submerged in the sockets. They lacked any activity. There were no tears. He had lost his vision during the civil unrest in 2010.

Amir is a resident of north Kashmir's Baramulla town, which is often called the "Garrison town" of Kashmir owing to the presence of army cantonments, checkpoints, barbed wires, bullet proof vehicles and massive troops in the region.

His tale of sufferings began on September 18, 2010, when his mother asked him to accompany her to a local hospital. "She had developed some complications in stomach. So I went with her," he said.

"Tempers were running high in those days. There were curfews, firing, and clashes going on in between police and youth," he added in the same breath.

When Amir's mother entered the hospital, he stood up near the gate and waited for her to return. Suddenly, there was a rumble of gunfire, followed by the thuds of tear gas. Police was acting in a bid to disperse the pro-freedom seeking youth, who were hurling stones in retaliation.

"My mother came out and she gave me the doctor's prescription to fetch medicine. As I moved away from the gate, I saw the batches of youth raising pro-freedom slogans nearby. The moment I preceded further, the police and CRPF fired pellets on the youth to disperse them. Dozens of them hit me as well. I fell unconscious," he said with his hands moving in all directions.

As he stops, his mother, who sat beside him breaks into tears.

"The blood was oozing out of my body. The boys there lifted me up and ferried me to Srinagar for the treatment," he said amid the sobs of his mother that became louder with every minute.

On that day travelling on Srinagar - Baramulla road was perilous. Apart from being intercepted by groups of youth seeking freedom, 'the ambulance was stopped by government forces at several places'. "They would beat up the attendants. They would often question why we people wanted Azaadi from India?" he said emphatically.

Amir said his pain was unbearable at that time. In his words he felt somebody had poked a hot iron into his eyes. "The perilous travel had to be taken and somehow the ambulance managed to reach SKIMS Medical College Bemina, Srinagar" he remarked.

The doctors at the medical facility diagnosed him with a bilateral injury with open globe damage in left eye and vitreous Hemorrhage in right eye. In a common man's language there were very few chances of him seeing again. He was later referred for specialized treatment to All India Institute of Medical Sciences New Delhi, but thus far the efforts to restore his vision have failed.

Suddenly, the life for the teenager changed forever. It was difficult for him to reconcile with the abrupt entry into the life in darkness. Slowly, he did found ways to accept the reality. His life was reduced to that semi-lit room, with pale mud walls, shabby wooden shelves, and piles of quilts stuffed in one of the corners adjacent to the place where he sits.

It appeared to me he had found a refuge in loneliness, in religion, in those prayer beads.

Amir showed me his photograph taken before the incident. He stood in a garden, clean shaven, had oiled hair parted sideways, with brown eyes. For some time, I could not believe he was the same person.

A year later Amir has gained weight. He sported a cropped beard and had sprayed the attar (perfume) all over his clothes. Physically, he looks like a man in his early thirties. His pictures from the 'good days', when he was a class 12 student and wanted to be a singer ran contradictory to his present. When he could see he wanted to pursue singing as a career. Not anymore.

"Now my dreams lay shattered," he said. "I only pray now and listen to the religious talks. I draw my strength from Allah. He has been the biggest support which keeps me going."

His mother, Jahanara, who by this time seemed to be settled while mopping her eyes chipped in and said she remembers that her son never remained static at one place. "He would always sing. He would regularly meet his friends. And we would always scold him for that he never used to be at home," she said and broke down again.

"It's not so now. He never leaves this room. He never comes to kitchen where he would crack jokes with me. He needs help even to go to bathroom. I would always ask Allah why you snatched the vision of his both eyes. If his only one eye would have been damaged, things would have been different," she said amid sobs.

I was curious enough to ask Amir why he never left the room. After several insistences, he told me he now 'prefers to live a lonely life'. "I was not a born blind. Whenever I used to speak to people like you, I would look into their eyes," he told me. "Now it becomes very hard for me to accept that I could not see people. It makes me angry, very angry. I don't want to meet anybody."

Social relations are also fast changing for Amir as he told me that he used to have scores of friends. "It has changed now. During early days of injury, they would come to home. But, now, they call me once on my cell phone in a week. Life is changing with the change in my physical status," he said.

Amir has also changed many new things after he lost his vision. He can operate cellular phone by remembering numbers and digits with his fingers. He can differentiate between shade and light with the changing position of the sun.

His family faces a real challenge as it is extremely difficult to bear medical expenses. They have to ferry him to the top most hospitals in Delhi and other places of India. But, as Amir could not travel by road, he had to be always air flown.

The family lives in rickety two storey structure on rent in old town of Baramulla. Amir's father, Abdul Kabir, is a street vendor selling clothes and had come to Baramulla from a nearby village.

Abdul said, Chief Minister Omar Abdullah had pledged that government would bear the medical expenses, but so far nothing has been paid. He believed that although the gesture will not bring back his son's vision, but it would at least bail the family out of the debts they were in while spending his treatment.

Amir is not alone. He is one of the scores of other people who have remained the invisible victims of the conflict in Kashmir. Those victims, who never made it to the list of killed, but are living the life of dead and helplessness.

At least 120 persons, predominantly youth, were killed during the five months of unrest last year.

However, the government claims that only 104 people were killed in that period of time, 894 people were injured, and 18 people suffered permanent disability.

At Srinagar's SMHS hospital a doctor, who is an ophthalmologist, told me that last summer he treated 50 people for eye injuries, who were injured after they received tear gas canisters and ammo fired by the troopers. He told me that many among those "young boys" lost one of their eyes due to grievous injuries.

As I started to end my conversation with Amir, I asked him does he regret his decision of being at a wrong place at a wrong time. "No I don't," he remarked.

As I winded up, I sought permission to leave. He shook both hands with me and lamented: "Why Kashmiri nation, its people, and its leaders have a tendency to forget things so earnestly."

(Wasim Khalid is a journalist. He traveled to north Kashmir's Baramulla a year after the civil unrest to figure out the conditions of the victims' families and the injured)

Wasim Khalid is a Srinagar based journalist. He has worked with local, Indian and International Media Organizations. This article first appeared on Kashmir Dispatch website on 19th November 2011 and later on several other websites and news papers.

Rhetoric Concept of Non-Lethal Weapons – Untouched by International Law

Harshed Kapoor

ABSTRACT

Establishing national mechanisms to review the legality of new weapons is especially relevant and urgent in view of emerging new weapons technologies. This article asserts the need for a international mechanism to review newly invented weapons that are wrongly termed as non- lethal.

Henry Dunant in his famous book 'A Memory of Solferino' wrote "Ensuring the legality of new weapons is crucial if the development, proliferation and use of cruel and indiscriminate weapons are to be prevented and if humanity is to be protected from new and frightful weapons of destruction."

Non-lethal weapons are characterized by some scholars as "weapons of mass protection" that constitute a "new arsenal for a new era of warfare." The most frequently mentioned reason behind the development of the "non-lethal" weapons concept is the changing nature of military operations in the post-Cold War world in what are called "military operations other than war." In addition, ethnic hatred and ineffective or non-existent governments

have fueled the ferocious fires of civil war in many parts of the developing world, deepening the crisis for ethical and legal restraints on war. NLWs are not required to have a zero probability of producing fatalities or permanent injuries. Moreover, the term "non-lethal" suggests that the weapons in question are anti-personnel weapons only. The area of "non-lethal" weapons covers, however, more than anti-personnel weapons. It includes weapons designed for use against "anti-materiel" weapons. Medically, the intended and unintended health consequences of "non-lethal" weapons are not yet well understood. NLWs cause debilitating or permanent effects such as blindness or paralysis, long-term lethal consequences, or other unnecessary suffering. So, the labels "lethal" and "nonlethal" do not accurately reflect how weapons ought to be examined from an ethical perspective.

For a state that is party to Additional Protocol I of 1977, determining the legality of new weapons is a treaty obligation pursuant to Article 36 of the Protocol. Indeed, it is in each state's interest to assess the lawfulness of its new weapons in order to ensure that it is able to comply with its international legal obligations during armed conflicts and other situations of violence. The ICRC is aware of only a handful of states that have such procedures in place, one of which is not party to Additional Protocol I.

In some nations there are no consistent and coherent standards applicable to all policing forces across the nations. The legal framework for the testing and approval for use of new forms of less than lethal weapons by police agencies is unclear. The difference in the interpretation of conventions also imposes

ambiguities in the application of these weapons. The principles of distinction and proportionality, the principle of unnecessary suffering, rules governing hors de combat, and the so-called Martens clause are constantly violated. International humanitarian concerns about how NLWs might encourage military forces to violate the IHL principle of 'hors de combat' are also discussed in detail.

INTRODUCTION

Ethics and international law have since the late nineteenth century been losing a running battle with technological developments that have vastly increased the killing power of military forces. In addition, ethnic hatred and ineffective or non-existent governments have fueled the ferocious fires of civil war in many parts of the developing world, deepening the crisis for ethical and legal restraints on war. Military forces from various nations ordered into war-torn societies to keep the peace or distribute humanitarian aid often find themselves confronted with non-military functions, such as crowd control, that seem difficult to fulfill with traditional military weapons.

Any use of a lethal or non-lethal weapon in a combat situation is subject to the basic principles and provisions of international law. These include the principles of distinction and proportionality, the principle of unnecessary suffering, rules governing hors de combat, and the so-called Martens clause. Embedded in these principles and provisions is the

idea of protection for civilians and protection for combatants.

Parties to an armed conflict are limited in their choice of weapons, means and methods of warfare by the rules of international humanitarian law (IHL) governing the conduct of hostilities. Relevant rules include the prohibition on using means and methods of warfare of a nature to cause superfluous injury or unnecessary suffering and the prohibition on using means of warfare that are incapable of distinguishing between civilians or civilian objects and military targets, which are the "cardinal rules" of IHL applying to weapons. In addition, particular treaties and customary rules impose specific prohibitions or limitations on the use of certain weapons, for example anti-personnel mines and blinding laser weapons.

For a state that is party to Additional Protocol I of 1977, determining the legality of new weapons is a treaty obligation pursuant to Article 36 of the Protocol, which requires each state to determine whether the employment of "a weapon, means or method of warfare" that it studies, develops, acquires or adopts would, "in some or all circumstances", be prohibited by international law applicable to the state. But it also makes good policy sense for all states, regardless of whether or not they are party to the Protocol, to carry out legal reviews of new weapons. Indeed, it is in each state's interest to assess the lawfulness of its new weapons in order to ensure that it is able to comply with its international legal obligations during armed conflicts and situations of violence.

WEAPON REVIEW MECHANISM

The 27th International Conference of the Red Cross and Red Crescent in 1999 and the 28th Conference in 2003 called on states to establish mechanisms and procedures to determine the conformity of weapons with international law. In particular, the 28th Conference declared that "in light of the rapid development of weapons technology and in order to protect civilians from the indiscriminate effects of weapons and combatants from unnecessary suffering and prohibited weapons, all new weapons, means and methods of warfare should be subject to rigorous and multidisciplinary review."

The obligation to review the legality of new weapons implies at least two things. First, a state should have in place some form of permanent procedure to that effect, in other words a standing mechanism that can be automatically activated at any time that a state is developing or acquiring a new weapon. Second, for the authority responsible for developing or acquiring new weapons such a procedure should be made mandatory, by law or by administrative directive. A proposed means of warfare cannot be examined in isolation from the way in which it is to be used – that is, without also taking into account the method of warfare associated with it. This raises three questions. The first is whether the reviewing authority should consider only the proposed or intended use of the weapon, or whether it should also consider other foreseeable uses and effects – the weapon's effects resulting from a combination of its design and the manner in which it is used. Article 36 of Additional

Protocol I appears to support the broader approach, since it requires a state to determine whether the use of a new weapon would be prohibited "in some or all circumstances".

RECENT INSTANCES

> An association of lawyers in Indian administered Kashmir will 'facilitate' the process of filing review petition in a court against its judgment which had legalized the use of pepper gas and pellet bombs against protestors in the disputed state.

> Amnesty International continues to be concerned by the use of less-than-lethal weapons, particularly Conducted Energy Devices (CEDs) such as TASERS. While some police forces have adopted stricter standards that limit the use of such devices to situations where there is a clear and serious imminent threat to life, most do not. Amnesty International has frequently expressed concern that the use of these weapons may, in some circumstances, be tantamount to torture or ill-treatment. This Committee has also expressed concern that the use of such weapons may constitute a form of torture. There are no consistent and coherent standards applicable to all policing forces across the country, as some are subject to federal government jurisdiction and others to provincial and territorial governments. Guidelines developed

by the federal government in October 2010 are not binding and do not adopt a threshold of harm standard which would justify the use of a TASER. Amnesty International has suggested that the Federal Guidelines should be amended to require that CED's will only be used in situations involving an "imminent threat of death or serious (potentially life threatening) injury which cannot be contained by less extreme options." The legal framework for the testing and approval for use of new forms of less than lethal by police agencies in Canada, such as sonic devices, is unclear. Some of these weapons pose a potential risk of resulting in torture or ill-treatment when used. Just as their lethal counterparts sometimes fail to kill, non-lethal weapons can sometimes be deadly. The description, therefore, applies to the intent rather than the effect.

➢ The ICRC reported that the destruction and disruption of electricity caused Iraqi civilians great hardships in forms of disease and other adverse health consequences. Calling a weapon "non-lethal" does not remove its potential consequences from scrutiny under IHL.

➢ The Chechen assault on the Nord-Ost Theatre in Moscow, and the crisis involving approximately 830 hostages, ended when Russian security forces pumped an incapacitating chemical, believed to be a derivative of the opiate fentanyl, into the theatre as a prelude to storming the building. Russian forces killed all the terrorists and

rescued hundreds of hostages. The fentanyl, however, killed approximately 130 hostages — a fatality rate of 16%, more than twice the fatality rate of "lethal" chemical weapons used on World War I battlefields. The use of an incapacitating chemical to end the Moscow hostage crisis hit the debate about NLWs and international law like a thunderbolt.

POTENTIAL DRAWBACKS

The advantages outlined above potentially offer significant enhancements to our ability to bring about desired political outcomes via military means. However, employment of these types of weapons does present numerous challenges and concerns as described below.

➤ Non-lethal weapons may produce unrealistic expectations

The first concern is that the weapons might present unrealistic expectations about the prospects for bloodless war. The problem arises from the term "non-lethal" itself, leading some in the defense community to advocate adoption of substitute terms such as "less-lethal" or "sub-lethal effects weapons."

Non-lethal weapons shall not be required to have a zero probability of producing fatalities or permanent injuries. However, while complete avoidance of these effects is not guaranteed or expected, when properly employed, non-lethal weapons should significantly

reduce them as compared with physically destroying the same target.

> ➢ Non-lethal weapons offer the potential for the enemy to fight again.

A second concern regarding non-lethal weapons is the potential for opposing forces to return to the battlefield to fight again. Mercy on the battlefield sometimes backfires. For example, some of the prisoners paroled by General Grant at Vicksburg during the U.S. Civil War fought him again in later battles. Clausewitz warned that, in general, the enemy's "fighting forces must be destroyed: that is, they must be put in such a condition that they can no longer carry on the fight." This is an issue that must be considered if increasing reliance on non-lethal weapons becomes a reality.

> ➢ The availability of non-lethal technology may lure adventurism.

A possible criticism of reliance on non-lethal weapons is that they may make us more prone to commit to military action that may have negative economic or diplomatic consequences or may escalate to become an unintended major conflict. The argument goes that since bloodshed and destruction can be greatly reduced with these weapons, we may be tempted to intervene at an earlier point. Moreover, lack of training can increase the level of lethality to even causing death.

> ➢ More than Anti Personnel.

The area of "non-lethal" weapons covers, however, more than anti-personnel weapons. It includes weapons designed for use against vehicles, equipment, materiel, and computer systems (collectively "anti-materiel" weapons)." Describing these anti-materiel weapons as "non-lethal" does not accurately reflect their purpose or nature. In addition, use of some of these anti-materiel "non-lethal" weapons can be lethal as vehicle, equipment, or materiel failure places the human operators in mortal danger.

> ➢ Combination of lethal and non lethal weapons.

As noted before, the term "nonlethal" is not an accurate description of these weapons because they can be lethal and they include anti-materiel weapons. Further, military commanders looking at the battlefields of the future may want to combine "nonlethal" and "lethal" weapons to achieve more effective destruction of the enemy. The existence of true "non-lethal" weapons would not alter the way military forces approach their objectives. It is unlikely that military commanders would equip their forces only with "non-lethal" weapons. Use of truly "non-lethal" weapons may actually increase the effectiveness and lethality of traditional weapons during armed conflict.

WEAPONS AND INTERNATIONAL TREATIES

The conventional, biological, and chemical arms control regimes severely limit the potential use of "non-lethal" weapons. This limitation further reinforces the problems noted with the concept of "non-lethal" weapons earlier in the Article. Calling weapons "non-lethal" does not render them susceptible to a lower standard of international legal scrutiny in connection with arms control regimes. However, some important potential "non-lethal" weapons technologies, such as acoustic and electromagnetic weapons, are not affected by the existing arms control disciplines because they do not fall into any of the current treaties on conventional, biological, and chemical weapons.

While relevant principles can be extracted from the conventional weapons regime that can be applied to acoustic and electromagnetic weapons, such application is not required under any existing treaty. At present, international legal analysis of the use of these weapons will primarily fall under principles of customary international law, such as the duty not to cause superfluous injury or unnecessary suffering.

Developments in weapons technology, especially aircraft, made civilian populations increasingly vulnerable to military attack. Civilians also suffered terribly when attacked by armies and governments that had no intention of honoring the laws of war. But civilians also face threats from forces committed to IHL because civilian fatalities are caused by smart weapons. In addition, military forces often attack

or destroy facilities, such as power plants, that are important to the health and well-being of civilian populations.

In some situations, "non-lethal" weapons pose familiar problems. During the Persian Gulf War, allied forces used "non-lethal" anti-materiel weapons to disrupt the Iraqi electricity infrastructure.

The ICRC reported that the destruction and disruption of electricity caused Iraqi civilians great hardships in forms of disease and other adverse health consequences. Calling a weapon "non-lethal" does not remove its potential consequences from scrutiny under IHL.

Equally important is the possibility that the development of "nonlethal" weapons will encourage military forces to attack civilians and civilian targets more rather than less. Military forces might perceive that attacking civilians and civilian targets with "non-lethal" weapons is acceptable because the intent is to incapacitate or demoralize rather than kill. In some contexts, incapacitating or demoralizing civilians might make the use of "lethal" weapons against opposing military forces easier.

Behind the IHL prohibition is the principle that military forces must discriminate between military and civilian targets. Important to the IHL analysis will be whether "non-lethal" weapons can only be, or are being, used indiscriminately. A "non-lethal" weapon that cannot be used in a discriminate way would cause IHL concerns. Thus, if an acoustic weapon intended to incapacitate military forces cannot be used without also incapacitating civilians, such a "non-lethal" weapon cannot satisfy IHL. But one can easily see that

people wanting to use the "non-lethal" weapon would argue that its indiscriminate use does not violate IHL because the intent is not to kill and the civilians are only temporarily incapacitated. In other words, the indiscriminate use of a "non-lethal" weapon causes acceptable collateral damage to civilians.

IHL prohibits military forces from attacking combatants who are incapacitated or disarmed and no longer present a military threat *(hors de combat)*. This aspect of IHL is clearly relevant to the use of "non-lethal" weapons on the battlefield,'2" and "non-lethal" weapons raise a number of questions in this regard.

First, it is not clear how a soldier will be able to determine in the heat of the battle whether an enemy combatant is *hors de combat* as a result of the use of a "non-lethal" weapon. How much incapacitation is necessary to render a combatant *hors de combat?* Just as a soldier wounded by a "lethal" weapon may still pose a military threat to his enemy, an incapacitated soldier may also constitute a threat. Perhaps this observation suggests that the identification of a combatant *hors de combat* is difficult regardless whether "lethal" or "non-lethal" weapons are used, and that "non-lethal" weapons do not complicate this already difficult task. Much would depend, of course, on the particular physical effects of a "non-lethal" weapon, so it is difficult to speculate much. But the easier it is to recognize incapacitation the stronger will be the physical effect of the "non-lethal" weapon, perhaps raising other questions under.

IHL protections for combatants *hors de combat* have not been widely respected in twentieth century wars. Military forces in all likelihood will

see incapacitation through "non-lethal" weapons as a means to maximize the impact of "lethal" force. The tactic might be to hit enemy troops first with "non-lethals" and to follow up this attack with "lethal" force. This combination tactic might maximize battle impact on the enemy while reducing casualties for the attacking side.

PRINCIPLE OF SUPERFLUOUS INJURY AND UNNECESSARY SUFFERING

This principle has been behind a number of prohibitions of specific weapons systems, such as exploding bullets, blinding laser weapons, and anti-personnel land mines. At first glance, it would seem that "non-lethal" weapons cause no concerns for this IHL principle because the intended physical effects are assumed to be temporary. It remains important for the integrity of IHL to apply the superfluous injury or unnecessary suffering principle to "non-lethal" weapons because the assumption of temporary incapacitation may not be warranted. One concern for this principle of IHL is that the health effects of many potential "non-lethal" weapons are, as mentioned earlier, not known. The superfluous injury/unnecessary suffering principle should guide development of "non-lethal" weapons to ensure that the physical effects of the weapons are not severe or permanent. The ICRC advocates using this objective approach to analyze all newweapons, including "non-lethal" weapons.

The categorization of weapons as lethal and non lethal is not correct as it leaves some scope for wrongful use of weapons to an extent by which fatality can be caused and so the categorization of weapons shall be done as causing superfluous injury, potentially causing superfluous injury and not causing superfluous injury.

CONCLUSION

The feel-good term "non-lethal" masks the extent to which these weapons create significant concerns for arms control, international law on the use of force, international humanitarian law, and other areas of international law. The need to review and scrutinize "non-lethal" weapons under international law is manifest, and it can never be taken for granted that the development or uses of "non-lethal" weapons are legitimate under international law.

Establishing national mechanisms to review the legality of new weapons is especially relevant and urgent in view of emerging new weapons technologies such as directed energy, incapacitants, behavior change agents, acoustics and nanotechnology, to name but a few. Weapons review mechanisms would also be relevant in reassessing existing weapons stocked in a state's arsenal in the light of new or emerging norms of international law, such as when a state becomes party to a treaty prohibiting or limiting the use of a certain weapon.

Moreover these national mechanisms shall be established under the canopy of an international body

to which reports on approved weapons would be sent by the national mechanisms for further review.

"Non-lethal" weapons emerge into a situation already marked by great tension between international law and the realities of international politics. Nowhere is this tension more serious than in times of armed conflict. This is why there should and will be tension between international law and the development and use of "non-lethal" weapons. Without this tension, benign motivations behind "non-lethal" weapons development will quickly be drowned or corrupted into malevolent designs that adversely affect the lives and hopes of peoples.

Harshed Kapoor is a practicing lawyer at Rajasthan High Court. Besides working on social and legal issues he works on writs relating to student admissions, attendance and equivalence in colleges and universities and affiliation rules of RBSE and other boards. He has also prepared reports on the condition of consumer courts in Rajasthan. His article Rhetoric Concept of Non- Lethal Weapons – Untouched by International Law, appeared on http://rostrumlegal.com/ blog, on 06 August 2014.

Casualties of Kashmir's Unrest Live in the Dark

Zahid Rafiq

SRINAGAR — On an October afternoon I drove to Bemina, a middle-class area in Srinagar, the summer capital of Indian-administered-Kashmir. An acquaintance led me to a spacious double-storied house to meet Hayat Ashraf Dar, 21, who is one of the numerous young men in Kashmir who have lost their eyesight after being fired at by the Indian troops and police with pellet guns. Most of the injured have lost one eye. Mr. Dar had lost both.

Mr. Dar has a fuzzy beard and blank eyes. The afternoon sun streaming through the large windows fell on his makeshift bed, the pattern on the carpet, a Kindle, a mobile phone, a transparent box stuffed with medicine strips and eye drops.

"Who is it?" he asked, stretched out on the carpet, his aunt putting drops into his eyes from a little plastic bottle. Our arrival had stirred the stillness of his room. "Who has come?" Mr. Dar asked.

I was just another voice in the hazy glow of his blindness.

Mr. Dar stared into an unending night. For three months now, everything has been dark. The world has been wiped out from in front of his eyes. "It is me," said Faraz Yasin, his friend, who had brought me to meet him. "And the journalist."

The two men began talking, and the conversation soon drifted to news, to an encounter between militants and Indian soldiers on the border and then to another encounter in the outskirts of the city. "I have someone read to me," said Mr. Dar. "Three newspapers every morning and then I watch the news and debates on television. I want to keep track of what is happening in Kashmir."

His eyes wandered beyond the curtains and walls of his room and rested at some far away point. As he spoke to me, his gaze moved right past me, as if I were someplace else.

The last thing Mr. Dar saw was a policeman 50 meters (160 feet) away, with his gun pointed straight at him. That moment bisected his life. Before that moment there were colors and streets, his favorite Wayne Rooney blazing through the TV screen with the ball at his feet, books with their large and small typefaces. Now, there is darkness.

Before that moment, he was an economics student dreaming of joining a business school. Now, he is a young man blinded into sitting inside a room, chilly on a sunny day.

Mr. Dar left Kashmir in fifth grade and has spent the last 10 years in Delhi, where his family has a flourishing handicraft business. As he entered high school, he began to develop a greater consciousness of his identity as a Kashmiri. "I felt that my relationship with India was much more complicated than that of my classmates," he said.

The feeling of that difficult relationship was strengthened by his visits back home every summer for two months. He rekindled old friendships, made new

friends and walked through the labyrinthine lanes of Srinagar's downtown. In this Nowhatta neighborhood of downtown Srinagar, politics is enmeshed with life. Downtown Srinagar and its labyrinthine lanes are the center of separatist politics in Kashmir.

Mr. Dar was in Srinagar in 2008 when mass protests returned after several years and Indian troops fired upon unarmed protesters. "I saw people getting shot and dying on the streets of Srinagar. People I knew, I saw them bleeding on streets," he recalled. "Something changed in me." On his return to Delhi, he felt like a stranger in the amnesic bustle of the metropolis.

On June 14, Mr. Dar was walking back from a religious gathering in Nowhatta. It was Ramadan, the Muslim month of fasting. He entered a street leading to his uncle's house and saw a group of policemen coming out of the street, firing teargas shells. "There was smoke all over," he recalled.

"A policeman, who was also taking video on a Handycam, was shouting the vilest of abuses and making vulgar gestures," Mr. Dar recalled. "I shouted at him if did he not fear God even in this month of Ramadan."

Mr. Dar stood on a black manhole cover. All that stood between him and the policeman was the tear gas smoke. "He pointed his gun straight at me, but I thought he was just scaring me," he said.

The policemen fired the pellet gun.

Mr. Dar had more than 20 pellets in his upper body, seven of them making an arc around his heart, and two in his face: one in each eye.

"It was like one of those scenes from 'Tom and Jerry,' where they are hit so impossibly hard that they see stars. I literally saw hundreds of stars in a flash, and then it all went dark and I was stranded," he said. His eyes bled and a fluid oozed out of them.

The family rushed him to one hospital, from where they were immediately referred to another and then another in Delhi. As his aunt recounted their journeys to multiple hospitals, Mr. Dar looked in the direction of her voice. "Don't cry," he requested her. "It is a test from God and nothing will come out of crying. *Inshallah,* God will restore my sight," he said.

Mr. Dar sought solace in faith and accepted his blindness as the will of God: "There is no other way. Or I will get depressed. And depression can be fatal, not only for me but for my relatives and friends too."

His voice was sharp and his shoulders erect. Maybe it was the hope that the doctors will be able to heal him, his firm belief that God will not forsake him.

In these months of darkness, Mr. Dar said, things have actually become clearer, and the world has been stripped of its distractions. "We are in a state of war; I know that now more than ever," he said. "I have been killed, without leaving my dead body behind."

A little later, his aunt brought tea and homemade bread, and fed him like a child. He opened his mouth and waited uncertainly for an invisible piece of food in an invisible hand.

Things, useful things — books, tables, chairs, cups — have suddenly become obstacles, and someone's hand or shoulder is always needed to negotiate hundreds of such obstacles in a journey to the bathroom.

At times, he would endure the need to urinate for up to six hours, he said. "It would kill me to be suddenly so dependent that I couldn't even piss by myself."

In the early days of his injury, he would avoid bathing for days. He was uncomfortable being naked around his brother who had to bathe him.

His right eye, which was operated on three times in the first two weeks of his injury, is now completely blinded to light, and he can see a slight glow through the left one. For four days and four nights after the first surgery, he did not sleep a wink. He was awake in darkness and in such pain, as he had never known before.

"The darkness was nothing compared to the pain. We sometimes say the word excruciating, that pain was truly excruciating," said Mr. Dar. "But maybe I wouldn't have felt that pain so much if I could see something. Maybe darkness added to the pain."

The intraocular pressure of his right eye, which for a normal eye ranges from 10- 20, was 50. An ophthalmologist at Shri Maharaja Hari Singh (S.M.H.S.) Hospital in Srinagar said it must have been pain from another world. "It is pathological," he said, "and pellets do that to the eye."

Mr. Dar's left eye has a little bump, which Mr. Dar points out for me, just above the iris. "That is the pellet," he said.

"The pellet is slowly coming out itself; the bump wasn't there before," his aunt added. She walked across the room and brought back a small glass bottle from a shelf. A little black ball lay at the bottom of the

bottle; it was like the ball bearings in a bicycle wheel, only smaller. "They removed this from his right eye."

"The doctors in Delhi had no idea what was in his eyes," she recalled. "'What are they shooting the boys in Kashmir with?' they kept asking us."

A pellet cartridge holds around 500 little iron balls in it, a senior police officer said, and when shot, they scatter in the air, hitting anyone in the range. The Jammu Kashmir Police say that the pellet gun is a nonlethal weapon that is very useful in controlling crowds without causing much damage.

According to the ophthalmologist, S.M.H.S. Hospital has already treated more than 300 young men with pellets in their eyes. "And most avoid coming here if they can, because of the spies that police has posted here," said the doctor, who asked to remain anonymous because of the sensitivity of the matter. "They keep a check on our registers and see who has pellet injuries, and then the police comes and arrests them."

Most of the boys with pellets buried in their eyes either go to or are referred to specialty eye hospitals in Amritsar in the northern state of Punjab. Mr. Dar has consulted seven doctors, who have different opinions. One of them has recommended another surgery and remained hopeful that Mr. Dar would recover eyesight.

"My days are like nights," Mr. Dar said. "Sometimes I simply cry." He finds strength in the answers he gives himself. "If I become depressed and broken, wouldn't they, who shot me, succeed? Didn't they want to make an example out of me and scare the people around me from resisting the oppression?" he explained.

Without this argument, he said, he feared that his voice would have been filled with self-pity, his shoulders would have drooped, his head bent — another victim without agency.

As we got up to leave, Mr. Dar hugged his friend and then shook hands with me and hugged me too, and the strap of my haversack lightly slapped against his face.

"I can see you," he said. "You are wearing a bag, I can see the strap," he said, touching it.

"You are wearing a bag too," he turned to Mr. Yasin. "I can still make out things, you see."

"No," Mr. Yasin said. "No bag today."

"But he is wearing one," Mr. Dar said, laughing, as he turned toward where I was standing a moment ago.

Zahid Rafiq is a renowned Srinagar based journalist. He has worked with a number of Indian and International media outlets and has covered wide array of topics. Besides Tehelka, New York Times, The Hindu and Greater Kashmir his work has appeared in number of publications and websites. This article was published in New York Times, dated 25 Nov 2013.

'Dark' Days

Saima Bhat

Every year May 21, the death anniversary of Mirwaiz Moulvi Mohammad Farooq, is marked as a shutdown in Kashmir valley. Day long curfew ends up with protests in the evening. On the same day of year 2014, one teenager boy 'unaware' of protests and a middle aged man who went to save the boy, received pellets in their eyes which left both of them almost blind.

Sahil Bhat, 17, a class 10th student was on way to his home in Bohri Kadal, in down town Srinagar when he was caught in the middle of a link road between stone throwers and government forces in Nowhatta. He was shot with a pellet gun and nearly about 72 pellets hit him from head to naval.

Soft spoken Bhat who shy away his gaze while talking was at his maternal aunt's place in Rajouri Kadal but at about 6.30 in the evening, when curfew was lifted from the area he decided to go home. He left through criss cross lanes, which usually remain free of protests, to reach his destination. By that time stone pelting was going on the main road of Nowhatta, where it was all chaos.

"Boys were running, throwing stones and CRPF men and state forces were chasing them," recalls Bhat what he observed from a distance.

But once he crossed that spot safely and reached in the middle of one lane between Nowhatta and

Malaratta, he saw some men in uniform. "I thought I was not doing stone pelting so why should I be afraid of them but at the same time I decided to save my life first. As soon as I thought of hiding, one armed man fired towards me. He directly aimed at me. I saw him when he shot me. He was very near. I couldn't move. I felt something was flowing on my face and when I touched it with my hand, it was blood. And with that I lost my conscience. Everything went black and I fell down."

On seeing Bhat lying on road, one man, Mohammad Sidiq Chota, came forward to help him. Once he reached near him, some men in uniform appeared on the scene and fired pellets again. But this time it was aimed at Chota. He too was shot from a point blank range. But he stood up and managed to find a water tap where he washed his face and saw blood oozing out from his face.

Soon after seeing two injured people on road, the protests gained momentum again. Those government forces sensing the uproar around and they left the place. Later those protesters managed to take both the injured to a government hospital in Rainawari from where they were shifted to state hospital, SMHS.

"Out of the 72 pellets that hit Sahil from head to naval, 40 were found in his head, 4 in his eyes-two in each eye, and rest were found on his chest and face. Pellets had hit his whole body but luckily none damaged internal organs and that is why he is alive," says Bhat's uncle who received him at hospital where he was operated upon for his serious eye injuries.

After some days doctors advised the family to take Bhat outside state for specialized treatment. His right

eye was recovering and was showing improvement but his left eye was not responding.

Bhat's father, from a lower middle class family, was managing his family of five-wife, daughter and two sons, from a meager amount and he couldn't fetch much amount for his son's specialized treatment outside state. But his uncle (maternal) sold off some valuables and only after that the family managed to go outside state for the emergency treatment.

His uncle says, "To take him for specialized treatment was not possible at that time but at the same time, it was very important for his life. So without giving it a second thought I sent them for treatment to Delhi, where he was operated again for his left eye."

"While in Delhi when Bhat was given anesthesia his body reacted and blood started oozing out from his mouth and then he was taken to another specialized hospital, Sanjeevani hospital, where they were charged Rs 24,000 for 24 hours", says his uncle. So far, the family has spent Rs 3 lakhs on his treatment.

Bhat's uncle monitored the things throughout their stay in the hospitals in Kashmir. "I still remember one person, dressed like a civilian followed us for some days continuously in the hospital. May be they (state) were keeping a vigilant eye on Sahil but soon when he got satisfied that our kid was not able to see from his both eyes, initially, he eloped." He adds, "2014 was an election year and by that time Parliamentary elections were over, so one of our neighbor who was associated with governing party came in the hospital and offered us a job. But I know he was rubbing salt to our wounds so I asked him politely to leave. He was there to make his name in the newspapers. Since then nobody came

to even check if we may need their help, barring the chief cleric, Mirwaiz Mohmmad Umar Farooq who visited and helped us."

Now after almost 10 months of his last surgery, Bhat says he is not able to see from his left eye. "What I see from my left eye is all blurred. It is almost 75 percent damaged." Bhat talks less but when talked about his education he raises his head and says, "I am not able to concentrate on my studies."

But at the same time while thinking about the fateful incident, Bhat is feeling bad for his decision of that day to venture out thinking that he was not involved in stone pelting and would not be harmed. Now he is preparing for another surgery in coming summers and the family is hoping this time his eye shows some improvements. "Sahil was very austere about his clothes and looks but now he is mostly confound indoors. We don't allow him to watch TV for longer hours and he can't go outside for playing, that can lead to infection in his eye" says his uncle.

Mohammad Sidiq Chota, 55, a fruit vendor outside the main gate of Jamia Masjid in old city is witness to many street protests around his area. He resides just opposite to the gate of this historical grand mosque.

Chota, a bachelor is living with his two brothers, one fruit vendor and another tailor. He is not able to see through his both eyes but still he can stroll outdoors on bright sunny days, like any other blind person. He has been brought up in this house and this area so he remembers every minute detail of both.

Of that day Chota recalls he was sleeping through out that day as it was strike outside. But around 5 pm a policeman came inside his compound and was

asking for his cousin. "I told him he is not here but I remember, I had kept a box of musk melons on side of my compound and since morning that policeman was stealing them one by one. But then I decided to shut the main entrance and I started washing my clothes." He adds, "Around 7 pm I decided to go out and meet my friends as curfew was lifted. Once I got some cigarettes from a shop I returned back. But while coming back I saw a boy lying on road, I came forward to help him. But as soon as I came near, some men in uniform appeared on the spot and they shot!"

Unaware of what happened, Chota with the help of a wall stood up and started running. "But something was irritating my eyes. I found tap water and washed my eyes but I saw blood on my hands."

After that what Chota recalls is the hue and cry of protestors who took him and landed him in a hospital, where he was taken in the operation theatre. While waiting for his surgery in the state hospital, SMHS, he feels only nurses were present in the theatre. "I don't recall a moment when I heard a word from a doctor so I came out of the theatre. Later my sisters, relatives and Mirwaiz Umar Sahab gave me assurance that I will be operated upon by a doctor so I allowed them. But now my one eye, left is completely damaged and another is almost 95 percent damaged. Doctors have advised to go outside state for treatment but I don't have money to do so."

His brother adds, "We consulted some private doctors as well who said his left eye was completely damaged because of doctor's negligence. They don't give us assurance that if we take him outside state for treatment that his eye will start functioning again."

Chota a class 8th dropout recalls every minute detail of that day but since then he feels he doesn't trust anybody. He keeps on repeating, "How can I trust doctors? Why should I trust my brothers?" but he is quick to add, "I want any one should help me in treating my eyes, may be if I get to see world again by one eye at least." And then he touches his forehead to show pellets still present there, "look they are palpable, I can feel them."

Saima Bhat lives in Srinagar, Kashmir, where she works with a weekly newsmagazine, "Kashmir Life" and her work has been published by Heemal. Her memoir was published in the book, "Of Occupation and Resistance".

Sifting facts from fiction:
The latest victim of Kashmir's 'non-lethal' weaponry

Sameer Yasir

I always cherish surprise visits to home. No matter which corner of the world you put up in, home is always missed and perpetually longed for. But when home is in a place in Kashmir where violence is a routine affair, like buying morning bread, anxiety becomes a furtive companion which stays with me for a long time even after I am gone.

I lived the formative years of my life in Old Town of Baramulla, known among government forces and some journalists as the 'Red Zone' of Kashmir. The sentiment of freedom from Indian rule remains high here. On May 7 when Lok Sabha elections were conducted in the town, anti-election and pro-freedom protests erupted in many localities, forcing the authorities to shift the polling centers to 'safer places', a euphemism invented to describe places in Kashmir which live at the mercy of forces.

I arrived in the town on May 10. Once a bustling trade center, Baramulla now looks like a dark shadow of its vibrant past. A paramilitary trooper is keeping vigil on a bridge, one of the five that connect Old Town with the recently built swanky bungalows and shopping malls on the opposite banks of Jehlum that

bisects the town just before wriggling its way into Pakistan.

On the day of my arrival, a civil curfew was being observed in the town after Kashmir police had conducted raids on previous night and arrested dozens of youths from Old Town who were reportedly involved in stone pelting. Many families had alleged that police ransacked their property and robbed gold jewelry and cash from their homes, an allegation denied by police, forcing the Baramulla Traders Association to call for a three-day shutdown against the 'police excesses'.

I told the mustached trooper near the bridge to remove the concertina wire so that I could go home. He asked me to produce my identity card. "You have to wait," he said politely, observing my black waistcoat and Woodland shoes, "Let more people gather sir. We allow people in groups."

The town looked like a military garrison. Hundreds of troops in riot gear with automatic weapons were deployed on all the five bridges to prevent protesters in Old Town from crossing over into new town. No matter how small or big, the clampdown by forces brings back memories of death and destruction, of crackdowns and funerals, of pallbearers who abandon corpses in the middle of road, of those countless cold nights spent in fear.

As the groups of people swelled near the two mouths of the bridge, the trooper signaled us it was time to cross over. We walked in fear. A women, part of our group, had her Burqa stuck in the concertina wire but she managed to set it free on her own. When everyone had crossed over, the bridge was sealed again.

I was finally home. I felt relieved but I was not happy. I had to meet a '12-year-old boy' whose photograph I has seen on Facebook. The picture, purportedly taken by his friend on the day of Lok Sabha elections in Baramulla, showed the bruised back of the boy with numerous pellet injuries. The picture had gone viral on social networking sites and many people had questioned its authenticity.

My task was clearly set out. I had to locate him. It didn't turn out to be a task as I had anticipated. When I showed his picture on my mobile phone to a cheerful boy playing cricket on the roadside, he nonchalantly replied: "Oh, this is Shoiab. He was injured by a pellet bomb few days back." He gave me the address of Shoiab – Syed Karim Sahib Mohalla, a congested locality of crumbling and irregularly build houses in Old Town.

On the day of Lok Sabha elections in the town, six friends including Shoaib, all in their teens, were playing carom inside one of the narrow lanes of Syed Kareem Mohalla, a soon-to-be dismantled locality under a plan for decongestion of Old Town. The boys were focused on the game until a bang in the neighborhood broke their concentration, which was followed by loud cheering.

A teargas shell had been hurled towards a group of youths shouting pro-freedom and anti-election slogans near the Cement Bridge over Jehlum river in the town, five hundred meters away from the place where the boys were playing carom. Stones were flying over the bridge, shooting down on the forces who used transparent shields to protect themselves. Enthusiastic children, without realizing the danger,

wanted to be as close to the scene of clashes as they could. They saw dozens of youth pelting stones at the forces. As the crowd of curious onlookers swelled, the clashes intensified. Police and paramilitary forces responded by firing aerial gunshots and pellet grenades at the protesters and also at the crowd of onlookers, according to eyewitnesses.

When a pellet grenade is fired, like a conventional grenade, it sends out hundreds of tiny metallic balls into the air. Although banned by western countries, paramilitary forces and police still continue to use pellet grenades in Kashmir. The lethality of this weapon has led to severe criticism of its use by human rights groups but it hasn't stopped the government in Kashmir from using them as a tool of crowd control.

In recent times, the pellet grenades have earned India more enemies in Kashmir than any other weapon. It has blinded people. There are young boys with disfigured faces, without eyes, boys whose bodies carry the scars of these vicious metallic balls. In Kashmir, those protesting on the streets have many reasons for pelting stones. Stone throwing is a political statement. But here in Old Town of Baramulla, stone is a weapon for children, not just to express their resentment but also to stare fearlessly in the face of a State whose coercive tactics have failed to obtain their submission.

When the six friends left their game of carom on May 7 to watch the clashes, they sat on a large empty kerosene tank. Within minutes, teargas and pellet grenades were fired towards them. Shoiab, 14, tried to run but a grenade exploded behind him, shooting hundreds of pellets towards him. The pellets bored

through a white Tee he was wearing and pierced his back.

"I thought I was hit by bullets. It felt like someone had poured petrol and set fire from my shoulders to thighs but I kept running to a safer place," he told me.

The boys accompanying Shoaib took him to a makeshift dispensary in Old Town where he was given a soft drink to ease his pain. Once hit, most of the victims are afraid of visiting doctors for treatment, fearing that they will be arrested by cops who are tipped about their presence in hospitals by sleuths in plainclothes.

But the news had reached his home and his mother entered the dispensary, giving him a tight slap. She hugged him then and, after nearly 117 pellets were removed from his back, took him home.

The smell of freshly cemented walls hung in the air as I arrived outside the two storied concrete home owned by Shoiab's father. Within minutes, the entire family came out to meet me. Shoiab's father cursed the day when he migrated to Baramulla from a nearby village so that his children could get better education. His elder son who is fifteen-year-old was arrested recently on charges of stone throwing and let off after a warning by the judge when the boy turned out to be a minor.

"He was a stone-pelter but, thanks to a police official, he doesn't indulge in it anymore. But Shoaib was playing carom on that day. He doesn't throw stones. He is too small. He had gone there to watch the clashes, like many other kids," his father told me.

Shoaib's furious mother joined her husband as they together started cursing their son for joining

young boys who were watching the clashes on May 7. I closed my notebook and asked Shoiab if he could accompany me to a nearby street. As I walked out of the narrow alleys of Old Town, I kept thinking about Shoiab and his father's journey from a small village to Baramulla, and as much I walked away from Shoiab's home, I felt leaving a dark trail behind me.

Sameer Yasir is a journalist based in Kashmir. He has reported for the New York Times, Wall Street Journal, Firstpost.com, among other publications. He writes extensively on defence, human rights and security issues and spends most of his time in the rural areas of Kashmir.

Life Long Torture

Shahid-ul-Islam

The pellet guns used by the Indian troops and police in Kashmir are lethal in all manners. They have not only killed innocent Kashmiris, but the deadly pellets have inflicted serious injuries as well.

After spate of killings in 2010 (which left 122 persons dead), the police and CRPF, which have been in the forefront of curbing street dissent in Kashmir, have invented a new weapon to aim at unarmed protestors. They use now pellet guns to fire at their target. However, a study has revealed that pellet guns have caused death of at least six persons and injuries to 198 since 2010. Five persons, according to it, have also lost their eyesight following pellet injuries. The police however continue to with its use.

The pellets are fast becoming a cause of blindness among our youth. The shrapnel balls pierce the eyes and lead to partial or complete blindness to the victims. There are scores of such youth who have lost ability to see. Some estimates put the number of people blinded due to pellets at seventy.

Besides vision loss pellets also cause injuries to other parts especially when someone is hit on face if by chance his eyes do not get damaged completely his face is disfigured to such an extent that becomes a cause of lifelong mental torture for him. Same is the result if any of his limbs is damaged.

It is not only the eyes or any limb of the victims which are snatched by the deadly pellets. What we have to understand is the aftermath when such cases do take place. Just imagine the sufferings of family members of victims who have to tend their ward after hit by the pellets in their eyes. Not to speak of financial costs.

The Punishment does not come only physically for the victims. The police register cases against the pellet victims under sections of sedition and waging war against the state. It means they are not entitled for any government compensation and they won't get any job or passport since their verifications would not be cleared.

The pellet victims are such casualties of the conflict who suffer every day, along with them, their parents and families do suffer as well as it is very difficult for them to withstand the mental torture they have to undergo daily in their lives.

It is not easy for pellet victims who suddenly lose their eye sight to reconcile with the routine course of happenings. These victims are not visually impaired by birth. So it is almost unconceivable for them to get settled in the new life of darkness.

So far the causalities due to pellets are lesser known. The police, inept to use the pellet guns, fires from close range on pro-freedom protesters, which becomes cause of serious injuries to the youth.

The policemen in civvies note down the names of the youth hit by pellets and file FIRs against them by slapping serious charges. In some cases these youths arc also arrested from the hospitals and lodged in Police lockups. In this situation the injured youth

prefer to get treated at home. Sometimes, if the wounds are not treated well, it leads to serious complications.

In absence of any political solution to the Kashmir problem, the pro-freedom demonstrations are expected to continue as the armed insurgency takes a back seat. Hence it is high time for the civil society and leaders to mobilize an opinion to stop the use of lethal pellet guns. Or else it won't be ruled out that Kashmir is bound to witness more deaths and blindness among youth due to this "non lethal weapon".

Advocate Shahid-ul-Islam, is media advisor of APHC and has been contributing in English dailies of Kashmir. He also works on social reforms fronts in the valley.

Use of 'non-lethal' weapons in Kashmir: More than what meets the 'eye'

Abdul Rauf

"...then I went to New Delhi where doctors told me that my right eye is lost forever. They said the pellets inside it could only be removed through skull with a surgery though without any chance of restoring my eyesight," says 26–year-old Ibrahim (name changed).

On a protest day in 2010, pellets fired indiscriminately by police and CRPF hit this young shopkeeper from downtown Srinagar all over his body. They pierced into his neck, shoulders, back and the right eye. Friends rushed him to the SMHS Hospital here where doctors removed pellets from his body, and operated upon his right eye. But Ibrahim 'escaped' from the hospital fearing that the police may trace him.

"We were three of us, all hit in the eyes. The two of us were operated upon in the hospital and we later escaped. The third one was a 12th class student hit in the left eye, and he escaped even before treatment," Ibrahim was quoted by Srinagar-based daily Kashmir Reader.

Back home, bandage over Ibrahim's eye was removed a few days later only for him to find his vision partially impaired. Ibrahim couldn't see with his right eye. He met the doctors at SMHS Hospital again who

asked him to get an X-ray of his eye. And it confirmed that two pellets were still inside the eye-ball, and that the eye was damaged beyond repair.

"I was given a recommendation letter for AIIMS, New Delhi, and PGI, Chandigarh. But the doctors there started enquiring too much and we had to return without treatment again," Ibrahim recollected.

"Finally," he continued, "I spent a lot of money to go to a private hospital in New Delhi. Unfortunately, the doctors there said my eye can't be repaired. Yet they put me on medication, but there is no improvement."

Ibrahim returned after fresh check-up in New Delhi two months ago, but with no hope of being able to see properly again.

"I haven't been doing anything all these years, and it really is a curse to be disabled at this age. Fortunately, my family is financially well to support me. The other guy (12th class student) wasn't so lucky and I recently heard he is disabled too," Ibrahim added.

While Kashmir Valley has been simmering with mass protests off and on in past few years, the indiscriminate use of pellet guns and other so-called non-lethal weapons by police and paramilitary CRPF has become a trend. And Ibrahim's is not an isolated case of visual imparity caused by the use of these 'non-lethal' weapons.

A survey of 2010 by a team of doctors at Ophthalmology Department of Government Medical College in Srinagar showed that at least 60 persons lost their eyesight because of the pellet guns, slingshots and tear smoke canisters used to quell the protests. Of the 60 cases, 75% were aged 16-26 years,

16% between 5-15 years, and 14% were 27-years-old or above. Ninety-five% of the victims were males.

About 43% of the victims, the study showed, could only perceive hand movements, 6.7%could see only partially, and 18.4%could see nothing with the damaged eye. Shockingly, 40% of the cases were found to be 'open globe', meaning the pellets had pierced the eyeball.

The study showed 29 patients were hit in the eyes by stones; 18 were hit by pellets; five by rubber bullets; six by slingshots and two by teargas canisters.

"We were receiving many cases of eye injuries in 2010, so we conducted this analysis. We studied all the cases we received in those few months of unrest and the results were disappointing," Head of the Ophthalmology Department, Dr Manzoor Qadir Keng, said about the study, which is being considered by World Health Organization (WHO) and a prominent British journal for publishing.

Given that the department is the only specialized eye-care centre in Kashmir, the figures are an index of eye-injuries caused by pellet guns, slingshots and tear smoke canisters across the Valley. And most of the victims received at the department, Dr Keng said, have their eyes damaged forever.

"The injuries leave them (victims) with partial eyesight for the rest of their lives," he said. "It becomes difficult for us to keep track of the cases because they escape due to fear of police."

The cases of injuries due to pellet guns continue to surge as the use of pellet guns to quill protests hasn't stopped. Earlier this year, when Kashmir was on boil after the hanging of Mohammad Afzal Guru, injuries

were reported from across the Valley. But the fear of police action is making it difficult to find the exact count of the cases. Sources said four fresh cases of eye-injuries were admitted at SMHS in February, "but they were reluctant to reveal their details and left the treatment midway."

"Only recently, I received a call from the family of a boy from Saraf Kadal. The boy was hit in the eye by a pellet, and they wanted to know the treatment they can get him," Ibrahim said. "I have five friends with eyes damaged due to pellets, but you know how much they (police) harass us in case police gets to know about us".

Last week, on May 21, a youth Suhail Majeed Khan of Owantabavan here was critically injured when police fired pellet guns during a protest demonstration at Bohri Kadal in old city. He is reportedly battling for life at SKIMS Soura where he is under treatment at present.

Abdul Rauf writes for news papers and his articles have appeared in several publications and websites. This article first appeared in Kashmir Reader (May 2013) and latter on the Website Fresh Initiative.

Weapon of Repression

Mannan Bukhari

While some democracies debate whether to use even water cannons for disbursing mob, but in trouble torn Kashmir Valley the "Deadly" pellet gun is a preferred weapon of the government forces to quell the civilian protests. The use of Pump Action Pellet Gun, described as "non lethal" by the authorities has proved to be so fatal that its use has resulted in a number of deaths, permanent loss of eyesight to scores and fatal injuries to number of persons.

According to the experts the Air guns or Pellet guns are very powerful and cause serious injury, they should be handled with the utmost care. The same safety protocol used on real firearms should be exercised with pellet guns. Contrary to popular belief, pellet guns should not be considered "toys". Pellet guns have the ability to shoot at speeds that are literally supersonic. The level of velocities is such that the velocity alone could cause light pellets to shatter, split or change form. This phenomenon occurs during the powerful transition or transformation of the pellets travelling between subsonic and supersonic speed.

Senior doctor on duty at SKIMS Medical College Hospital Bemina, requesting for anonymity, says that the use of pellets is outrageous. "These pellets are more dangerous than bullets and other firearms because their target is not specified. This makes it difficult to operate for us as the injuries are scattered all over,"

he said to me while coming out of an emergency operation theater, where they were operating upon a pellet victim Hamid Nazir of Palhallan Pattan.

Sixteen-year-old Hamid Ahmad, a student of class X at Hanfia Gousia Model High School, Palhallan suffered severe pellet injuries when he was on way to meet his friend in the neighborhood locality around 6:35 pm, on May 21, the day Kashmir observed shutdown against Hawal Massacre. The police and paramilitary soldiers who were chasing the protesters fired pellets indiscriminately and Hamid was hit by a rain of pellets in his skull, forehead and face.

He was rushed to the Sumbal hospital, where doctors referred him to SKIMS Medical College, Bemina. The brutal pellet attack was so serious in nature that the number of pellets in his entire skull was more than 100. After initial investigations the doctors treating him at SKIMS Medical College Hospital, Bemina, M.R.No. 342590, IPD No.003683, found that at least two pellets had entered his brain and in view of the severity of his injuries he was shifted to SK Institute of Medical Sciences, Soura, Srinagar, for the neurological checkup. At SKIMS, Soura, doctors find that there was no damage and he was shifted back to SKIMS Medical College Hospital, Bemina, for further treatment.

Inside the operation theatre the teenager is being operated for severe injury in his right eye, which according to the doctors has been damaged badly while outside the operation theatre his father Nazir Ahmad, his uncles, relatives and other concerned are waiting in deep distress and anguish. As I along with Mir Imran (Human Rights Defender) were expressing

our sympathies and moral support with Hamid's father Nazir Ahmad, during conversation Nazir Ahmad told me in a mournful tune, "we are not short of anything but how can I bring back his eye sight? They have ruined his life. He cannot live a normal life and may never see the world clearly again," he said with big tear drops in his eyes. And alleged that the brutal men in uniform have deliberately targeted Hamid's face from a close range.

Doctors who performed the surgery were not sure about the conditions of his eye. "Things would be clear only after 48 hours. We have closed the open injury successfully. There are at least two pellets stuck in his right eye and we will take a decision on removing them after 48 hours," said a senior doctor.

"He has vitreous hemorrhage in his right eye. As of now, he cannot see with his right eye, it is damaged. He has blurred vision in his left eye," says Dr Waseem Rashid, one of the doctors treating Hamid.

Hamid is not the only victim who received fatal pellet injuries during the P.D.P and B.J.P collation rule. On the same day, Imtiyaz Rasool Tantray, 16, a class X student also from Palhallan too was admitted in SKIMS Medical College Hospital, Bemina, for pellet injuries. His right arm was hit by a rain of pellets at Palhallan and he was rushed to the Hospital. With visible marks of hundreds of pellets on his right arm and writhing in pain, Imtiyaz will take some time to recover but the negative psysocological impact of this pellet attack is not ever going to fade.

On the same day two more youth namely Reyaz Ahmad a class IX student and Tariq Ahmad Hajam a class XII student also from Palhallan were hit by

pellets of government forces. Reyaz sustained minor injuries on his back and legs while as Tariq was hit on the back and scalp. Though the injuries were not serious but the pellets still present in skin are the main cause of concern for young Tariq.

It is worth mentioning here that the PDP while they were in the opposition used to condemn and criticize the use of pellet guns and pepper gas in their statements, and demanded ban on their use. They even staged walkouts from the state assembly. However, since they took over the reins of power at least three persons have received serious eye injuries due to pellet guns. Before Hamid, on 17 April 2015, Aquib Ayub Bhat son of Mohmmad Ayub Bhat of Zonimar, Srinagar and Bilal Ahmad Lone son of Ab. Rahman Lone of Syed Pora, Eid Gah, Srinagar were also hit by pellets near *Jamia Masjid* (Grand Mosque) Srinagar, when forces fired tear smoke shells and pellets to disperse a pro freedom demonstration. The injuries inflicted upon both of them were serious and they were rushed to SKIMS Medical College Hospital, Bemina.

Thirty five-year-old Bilal Ahmad, a handloom worker and father of three kids had received pellet injury in his left eye. Because of severe pellet injury he was operated upon under MRD NO. 1726 and was discharged from the hospital on 20-04-2015. Later he was taken outside the state to a private hospital in Amritsar for advanced treatment but still his eye sight has not been restored.

18-year-old Aquib Ayub Bhat, a student of class XII was treated at SKIMS Medical College Hospital, Bemina, for pellet injury in his right eye under

M.R.NO.(305683). He was taken outside the state and was admitted at Dr. SOHAN SINGH EYE HOSPITAL PVT. LTD. Amritsar Punjab, where he was operated upon. Since then he has been taken there a number of times but the doctors treating him are not sure that they will be able to restore the vision of his damaged right eye.

The barbaric treatment that has been meted out to these pellet victims is nothing new in this part of the word. The inhumane approach adopted by the state to silence the genuine voice of the masses and to quell the civilian protests depicts the military mindset of the Indian state while dealing in Kashmir and shows how Indian state systematically kills, maims and suppresses the people of Kashmir. Such oppressive systems can kill individuals and incarcerate them but they cannot mute the voices of dissent forever.

Lethality of 'Non-lethal' Weapon

Javed Iqbal

Pellet gun injury in Maisuma firing, which left four young boys maimed is a glaring example of how even supposedly non lethal weapon could wreck havoc in Kashmir. Barely a couple of days after my interview with BBC Urdu Service in which I had explained the nature of pellet injuries because of the experience of firearms including pellet gun injuries gained during my five years of working in a hospital near Iran/ Iraq theatre of war on Iran's western front, the gun proved its lethal effect in Maisuma in exactly the manner I had explained in the interview. The propagation that it may cause multiple superficial injuries flies in the face of evidence. To study the highly lethal effect of the much propagated least lethal 'Pellet Gun' foursome of [KCSDS] team visited S.M.H.S hospital and while other members tried to soothe and assuage the feelings of young victims and provided need based relief, I collected the medical details of pellet injured boys.

'Pellet Gun' as a firearm does have a damaging effect, though of a different denomination in medical terms. Distance does count in this type of firearm-a high velocity bullet may penetrate the human flesh and damage internal anatomical structures-sensitive ones even from a distance, while as pellets fired from a pellet gun from similar distance may cause relatively minor injury. The closer aim is however a

different story-the penetrating power increases and proportionally the damaging effect. Maisuma is a test case, where as per the testimonies, the pellet gun was fired from a close range, the gun being aimed at some young man playing carom. We may now get down to assessment of these cases on our 2nd September visit, as we got a measure of what they had suffered:

(1) Yasir Rafiq Sheikh S/o Rafiq Sheikh aged 28 years, suffered as per the testimonies furnished, pellet gun abdominal injury at close range. He was operated upon immediately on being brought to S.M.H.S hospital, for the next four to five hours doctors battled to save his life. The operative findings were intestinal perforation, for which a portion of intestines was removed [resection in surgical terminology] and the healthy ends rejoined (anastamosis)-resection & anastamosis might not have posed a problem, but the deadly pellets had resulted in intra-abdominal vascular injuries. The bleeding major vessels had resulted in drop in blood pressure [hypotension] and in spite of getting 10-15 units of blood, which amounts to replacement of major part of total blood in the vascular system, his blood pressure before being operated [pre-operative phase] during the operation [per-operative phase] did not stabilize, until the bleeding in the vessels was controlled by surgical measures.

Prolonged phase of low blood pressure [hypotension] results in shock-defined as a state of circulatory collapse, where along with hypotension there is increase in pulse rate resulting from increased heart rate [Tachycardia] as heart tries to accelerate its working to pump in more blood into a failing circulation, however due to lowered total blood volume [blood flowing in vascular system] the distribution of blood in various body systems suffers. The earliest sign of this failing distribution is cold, clammy skin due to less cuteneous blood supply [blood supply through the skin]

Following control of bleeding vessels, the state of shock was reversed in case of Yasir. Shock, depending on how prolonged it is results in organ damage-one by one-a state called 'Multiple Organ dysfunction system' [MODS] shock may become irreversible, with fatal results. In Yasir's case prolonged period of shock-collapsing circulation resulted in low respiratory status, so his respiration had to be supported-a measure undertaken when spontaneous respiration suffers and his kidney function suffered damage. The required blood has to flow through kidneys' [renal blood flow] for functional viability, with drop in circulatory blood volume, renal blood flow suffers. Main kidney function is to make urine-much needed excretion to drain out waste products.

Accumulation of such products in blood leads to toxic effects with fatal results.

Kidney damage due to low renal blood flow resulted in low urinary output in Yasir's case [Oliguria] which eventually leads to no urinary output [anuria]. As Yasir started showing cumulative effect of accumulating toxins, he was dialyzed on 2nd September, when we saw him first, as also on 4th-on our second visit, however his kidney function did show some improvement, as he passed 250-300 ml [normal 1500 ml/a litre and a half] of urine. Dialysis involves removal of toxic waste products by mechanical means, once the vital body function fails to perform. Kidney function could improve in his case, as the organ regenerates, however urine output has to stablise, until then dialysis has to continue, as frequently as required.

Yasir's treatment line faces other challenges; he is still on supported respiration and prolonged use of life support system [ventilator] that makes him breath has its own hazards, it may lead to a toxic lung-the infection would add to the risks, he is already facing. The ideal prognostic scenario could be Yasir's weaning away from ventilator, but then his clinical and Para-clinical parameters should match up-which includes blood gas study, a normal mix of gases- inhaled (breathed in) oxygen and exhaled (breathed out) carbon dioxide.

Earlier Taufiq Ahmad Lone S/o Mushtaq Ahmad Lone, aged 17 years from Nowopora-Lone Mohalla [contact: 9858833487] injured on 13th August- Nowhatta Chowk firearm victim admitted in ward 17, where Yasir is admitted-surgical ICU had multiple abdominal injuries-an operated case on life support system [ventilator] developed toxic lung, which was successfully combated. The teenager was off the support system [ventilator] and breathing spontaneously with a cheerful demeanor, when we re-visited him on 4th September. One would hope and pray for a similar outcome in Yasir's case, as a competent team of high grade medical professionals are battling to save his life!

We may now move to other Maisuma cases seen on 2nd September

(2) Sajid Mushtaq S/o Mushtaq Ahmad Dar aged 19 [ward 16-contact: 9622424037] was admitted and operated on the same day as Yasir-30th August. Sajid too sustained multiple pellet injuries on right side of chest and right arm. The pellet injury in the chest resulted in injuring the liver which is covered by thoracic bony cage [ribs] he had hemoperitoneum [blood in abdominal cavity] after repairing the liver, he had peritoneal toilet carried out [washing of abdominal cavity] post-operatively Sajid was stable, though a live witness of how lethal 'Pellet Gun' could be.

(3) Ashfaq Jan S/o Mehraj-ud-Din, aged 17 [ward 16-contact: 2472204] nephew of Yasin Malik with multiple pellet injuries-back, left shoulder and left arm-he was stable as we visited him on 2nd September, some superficial pellets were removed in his case, the one in the chest was not touched. Surgical prudence demands not to touch a pellet or bullet in a sensitive location, which has not resulted in any damage; however the effort to remove it might induce an un-intended trauma to a sensitive structure. Otherwise left inside, these foreign bodies cause no harm

(4) Aaqib Dar S/o Gh. Mohd Dar aged 17 [ward 16-contact: 2483556] with multiple pellet injuries on left side-axilla, forearm and loin, he too was stable managed conservatively [without an operative procedure]

It stands amply demonstrated how lethal 'Pellet Gun' could be; it may not leave a gaping wound of entry like other firearm injuries, such as a high velocity bullet. At the point of entry, there may just be, what is labelled as 'Puncture Wound' once it enters it may penetrate vital structures like heart resulting in 'Cardiac Temponade' a condition where bleeding suppresses the activity of heart [cardiac activity] usually with fatal results, it may puncture the lung causing Pnumohemothorax [Pnumo for air, hemo for blood] a condition where air escapes from he punctured site of

lung and mixes with blood-the bleeding could either be minor or major if a major blood vessel is ruptured. And as seen in Yasir's and Sajid's case, it may injure the inner vital organs and lead to numerous complications, as indeed Yasir is facing. Pellets may cause spinal injury, which may lead to wheel chair life. In limbs, they may result in piercing blood vessels and nerves, putting the survivability of limb in danger; to conclude it may affect the proverbial 'life and the limb'!

The purpose of the documentation is to record the gross human rights violations and to know the first hand truth about these brutal incidents. The truth needs to be laid bare by an impartial probe of all cases. Home Minister Chidambaram has already as per reports talked of 17 cases, what about others? The probe must be widened, the truth acknowledged and justice done. There cannot be any reconciliation unless truth is acknowledged, that alone could pave way for a peaceful resolution of Kashmir issue.

Javed Iqbal is a Kashmiri doctor and a writer. His columns and writings have appeared in leading English and Urdu dailies in Kashmir. He is also an active member of a Kashmir Civil Society group "Kashmir Centre for Social and Development Studies" (KCSDS) and is author of book "Kashmir Stray Thoughts". This article was first published in daily Greater Kashmir, dated 25 Feb 2014.

First cases of pellet injuries in 2014

Haroon Mirani

As Tariq Ahmad, 30, narrated the story of his descent into darkness after a brief introduction, he produced his medical prescription clearly mentioning pellet injuries.

Tariq is one of the four youths of Shopian who were recently hit by pellets after police used the deadly weapon to disperse people who were demanding bodies of the militants killed in an encounter with forces.

According to doctors at Sri Maharaja Hari Singh (SMHS) Hospital, the four are the first recorded cases of pellet injuries in 2014.

Two of them have almost lost vision of their right eyes, as doctors scramble to rectify or contain the spreading damage.

The last time Tariq had a clear and painless vision was on February 13, when he visited his in-laws in Pinjoora Shopian to pick up his son. The nearby encounter had long finished and Tariq along with others had assembled to demand the bodies of the militants.

"There was a bang, as if a high speed stone hit a tin and then everything went blank," said Tariq.

"I remember being lifted, taken to Shopian hospital and then came to senses with vomiting in SMHS."

Tariq feels those four hours were the most brutal hours of his life. "Now when I close my left eye, there

is darkness everywhere," said Tariq as he reluctantly closed his left eye with his left hand and his cousin fervently snapped fingers before his unresponsive right eye. Barring redness there is no mark or abnormality visible on his perfect looking eye.

"Two pellets are stuck in his right eyeball and we don't have any facility to remove it," said the attending doctor. "We have immediately referred him to outside and if possible they should leave today."

Tariq's relatives are on phone trying to make arrangements and put together some money. "Be it loan or selling whatever we have, we are trying," sighed Tariq, a laborer by profession.

Ghulam Mohuidin, 25, doesn't talk much but clings to his faith in God. "Yesterday I couldn't see anything but today there is slight vision," said Ghulam Mohuidin, also laborer by profession. But doctors are not that optimistic unless Mohuidin visits super specialty hospital in Amritsar or New Delhi to remove the pellets and then "hope for the best."

Ghulam Mohuidin was at the end of the procession when he was hit. "I didn't felt anything instantly," he said. "It was after I went to Shopian hospital who referred me to SMHS and my world changed."

Currently the biggest problem for these youth is to manage the money for treatment and medicines. "They are extremely poor," confided a doctor, even as Ghulam Mohuidin and Tariq shy away from saying anything.

The anxiety is evident on everyone's face in ward 8 as the next few days are going to determine whether the duo could ever see again.

They are racing against time and the biggest roadblock is their poverty. There is a murmur, can anybody help?

"Nothing has happened with me like this ever before and now all of a sudden....," says Ghulam Mohuidin, grappling with words.

The other two- Muhammad Ashraf, 25, and Umar Nabi, 18- have something to cheer about. "They can still see," says the medical report. Muhammad Ashraf was at the end of the procession when the pellets hit him. Luckily the pellets didn't hit any of his vital organs and he escaped the permanent damage.

Perhaps Umar is the luckiest of all. He was hit with a barrage of pellets. His nose, face, head and hands have the scars indicating those hot and high speed pellets pierced his skin. "Boom and I was hit by 12 pellets," said Umar who is a student.

"Everybody had assembled peacefully and then suddenly without any provocation forces fired teargas and then pellets on us."

Police countered the claims of peaceful protests and termed them as violent clashes.

Talking to Greater Kashmir on Friday, DIG South Kashmir Vijay Kumar said, "At least 13 policemen were injured by the protesters near the encounter site. They also damaged two vehicles of police. There were rumours that police used pellet gun but we have no such guns in South Kashmir."

Medicos feel frustrated with the latest pellet injuries. "Pellets are as dangerous as bullets and when fired from close range they can rupture vital organs," said Dr Nisar ul Hassan, president Doctors Association

of Kashmir (DAK). "Even if a person survives, he is maimed for life."

The doctors cite their inability to treat such patients particularly those hit on eyes. "The worst part is that we don't have facilities to treat such patients here," said Dr Hassan. "They have to visit the super specialty hospitals outside the State and that too immediately."

Haroon Mirani is a senior correspondent at Greater Kashmir where he covers wide array of topics including human rights issues. His features and various news stories have appeared in number of publications and websites. This news item first appeared in Greater Kashmir, Srinagar, 16 February 2014.

Deadly Pellet GUNS!

Majid Hydri

NOTWITHSTANDING the government claims that pellet gun was non-lethal, medicos treating the pellet victims in the summer Capital find it deadlier than bullets.

The doctors said not only the treatment was more complicated than that for a bullet injury, but that the damaged caused by the pellets was even more killing.

Since the introduction of pump action guns or pellet guns past week, some 100 persons have reportedly fallen prey to the pellets fired allegedly by police and paramilitary CRPF while the authorities insist the weapon is non-lethal.

While one of wounded succumbed to the injuries, the condition of most others continues to be critical.

Given the seriousness of the injuries, most of the injured have been admitted at Srinagar based hospitals: the SK Institute of Medical Sciences Soura, Valley's sole tertiary care hospital and the SHMS Hospital. The doctors reveal gory tales of the patients as they battle for life.

THE CASES

Teenager Aijaz Ahmed Lone son of Muhammad Subhan of Anchar, Soura was hospitalized on August

26 under MRD number 625311 after the CRPF allegedly fired the pellets on protesters there.

The patient with pellet injury was rushed to the operation theater where he was found having multiple perforations.

"He had a spleenic injury, multiple perforations in small gut stomach and haematoma around left kidney. Besides he had lung injuries on both sides," said a team of surgeons who operated upon the patient.

"These perforations in small and large gut required closure...Then haemotoma was removed and both lungs were also operated upon," the surgeons said adding "bilateral thorocotomy was also done."

While the other organs could be saved, the doctors had to remove the badly damaged spleen.

In another case, Khan Asif Ahmed son of Nazir Ahmed of Buchpora was admitted under MRD No 00625239.

Khan was operated upon for the injury which, as per the doctors, "shattered his kidneys, left lung and left large gut." The doctors fear such cases won't be able to live a normal life even if they recover.

SMALL WOUND SHOCK

The pellet cases have shocked the doctors because apparently the victims don't have any big wounds like that in case of a bullet injury.

"Pellets apparently go unnoticed. The entry mark is so small that if patient doesn't complain of pain the wound could be neglected and ultimately prove more lethal," said a medico.

"The wound is barely of the size of mosquito bite," he added. But the damage is big. The SKIMS medicos said the pellets have resulted in "devastating injuries to patients as almost all their organs were involved."

PELLET VS BULLET

The doctors in trouble-torn Kashmir have over 20 years of experience in treating the firearm cases. This makes them observe that the pellets are deadlier.

"A bullet hits one or two organs but a pellet damages multiple organs that too with multiple perforations," said a surgeon at SHMS Hospital in Srinagar.

'ZIONIST ASSAULT'

Kashmiri medicos working abroad are equally upset at the pellet assault on unarmed civilians in their homeland. "Such weapons have been tried on Palestenians by Islrealies. Now, Kashmiris seem to be the latest victims," a medico working in the Middle-East, recently poked on his facebook wall. The doctors community has linked the pellet attack with the cluster bombing, the US forces did in the Afghanistan war of 2001.

"Pellet gun is simply the miniature version of the cluster bombing because the results are equally killing," said a retired professor of Surgery who recently came across such cases at SKIMS.

KILLING ALTERNATIVES

Surgeries of the pellet wounded, as per the medicos, are so complicated that it not only takes several hours more as compared to other fire arm injuries, but requires presence of multiple super-specialists.

"The surgeries are being conducted under the multiple disciplinary approach whereby several super specialists are required in the life saving attempt," said an anestheologist. Operation theater insiders said that the surgeons are so furious with the assault that recently a senior specialist observed: "If they(forces) mean deadly damage. It's better to use grenades or bullets than pellets. At least that way the chances of recovery could be more."

'NLW TAG'

A police official said the pellet gun was turning to be their choice because of the Non-Lethal Weapon (NLW) tag attached with the weapon.

"In a single fire of the NLW we can target dozens in a mob and neutralize them for months," he said.

THE FISSION

The armed forces introduced the pellet guns following mount in fatalities in the police and paramilitary CRPF firing on protesters during the past over two months of unrest which till date claimed at least 64 lives.

An SKIMS official confirmed that atleast 38 pellet victims have been treated at the hospital while one of them died.

On August 19, paramilitary CRPF fired pellets in Sopur on protesters in which four persons were injured. One of the injured, 19-year old Mudasir Nazir Hajam, succumbed the next day. Another injured, Danish Ahmad Shiekh of Tarzoo Sopur, lost his eyesight in the pellet fire.

On August 22, police and CRPF uscd pump action shots on protesters at Chattabal in the summer capital injuring at least a dozen of them.

On August 24, seven persons were injured at Soura.

The forces also fired the pellet gun shots at protesters in Bemina, Rainawari, Soura and several other localities of the summer capital past week injuring at least two dozen persons.

A number of protesters from Islamabad is south Kashmir and Varmul in the north were also injured in the pellet action.

On August 30, police fired pellets on carom playing youth at Maisuma. While five boys were wounded, one of them is on a life support system battling for life at SMHS Hospital.

CONSPIRED TO KILL...

- Pellets damage multiple organs of a victim
- Treatment, surgery more complicated than other firearm cases

- Requires presence of more surgeons, which means not many injured can be treated in one go
- Internal damages are deadly but wounds outside are so small that it could go unnoticed
- The entry mark is so small that if patient doesn't complain of pain the wound could be neglected being taken as a mosquito bite and subsequently result in patient's death due to internal injuries
- Chances of total recovery are bleak.

(Source SKIMS doctors)

Majid Hyderi is a Kashmir based journalist with 15 years of experience in print and electronic media. He has worked for over a decade with Greater Kashmir, the prominent English Daily from Srinagar. Presently he is a freelancer and contributes for various newspapers and websites. This article first appeared in Greater Kashmir, Srinagar 02 September 2010 and later on several other websites.

Blinded in 'paradise'

Uzma Falak

It is summer in Indian-controlled Kashmir and stewards of 'manufactured peace' have swooped down here again with their glib ideas of 'change'. Michael Steiner, the German ambassador to India, recently met Kashmir's chief minister Mufti Mohammad Sayeed, offering his co-operation to change the 'negative perception' about this 'paradise on Earth'. A week later, Hamid Nazir, a 16-year-old boy, lies unconscious in the hospital with a visually impaired right eye; his disfigured, swollen face – a present from the custodians of 'paradise' – a reminder of India's brutal desires.

Hamid, a 10th-grade student, was, according to his family, on his way to a tutorial in Palhalan, northern Kashmir, when he was hit by scores of pellets in his skull and face. Indian troops were firing indiscriminately at protesters commemorating the 25th anniversary of the Hawal Massacre of 21 May 1990, when over 60 mourners in a funeral procession of a religious leader were killed by troops. One particularly haunting image from that massacre was the sight of hundreds of slippers on the bloodied street left behind by the dead mourners.

Hamid was rushed to a nearby hospital but troops had blocked the road. After an hour, the family managed to take him to another hospital, but his condition was continuing to worsen, and twice he had

to be moved to other infirmaries in the city. More than 100 pellets were lodged in his skull, with at least two in his brain; doctors reported a 'cornea-limbal' tear in his right eye. Though they operated on him, they were unable to restore his vision.

A senior Kashmir resistance leader remarked that the use of pellet guns in Kashmir resembles Israel's brutality in Gaza.

Pellet guns, also used for hunting, were introduced in Kashmir in 2010 and were touted as 'non-lethal weapons' for crowd control. That year, Indian forces killed over 120 people. Doctors say that pellet guns are deadlier than bullets and lead to high morbidity. 'Entry wounds, invisible or small, are not localized but diffused, making treatment difficult,' explains surgeon Ajaz Baba.

Pellet or pump-action guns use a compressed air mechanism, pushing out scores of high-velocity metal pellets, like ball bearings, which can target lots of people, or lots of parts of someone's body, at the same time.

According to a report, some 700 people have been disabled by pellet guns since 2010, with 70 per cent of them having lost their sight in one or both eyes. The report mentions that the police flout their own 'written directives' by using a grade of pellets not permitted 'officially'.

Beyond the maze of statistics and jargon lies a grim reality. Local infirmaries aren't equipped to treat such injuries. Some patients are referred to hospitals outside of Kashmir, which only a few can afford, but even that doesn't guarantee complete recovery. Moreover, due to a considerable police presence in

major hospitals, many injured boys avoid going there, fearing arrests and harassment.

The state systematically kills, maims and represses the people. It also desperately tries to create a façade of normality, by bringing in international diplomats who eye up potential investments as the Indian government pushes for rigorous corporatization. Bollywood's portrayal has reinforced the stereotypical 'exoticized' iconography and images nourishing Indian hyper-nationalism. For India and its puppet regime, both tactics work together organically

The German envoy, who was here to 'celebrate his wife's birthday', informed Kashmir chief Sayeed that 'Germany officially recommends its citizens to travel to Kashmir'.

Discussing issues of 'mutual interest', Sayeed disclosed his plans of organizing a 'tourist-mart' and a 'mini-Davos' economic forum in Kashmir, similar to Switzerland's WEF, inviting India's prime minster Narendra Modi 'to host the country's top corporate heads'.

Such attempts have always drawn flak from people here, and triggered intense protests.

In 2013, Steiner and his wife hosted a controversial event in Kashmir sponsored by corporate czars, in which Zubin Mehta – a pro-Israel Music Director for Life of Israel Philharmonic Orchestra, who helped Israel improve its global image – played to an 'invitee-only' audience. While he was playing for 'hope and peace', four youth were killed by troops in the region. The German envoy also 'orchestrated the end of isolation among EU countries' for Narendra Modi, before his coming to power. Modi is accused of

complicity in the 2002 pogrom against Muslims in the Indian state of Gujarat.

While the chief minister, who is busy organizing 'tourist marts', is silent on the use of pellet guns, the education minister is concerned about the image – 'It does not show us in a good light'. He said: 'We cannot really force them to stop using the pellets. We hope it will be curbed soon.'

Away from this talk, Hamid's father plans to shell out his savings and take a bank loan to afford his son's treatment in New Delhi. Hamid still has pellets lodged in his eyes and needs to undergo further surgeries.

But everything is 'normal' in Kashmir and Hamid's disfigured face is a portrait of that normality.

Uzma Falak, has written narratives from Kashmir for London-based New Internationalist, Kathmandu's Himal Southasian, Arab Studies Institute's e-zine Jadaliyya, Of Occupation and Resistance: Writings From Kashmir (Westland and Tranquebar Press, 2013), besides others. Her poetry has featured in Kafila.com, Currently, she is working on a film on Kashmir women and their agency vis-a-vis the resistance movement.

Facts Revealed

R.T.I. Reports

SKIMS Medical College Hospital Bemina, Srinagar

Information obtained through Right to Information Act (RTI) – 2009, from SKIMS Medical College-Hospital Bemina, Srinagar under number SKIMS/MCH/24/2013/457-59 Dated 16/12/2013 which came to be issued by the Dy. Medical Superintendent (PIO) in response to RTI application dated, 02/11/2013, states that:

During 2010 to 2011:	36 patients
2011 to 2012:	01 patients
2012 to 2013:	13 patients
2013 (up to October):	03 patients, with bullet injuries were admitted and treated in the hospital.
While during 2010 to 2011:	100 patients
2013(up to Oct. 2013):	18 patients, with pellet injuries were admitted and treated in the hospital.
and during 2012 to Oct.2013:	07 patients with blast injuries were admitted and treated in the hospital.

From June 2010 to October 2013, 19 patients with pellet gun injuries were admitted in the Ophthalmology Department of the same hospital, out of which 15 patients required surgery.

The total number of patients who got visually disabled due to pellet injuries by one eye was 12 and those who where visually disabled by both eyes was two.

Communication No. SKIMS/MCH/24/2015/ 464-65 dated 27-02-2015, which came to be issued by Dy. Medical Superintendent (PIO) SKIMS Medical College-Hospital Bemina, Srinagar in response to another RTI application states as under:

> "Total number of patients admitted in Accident & Emergency w.e.f November 2013 to December 2014 with pellet injuries was ten (10) as per records available".

On page two of the said communication regarding pellet injuries, Prof & Head, Department of Ophthalmology, under reference no. SKIMS/mc/ opth/15/2790 dated 25-02-2015, states as under:

> "Total number of patients admitted in Eye Ward is 12 (Twelve).
>
> Total number of patients who were operated is 10 (Ten)

As per the records submitted by the MRD Section of this hospital record of only 5 (Five) case files was made available to this department as the rest of the files are damaged in floods and one file not available. From these 5 case files, the eye sight in the eye involved in pallet injury was completely lost in 4 cases while as in the 5th case there was very little affect on eye sight."

(This information pertains w.e.f. November 2013 to December 2014)

S.K. Institute of Medical Sciences, Soura Srinagar, Kashmir

After filing second appeal against the First Appellate Authority and PIO – SKIMS, Soura, Srinagar, the Public Information Officer (Sr. Administrative Officer), hospital administration of the SKIMS Soura, Srinagar, after the intervention of the State Information Commission, in his communication number SIMS/RTI-258/ 2013-2384-86 dated, 24-03-2013 states as under:

"This department had sought two to three weeks time wide communication number SIMS 255/ 57/014-337-38, dated, 21-02-2014 for rechecking/reviewing our records. Accordingly after thoroughly rechecking the records, scattered at different areas of the hospital, and also getting permission

for access to the Operation Theatre Records of the Department of Anesthesiology, some deficiencies were observed in the previous information regarding pellet injuries submitted at different times.

Hence rechecked and revised information in respect of pellet gun injuries from the year 2010 to Oct. 2013 as desired is submitted as under:

Point a & b:

Number of patients admitted with pellet gun injury from 2010 to Oct 2013 (In SKIMS all injury cases are admitted through Accident and Emergency)

Year, 2010 – 71
Year, 2011 – 01
Year, 2012 – 02
Year, 2013 (Up to Oct.) – 21
Total: 95

Point c:

Number of in patients with pellet injury who underwent surgery: 17

Medical Record Department is not maintaining any specific record for patients taken for a particular surgeries, somehow this time we

have managed to obtain the information by making access to the Operation Theatre Records.

Point d:

Regarding deaths it is submitted that as per records available from face sheet and death certificates issued, no death has occurred as pellet gun injury. However while going through the files it was noticed that three death cases have received pellet injury also which is mentioned on history note records".

In response to another RTI application dated 21-01-2015, the authorities of S.K. Institute of Medical Sciences, Soura, Srinagar, reveal that:

Total patients admitted to the Accident and Emergency Department of the hospital with pellet gun injuries from November 2013 to December 2014 is 7 (Seven).

Total number of patients who required minor operative procedure due to pellet gun injuries from November 2013 to December 2014 is 4 (Four).

(Communication No. SIMS/255-57/15-339-40, dated 11-02-2015)

S.M.H.S Hospital Srinagar – Kashmir

According to the information which came to be issued by the Public Information Officer, SMHS Hospital, Srinagar, under NO. RTI/SMHS/8055 – 57, dated 08-01-2014, the Prof. & Head, Department of Ophthalmology, Government Medical College, Srinagar reveals that:

"Total number of patients admitted in our department with pellet gun injuries from 2010 to Oct. 2013 are 36 (18 in 2010, 5 in 2011, 6 in 2012 and 7 in 2013). Out of these 27 were open globe injuries and 8 closed globe injuries.

All open globe injuries were subjected to surgeries. Out of these, 17 had very severe injuries and very poor prognosis. 14 had retained pellets inside eyeball and were referred outside the state for further management. In closed globe Injuries, 3 had direct injury to optic nerve and had very poor prognosis and in rest Pellets were embedded in superficial structures which were removed and all recovered.

Overall about 14 had no chances of regaining some eye sight on initial examination. The fate of those referred outside the state is not known.

No death due to pellet injuries was reported from our department.

Regarding hazardous effect of pellet on eye, pellets hitting the eye is a grievous injury. Pellet being small, sharp and with high velocity can penetrate deep through and through the structures of the eye and cause damage to multiple delicate parts of the eye. Chances of complete recovery of eye sight depends on the part hit and the structures damaged and the extent of damage."

The Head of the Department of Postgraduate Department of Surgery, Government Medical College, Srinagar, in his response under No. SD/HOD/7000, dated 08-01-2014 which was also issued by the PIO concerned reveals that the number of patients admitted in SMHS Hospital, Srinagar with pellet gun injuries from March 2010 to Oct. 2013 was 91 (Ninety one only).

"Mode of treatment was conservative in all surgical patients. Patients having active bleeding or having protruding pellets were treated in the Operation Theatre by removal under local Anesthesia and antiseptic dressing.

Those with associated lacerated wounds were stitched primarily under local anesthesia.

All patients were treated on the lines of ATLS (Advanced trauma life support) guidelines and also received tetanus toxoid and analgesics as and when required.

All patients were investigated as indicated in individual cases including skeletal survey, Ultrasonography etc.

Patients having missile (pellet) injuries to eyes were referred to Ophthalmology, those with injuries to ear or nose were referred to ENT & Head & Neck Surgery Departments.

As far as the potential hazardous effects of the pellet guns can range from injuries causing superficial to deep burns at local areas, damage to eyes can cause temporary or permanent blindness or visual impairment. It can also cause penetrating in juries of brain, neck, chest and abdomen causing damage to vital organs and viscera. In which case the victim may need emergency surgery for life threatening injuries.

Among the long term sequelae we can include cosmetic disfigurement and psychological trauma which includes post traumatic psychosis."

Head of the Department of Postgraduate Department of Surgery further states in the same document.

It is worth mentioning herein that this information was provided after filing first Appeal against the PIO concerned for providing incomplete and vague information under NO. MRD 363 dated 30-11-2013, showing only 47 pellet injury patients were

admitted and treated in the Hospital. But after filing second appeal in the State Information Commission against the First Appellate Authority (FAA) and PIO concerned, 4 (four) more patients with pellet injuries to their eyes were incorporated in the list on 12-05-2014, under No. RTI/SMHS/1089-90.

Government Bone and Joint Hospital, Barzulla Srinagar

Information provided by the PIO, Government Bone and Joint Hospital, Barzulla Srinagar, under Communication No. BJS/MS/PA/969 dated 25-07-2014, reveals that from 2010 to June 2014, Twelve (12) patients with pellet gun injuries were admitted in the Emergency Department of the hospital and all 12 (twelve) patients were admitted in the hospital. The total number of patients who required operative procedure due to pellet injuries were also 12 (twelve). While as the total number of patients whose any part of the body was amputated due to pellet injuries inflicted upon them by the law enforcing agencies during the same period, i.e. from 2010 to June 2013 is one (01) only.

District Hospital Baramulla

Through official reply No.DHB/RTI/2562-63 dated 14-12-2013, the Medical Superintendent of District Hospital Baramulla, provided the information as under:

List of Bullet injury/ Pallet injury patients attended in District Hospital Baramulla w.e.f 31/07/2010 to 27/08/2010

S. No	Date of Incident	Location of Incident	Name	Parentage	Residence	Diagnosis	Status of Injured
1,	31.07.2010	Baramulla	Maqsood Ahmad Khan	-	Boniyar	Bullet Injury (Rt) side of face. Bullet Removed	Treated and managed in Hospital
2.	31.07.2010	Baramulla	Irshad Ahmad	-	Baramulla	(Rubber) Bullet Injury (Rt) Buttock	Treated and managed in Hospital

3.	31.07.2010	Baramulla	Iqbal Ahmad Rather	Gh. Nabi Rather	Sangrama	Three Bullet Injury on back & X-Ray shows pallets in chest.	Referred to Srinagar Hospital
4.	31.07.2010	Baramulla	Farooq Ahmad Maknoo	-	Baramulla	(Rubber) Bullet Injury (Lt) side of Thigh.	Treated and managed in Hospital
5.	31.07.2010	Baramulla	Umer Ahmad Najar	Gh. Din Najar	Baramulla	(Rubber) Bullet Injury (Rt) side of chest.	Treated and managed in Hospital
6.	31.07.2010	Baramulla	Irfan Ahmad Wani	Ab. Rashid Wani	Baramulla	(Rubber) Bullet Injury (Rt) foot.	Treated and managed in Hospital
7.	31.07.2010	Baramulla	Javid Ahmad Teli	Gh. Mohd. Teli	Banglobagh – Baramulla	Head Bullet Injury (Rt) side of occipit.	Referred to Srinagar SKIMS Hospital where he died.
8.	31.07.2010	Baramulla	Ab. Rashid Ahanger	Gh. Ahmad Ahanger	Jul Sheeri Baramulla	(Rubber) Bullet Injury in Abdomen	Treated and managed in Hospital

9.	31.07.2010	Baramulla	Iqbal Ahmad Mir	Ashiq Hussain Mir	Drangbal Baramulla	(Rubber) Bullet Injury on nose. Fracture Nasal bone.	Treated and managed in Hospital
10.	3.08.2010	Baramulla	Mohd Akbar Wani	Mohd Shaban Wani	Rangwara Baramulla	Hjead Bullet Injury Entry. (Rt) Parantal region lodged inside.	Referred to Srinagar
11.	09.8.2010	Baramulla	Gh. Mohd. Pala	Gh. Qadir Pala	Ladoore	Rubber Bullet Injury (Rt) Arm with Elbow. Bullet Removed	Treated and managed in Hospital
12.	12.08.2010	Baramulla	Ahsan Fayaz Liloo	Fayaz Ahmad Liloo	Baramulla	Rubber Bullet Injury (Rt) Shoulder	Treated and managed in Hospital
13.	12.08.2010	Baramulla	Umar Ahanger	Bashir Ahmad Ahanger	Baramulla	Rubber Bullet Injury (Lt) side of face.	Treated and managed in Hospital
14.	14.08.2010	Baramulla	Gh. Qadir Shayair	Gh. Ahmad Shayar	Seeloo Sopore	Blast injury Poly Trsmia, Pallets on chest	Treated and managed in Hospital
15.	16.08.2010	Baramulla	Shabir Ahmad Sheikh	Bashir Ahmad Sheikh -	Banglobagh baramulla	Rubber Bullet Injury (Rt) Temporal region	Referred to Srinagar Hospital

16.	16.08.2010	Baramulla	Hashim Rasool	Gh. Rasool Gojri	SyedKarim Baramulla	Rubber Bullet Injury (Rt) thigh.	Treated and managed in Hospital
17.	18.08.2010	Baramulla	Mohd. Subhan Khan	Ab. Aziz Khan	Sangrama	Rubber Bullet Injury (Lt) leg knee.	Treated and managed in Hospital
18.	20.08.2010	Baramulla	Adil Farooq	Farooq Ahmad	Tawheed gung Baramulla	Rubber Bullet Injury on head on (Lt) parietal region with depressed fracture.	Referred to Srinagar Hospital
19.	20.08.2010	Baramulla	Waseem Ahmad Gogri	Mohd. Shaban Gogri	Old Town Baramulla	Rubber Bullet Injury (Lt) leg.	Treated and managed in Hospital
20.	20.08.2010	Baramulla	Gh. Hassan Wani	Ab. Rahim Wani	Jalal Sahib Baramulla	Rubber Bullet Injury (Lt) Leg.	Treated and managed in Hospital
21.	20.08.2010	Baramulla	Majid Ahmad Sheikh	Nazir Ahmad Sheikh	Mohallah Jadeed	Rubber Bullet Injury (Rt) Knee.	Treated and managed in Hospital
22.	20.08.2010	Baramulla	Muzamil Ahmad	Gh. Mohd	Kanlibagh Baramulla	Rubber Bullet Injury on foot.	Treated and managed in Hospital

23.	20.08.2010	Baramulla	Gulzar Ahmad Darzi	Ab. Samad Darzi	Baramulla	Rubber Bullet Injury (Lt) leg.	Treated and managed in Hospital
24.	20.08.2010	Baramulla	Muddasir Ali	Ali Mohd. Wani	Drangbal Baramulla	Rubber Bullet Injury (Lt) shoulder	Treated and managed in Hospital
25.	27.08.2010	Baramulla	Farooq Ahmad Bhat	=	Shalkote Panzala Rafiabad	Rubber Bullet Injury (Rt) on foot.	A/s applied & Referred to Srinagar.

Details of injured patients attended
District Hospital Baramulla w.e.f 03/09/2010 to 25/08/2011

S. No	Date of Incident	Location of Incident	Name/ Parantage/Age/ Sex/Address	OPD/ MRD No.	Diagnosis	Name of Hospital/ Ward No/ Bed. No.	Status of Injured	Financial	Any Other	Details of Assistance
1,	03.09.2010	Baramulla	Farooq Ahmad Tantary S/o Ab. Rehman Tantary R/o Old Town Baramulla Age 20, M	MRD 6987	Bullet Injury (Rt) Leg	D.H. Baramulla	Treated and managed in Hospital	X	Medicines & other first aid given.	

2.	03.09.2010	Baramulla	Tanveer Ahmad Gogri S/o Sonaullah Gogri R/o Drangbal Baramulla Age 30, M	T.No 0040077	Multiple Bullet Injury both Leg	D.H. Baramulla	Patient under shock, rescusciated, Blood transfusion (B-ive) given & Referred	X	Medicines & other first aid given.
3.	03.09.2010	Baramulla	M. Yaseen Dar S/o M. Rajab Dar R/o Azad Gunj Baramulla Age 23, M	T.No 0040078	Bullet Injury (Rt) Leg & fracture.	D.H. Baramulla	Referred	X	Medicines & other first aid given
4.	03.09.2010	Baramulla	Amir Kabir S/o Ab. Kabir Beg R/o Old Town Baramulla Age 21, M	MRD 6986	Bullet Injury (Rt) thigh	D.H. Baramulla	Treated and managed in Hospital	X	Medicines & other first aid given

5.	13.09.2010	Baramulla	Iqbal Lateef S/o Ab. Lateef Khan R/o Khawa-jabagh Bara-mulla Age M	T.No 0035646	Rubber Bullet Injury (Lt) leg	D.H. Baramulla	Treated and managed in Hospital	X	Medicines & other first aid given
6.	14.09.2010	Baramulla	Taraiq Ahmad Sofi S/o Bashir Ahmad Sofi R/o Khanpora Baramulla Sex, M	T.No 0035685	Rubber Bullet Injury on head, occipital region.	D.H. Baramulla	Treated and managed in Hospital	X	Medicines & other first aid given
7.	Do	Baramulla	Shakeel Ahmad Khan S/o Bashir Ahmad Khan R/o Khanpora Baramulla Sex M	T.No 0035688	Multiple pellet Injury (Rt) leg and head	D.H. Baramulla	Treated and managed in Hospital	X	Medicines & other first aid given

8.	Do	Baramulla	Sajad Ahmad Najar S/o Mohd Ismaiel Najar R/o Khanpora Baramulla Sex, M	T.No 0035687	Multiple pellets injuries both legs	D.H. Baramulla	Treated and managed in Hospital	X	Medicines & other first aid given
9.	Do	Baramulla	Mohd. Shafi Baba S/o Gh. Din Baba R/o Khanpora Baramulla Sex, M	T.No 0038427	Rubber Bullet Injury, fracture middle philings finger	D.H. Baramulla	Treated and managed in Hospital	X	Medicines & other first aid given
10	16.09.2010	Putkhak	Ashiq Hussain S/o Ab. Rehim R/o Putkhak Sex, M	-	Pellet injury (Lt) Buttock & (Lt) Hand	D.H. Baramulla	Referred to SKIMS Srinagar	X	Medicines & other first aid given

11	Do	Do	Umer S/o Suliman Baba R/o Putkhak Sex, M	T.No 0039754	Bullet Injury (Rt) thigh with entry side of thigh & exit Middle side of left.	D.H. Baramulla	Treated and managed in Hospital	X	Medicines & other first aid given
12	Do	Do	Mohd Rafiq Hajam S/o Gh. Ahmad R/o Putkhak Sex, M	MRD 7538	Bullet Injury left thigh	D.H. Baramulla	Treated and managed in Hospital	X	Medicines & other first aid given
13	Do	Baramulla	Farooq Ahmad Dar S/o Mohd Sultan Dar R/o Azad Gunj Baramulla Sex, M	-	Pallets injuries both legs	D.H. Baramulla	Treated and managed in Hospital	X	Medicines & other first aid given

14	18.09.2010	Baramulla	Imtiyaz Ahmad S/o - R/o Old Town Baramulla Sex, M	T.No 0046641	Pellet injuries legs	D.H. Baramulla	Treated and managed in Hospital	X	Medicines & other first aid given
15	18.09.2010	Baramulla	Irfan Ahmad S/o - R/o - Sex, M	T.No 0046616	Pellet injuries arm	D.H. Baramulla	Treated and managed in Hospital	X	Medicines & other first aid given
16	18.09.2010	Baramulla	Farooq Ahmad S/o - R/o - Sex, M	T.No	Pellet injuries	D.H. Baramulla	Treated and managed in Hospital	X	Medicines & other first aid given
17	18.09.2010	Baramulla	Muddasir Ahmad S/o - R/o - Sex, M	T.No 0046648	Pellet injuries legs	D.H. Baramulla	Treated and managed in Hospital	X	Medicines & other first aid given
18	18.09.2010	Baramulla	Shareef Ahmad S/o - R/o - Sex, M	T.No 0046649	Pellet injuries arm	D.H. Baramulla	Treated and managed in Hospital	X	Medicines & other first aid given

19	18.09.2010	Baramulla	Zubair Ahmad S/o R/o Sex, M	T.No 0046650	Pellet injuries	D.H. Baramulla	Treated and managed in Hospital	X	Medicines & other first aid given
20	18.09.2010	Baramulla	Danish Maqbool S/o Mohd Maqbool R/o Jamia Baramulla Sex, M	T.No 0046651 & MRD No 7590	Multiple pellet injuries in chest	D.H. Baramulla	Treated and managed in Hospital	X	Medicines & other first aid given
21	18.09.2010	Baramulla	Ishfaq Ahmad S/o - R/o - Sex, M	T.No 0046652	Pellet injuries legs	D.H. Baramulla	Treated and managed in Hospital	X	Medicines & other first aid given
22	18.09.2010	Baramulla	Sajad Ahmad S/o - R/o - Sex, M	T.No 0046653	Pellet injuries legs	D.H. Baramulla	Treated and managed in Hospital	X	Medicines & other first aid given

23	18.09.2010	Baramulla	Mushtaq Ahmad S/o - R/o - Sex, M	T.No 0046654	Pellet injuries legs	D.H. Baramulla	Treated and managed in Hospital	X	Medicines & other first aid given
24	18.09.2010	Baramulla	Imtiyaz Ahmad S/o - R/o - Sex, M	T.No 0046657	Pellet injuries legs	D.H. Baramulla	Treated and managed in Hospital	X	Medicines & other first aid given
25	18.09.2010	Baramulla	Asif Ahmad Bhat S/o Gh. Mohidin Bhat R/o SyedKarim Baramulla Sex, M	-	Multiple pellets injuries	D.H. Baramulla	Treated and managed in Hospital	X	Medicines & other first aid given
26	18.09.2010	Baramulla	Unknown patient S/o - R/o - Sex, M	-	Pellet injuries on head, eyes & Chest. Eye damaged	D.H. Baramulla	Treated and managed in Hospital	X	Medicines & other first aid given

27	18.09.2010	Baramulla	Unknown patient S/o - R/o - Sex, M	-	Pellet injuries on face and neck	D.H. Baramulla	Treated and managed in Hospital	X	Medicines & other first aid given
28	29.09.2010	Baramulla	Mohd Altaf Panzoo S/o Bashir Ahmad R/o Kakar Hamam Baramulla Sex, M	-	Multiple Pellet injuries on head and chest	D.H. Baramulla	Treated and managed in Hospital	X	Medicines & other first aid given
29	29.09.2010	Baramulla	Mohd Raja S/o Gh. Ahmad Raja R/o Jamia Baramulla Sex, M	-	Multiple Pellet injuries on legs	D.H. Baramulla	Treated and managed in Hospital	X	Medicines & other first aid given

30	8.10.2010	Baramulla	Aqib Ahmad Wani S/o Mohd Ismaiel Wani R/o Baghisiam Sex, M	T.No 0017786	Multiple Pellet injuries in Chest & Rt. Eye	D.H. Baramulla	Treated and managed in Hospital	X	Medicines & other first aid given
31	8.10.2010	Baramulla	Ishafaq Ahmad Kaloo S/o Ab Ahad Kaloo R/o Old Town Baramulla Sex, M	t.No 0017750	Multiple Pellet injuries on Rt. Hand	D.H. Baramulla	Treated and managed in Hospital	X	Medicines & other first aid given
32	13.10.2010	Baramulla	Ashiq Hussain Lone S/o Mohd Akbar Lone R/o Nadihal Sex, M	T.No 0008728 MRD No 8405	Bullet Injury (Rt) Anterior chest ---	D.H. Baramulla	Treated and managed in Hospital	X	X-Ray done Medicines & other first aid given

33	19.10.2010	Baramulla	M. Yousuf Chana S/o Ismaiel Chana R/o Arampora Sex, M	T.No 0004701	Multiple Pellet injuries on legs & abdomen. Deep injury (Rt) leg Patient received in shock	D.H. Baramulla	Referred to Srinagar	X	I/v line given, Blood transfusion given but got pulmanry
34	19.10.2010	Baramulla	Idrees S/o M. Akbar R/o Sangri Colony Baramulla Sex, M	T.No 0004728 MRD No 8622	Rubber Bullet injury on back side (Rt.) thigh & buttock	D.H. Baramulla	Treaed and managed in Hospital	X	Medicines & other first aid given
35	19.10.2010	Baramulla	Rouf Ahmad S/o Nazir Ahmad Bhat R/o Gulnar Park Baramulla Sex, M	T.No 0004729	Multiple Pellet injuries on Rt. Hand & abdomen	D.H. Baramulla	Referred to SKIMS Srinagar	X	Paracentesis addomen done and patient was having intra abdomen

36	10.11.2010	Baramulla	Bilal Ahmad Jan S/o Ab Rashid Jan R/o Zainkadal Srinagar Sex, M	-	Rubber Bullet injury (Rt) thigh Entry- Rt. Side of thigh Exit – No exit lodged inside	D.H. Baramulla	Referred to SKIMS Srinagar	X	I/v line given, Blood transfusion (A+iv) given & patient was resuscitated
37	21.11.2010	Baramulla	Nisar Ahmad Bhat S/o Gh Mohidin Bhat R/o SyedKarim Baramulla Sex, M	11705	Multiple Pellet injury back, thigh & legs	D.H. Baramulla	Treated and managed in Hospital	X	Medicines & other first aid given

38	25.08.2011	Bus Stand Baramulla	Ab. Gani Gogri S/o Mohd Ahsan Gogri R/o Lar Ganaora Rafiabad Sex, M	-	Brought dead. Pellet injuries on Rt. Shoulder & (Lt) chest. Confirmed on X-Ray.	D.H. Baramulla	Brought Dead	X	-
39	25.08.2011	Bus Stand Baramulla	Naresh Kumar S/o Sham Prakash R/o 9th Bn BSF Singpora Sex, M	-	Pellet injury both thighs	D.H. Baramulla	Treated and managed in Hospital	X	Medicines & other first aid given
50	25.08.2011	Bus Stand Baramulla	Haider S/o - R/o H/C 9th Bn BSF Sin gpora Sex, M	-	Multiple Pellet injuries on chest and abdomen	D.H. Baramulla	Treated and managed in Hospital	X	Blood point was transfused. Medicines & other first aid given.

51	25.08.2011	Bus Stand Baramulla	Ab. Hamid Shah S/o GH Nabi Shah R/o Fakirwani Baramulla Sex, M	-	Pellet injury Rt. Arm	D.H. Baramulla	Treated and managed in Hospital	X	Medicines & other first aid given

S. No	Date	Name & Address	Age	Status of Injury	Status Referred/ Admitted
1	09.02.2013	Zahoor Ahmad Sumji S/o Ali Mohd Sumji R/o Doabgah Sopore	30	Injury left arm, fracture Humerus/ F.A.	Treatment given and discharged
2.	09.02.2013	Firdous Ahmad Buhroo S/o Gh. Ahmad Buhroo R/o Vijabai - Doabgah Sopore	25	Injury left Humerus, left side of neck/ F.A.	Required Treatment given and referred to SKIMS Soura Srinagar for further management
3.	09.02.2013	Ifran Ahmad Ganie S/o Manzoor Ahmad Ganie R/o Doabgah Sopore	25	Injury left Leg, (Splinter Injury)	Treated and discharged
4.	09.02.2013	Mushtaq Ahmad S/o Fazal U Din R/o Doabgah Sopore	25	Left leg Injury (Splinter Injury)	Treated and discharged
5.	09.02.2013	Azian Ahmad S/o Fayaz Ahmad R/o Doabgah Sopore	28	Scalp Injury (Splinter Injury)	Treated and discharged
6.	09.02.2013	Bilal Ahmad Gojree S/o Ab. Rehman Goree R/o Azad Gunj Baramulla	35	F.A. Injury Left upper thigh and glutted region	Required Treatment given and referred to SKIMS Soura Srinagar for further management

			F.A. Injury Splinter Injury	Admitted/Treated and discharged	
7.	09.02.2013	Shazir Ahmad Zargar S/o Ab. Qayoom Zargar R/o Chandoosa at present Baramulla	25	F.A. Injury Splinter Injury	Admitted/Treated and discharged
8.	09.02.2013	Ajaz Ahamd Bagwan S/o Mohd Sadiq Bagwan R/o Drangbal Baramulla	25	F.A. Injury Left foot (Devrident and A/S dressing done.	Admitted /Treated and discharged
9.	09.02.2013	Amir Ahmad Wani S/o Fayaz Ahmad Wani R/o Old Town Baramulla	22	Injury face, traumatic mandible (Shell Injury)	Treatment given and advised dental checkup.
10	09.02.2013	Nayeem Ahmad Sheikh S/o Mushtaq Ahmad Sheikh R/o Watergam Rafiabad	25	Compound Fracture right leg/ F.A. Injury	Admitted, dressing long leg cast and discharged
11	09.02.2013	Mohd Asraf Dar S/o Ab. Wahab Dar R/o Khanpora Baramulla	25	Left middle finger/ F.A. Injury (Shell Injury)	Treated and discharged
12	09.02.2013	Yasir Ahmad Bhat S/o Wali Mohd Bhat R/o KanilBagh Baramulla	25	Injury lip	Treated and discharged
13	09.02.2013	Mohd Maqbool Khan S/o Akbar Ali Khan R/o Rafiabad Baramulla	23	Injury on Right Hand	Treated and discharged

14	09.02.2013	Faiasal Ahmad Banday S/o Wasim Ahmad Banday R/o Jamia Mohallah Baramulla	24	Injury on Face	Admitted, Treatment given and discharged
15	09.02.2013	Rizwan Ahmad Parray S/o Gh. Ahmad Parray R/o Larganapora Rafiabad	26	Injury on Left side face.	Treated and discharged
16	09.02.2013	Tufail Ahmad Tantary S/o Ab. Razzaq Tantary R/o Old Town Baramulla	26	Injury on Left hand finger	Treated and discharged
17	10.02.2013	Jameel Ahmad Sofi S/o Gh. Mohd Sofi R/o Jahma	20	Injury on Left Side face. Tear gas Shell	Treated and discharged
18	10.02.2013	Javid Ahmad Gojri S/o Farooq Ahmad Gojri R/o Khanpora Baramulla	18	Trauma Right Eye with tear gas shell perforatly injury right eye	Required Treatment given and referred to SKIMS Soura Srinagar for further management
19	10.02.2013	Irfan Ahmad S/o Gh. Ahmad Shalla R/o Old Town Baramulla	15	Injury on forehead	Treatment given, admitted and discharged
20	10.02.2013	Mehraj Din S/o Gh. Ahmad Bhat R/o Watergam Rafiabad	30	Fire on left thigh, F/A injury left thigh	Admitted, Treated and discharged

21	10.02.2013	Rayees Ahmad Sheikh S/o Bashir Ahmad Sheikh R/o Chogal Handwara	15	Injury bullet Left Glutal region	Admitted, Treated and discharged.
22	10.02.2013	Ubid Ahmad Rather S/o Mushtaq Ahmad Rather R/o Watergam	22	Fire on Abdomen in L.A Right Side Abdomen	Patient Resuscitated blood point started and referred to SKIMS Soura Srinagar for further management.
23	10.02.2013	Sajad ZahoorBhat S/o Zahoor Ahmad Bhat R/o Watergam	30	F/A Injury head with bone shaving	Required Treatment given and referred to SKIMS Soura Srinagar for further management
24	10.02.2013	Athar Ahmad S/o Gh Mohd Rather R/o Rangwar Baramulla	15	Injury on Left side of nose.	Treated and discharged.
25	10.02.2013	Mohd Saleem Dar S/o Fayaz Ahmad Dar R/o Ganie Hamam	13	Face injury stone pelting	Treated and discharged.
26	10.02.2013	Sabeena Mushtaq W/o Mushtaq Ahmad Dar R/o Azad Gunj Baramulla	32	Alleged H/O Trauma Head hit by S.F	Treatment given admitted for observation and discharged.

27	10.02.2013	Gh. Mohd Dar S/o Ab. Rehman Dar R/o Khanpora	65	Injury Left lower eye lid hematoma with multiple injury on forehead.	Treated and discharged.
28	11.02.2013	Bashir Ahmad Dar S/o Ab. Rehman Dar R/o Khanpora	35	Injury left side neck alleged pellet injury	Treatment given and discharged.
29	12.02.2013	Muzamil Qayoom S/o Ab Qayoom Rather R/o Sheeri	17	Injury Left Eye (Pellet injury) vision loss	Required Treatment given and referred to SKIMS Soura Srinagar for further management.
30	12.02.2013	Abid Ahmad Sofi S/o Ab. Rashid Sofi R/o Heewan Sharee	32	Injury left frontal area head rubber bullet	Required Treatment and referred to SKIMS Soura Srinagar for further management.
31	12.02.2013	Arif Ahmad Mir S/o Gh. Qadir Mir R/o Heewan Sharee	20	Injury occipital area head splinter injury	Treatment given and admitted
32	12.02.2013	Sheikh Rashid ul Islam S/o Gh. Mohd Sheikh R/o Heewan Sharee	18	Head trauma splinter injury	Treatment given and admitted.

33	12.02.2013	Tariq Ahmad Wani S/o Nazir Ahmad Wani R/o Zandfaran Sharee	18	Aleged H/o F.A (Splinter Injury with Trauma Head)	Required Treatment and referred to SKIMS Soura Srinagar for further management
34	13.02.2013	Rafiq Ahmad Sofi S/o Gh Ahmad Sofi R/o Syed Karim Baramulla	20	Alleged H/o receiving Bullet trauma scrotum due to rubber bullet	Treatment given and discharged.
35	13.02.2013	Imran Rehman Najar S/o Ab Rehman Najar R/o Old Town Baramulla	21	Injury left lower leg with ankle fractured (Rubber Bullet)	Treatment given and discharged.
36	13.02.2013	Irfan Ahmad Ganie S/o Ab. Aziz Ganie R/o Old Town Baramulla	16	Pellet Injury forehead	Treatment given and discharged.
37	14.02.2013 4:30 pm	Musib Ahmad Lone S/o Gh. Rasool Lone R/o Chotipora Achabal	16	Open globe/ Penetrating injury Rt. Eye on 12/02/2013	Required Treatment and referred to SKIMS Soura Srinagar for further management
38	15.02.2013	Farooq Ahmad Dar S/o Bashir Ahmad Dar R/o Mirgund Pattan Constable Belt No 62 Brought by Mohd Iqbal Belt No 1355 PS Baramulla	32	Trauma Head / Scalp injury (Due to Stone Pelting	Treatment given

39	01.03.2013	Abid S/o Gh Mohd Sheikh R/o Bagh Islam Baramulla	17	Minor Injury, left eye lid, left arm left side chest	Treatment given.
40	01.03.2013	Majid Majeed Mir S/o Ab. Majeed Mir R/o Baramulla	19	Pellet Injury Rt. Eye	Treatment given
41	01.03.2013	Abid Ahmad S/o Ab. Ahmad Gojree R/o Baramulla	20	Pellet Injury left lower leg	Treatment given.
42.	04.03.2013	Asif Gul S/O Gh Mohuidin R/o Old town Baramulla	25	Multiple pellet injury both arms and head	Treatment Given
43	05.03.2013	Sabiya R/o Baramulla	16	Cut injury forehead and Rt. cheek	Treatment Given
44	05.03.2013	Tahir Ahmad Sofi S/O Gh. Rasool Sofi R/o Kakar Hamam Old Town Baramulla	25	F.A Injury Head	Brought Dead
45	05.03.2013	Mohmad Abrar S/O Farooq Ahmad Leloo R/o Old Town Baramulla	15	F.A injury Rt. Foot	Treatment Given

46	05.03.2013	Mudasir Ahmad S/O Bashir Ahmad R/o Old Town Baramulla	20	Minor injury face by tear gas shell	Treatment Given
47	05.03.2013	Ifran Ahmad Dobi S/O Gh Qadir Dobi R/o Noor Bagh Baramulla	22	Alleged H/o Fall from height after chased by Security Forces both wrist both arms Scaphold fracture Lt Wrist. 1. Colles fracture Rt Wrist	Treatment Given
48	05.03.2013	Niem Ahmad S/O Manzoor Ahmad Sheikh R/o Sangree Baramulla	20	Pellet injury left closure eye lid and left hand	Treatment Given
49	06.03.2013	Shahid Ahmad S/O Nazir Ahmad R/o Microwave Kalnibagh Baramulla	22	Alleged H/o being beaten by Security force and trauma head injury	Treatment Given
50	06.03.2013	Zubair Ashraf S/O Mohd Ashraf Malik R/o Khawajabagh Baramulla	20	Trauma Rt leg Pellet injury on 5/03/2013 and reported today on 6/03/2013	Treatment Given
51	07.03.2013	Mohd Sharief S/O Haji Abdul Samad R/o Khawajabagh Baramulla	40	Hit by stone left knee	Treatment Given

52	07.03.2013	Suhail Ahmad S/O Nazir Ahmad Hajam R/o Khawjabagh Baramulla	19	Pellet injury forehead and nose	Treatment Given
53	07.03.2013	Touseef Ahmad Khan S/O Mohd Amin Khan R/o Kakar Hamam Baramulla	-	Pellet injury eye lid and left upper Sdera	Referred to SHMS for Opthalmic consultation
54	07.03.2013	Tasleem Begum W/O Gh Mohi Din R/o Ushkara Baramulla	-	Pellet injury Rt Gluteal region and Rt Medio Lateral Thigh	Treatment Given
55	07.03.2013	Nazir Ahmad Mir S/O Gh Qadir Mir R/o Kanispora Baramulla	75	Injury Eye Perioccupital region due to hit by stone	Treatment Given
56	07.03.2013	Azhan Ashfaq Mir S/O Ashfaq Ahmad Mir R/o Kanispora Baramulla	09	Injury left perital region, hit by stone	Referred to SMHS Srinagar
57	07.03.2013	Musaib Ahmad S/O R/o Baramulla	-	Pellet injury left upper eye lid, vision checked bed side normal	Treatment Given
58	08.03.2013	Ab Majeed Taas S/o Sumandar Taas R/o Kalaroos Kupwara	26	Pellet injury Rt Gluteal Region	Treatment Given

59	08.03.2013	Ram Singh S/O Amar Singh R/o Punjab	18	Pellet injury head	Treatment Given
60	08.03.2013	Manzoor Ahmad S/O Ab. Gaffar R/o Old Town Baramulla	40	Pellet injury forehead	Treatment Given
61.	08.03.2013	Mahbooba W/O Parvaiz Ahmad Dar R/o Fatehpora Baramulla	40	Injury on right arm by stone pelting	Treatment Given
62.	08.03.2013	Habibulah S/O Ab. Gani Mir R/o Phalipora Boniyar	45	Pellet injury neck and chest + Rt Arm	Treatment Given
63.	8/3/2013	Azim Farooq s/O Farooq Ahmad R/O Noor Bagh Baramulla	25	Stone Pelting Injury Arm and abdomen	Treatment Given
64	8/3/2013	Shafkat Ahmad Khan, R/O Baramulla	50	Multiple pellet injury back arm and legs	Treatment Given
65	8/3/2013	Surender Singh, S/O Kashmir Singh R/O Baramulla		Multiple pellet injury back both arms and legs and thigh	Treatment Given
66	9/3/2013	Mohd Jeelani Peer, S/O Gh Mohi ud Din Peer R/O Sopore	59	Pellet injury Rt Eye Brow	Treatment Given

67	9/3/2013	Arif Ahmad Lone, S/O Ab Rehman Lone R/O Old Town Baramulla	17	Pellet injury Rt Arm	Treatment Given
68	18/3/2013	Mohd Ayoub Burhoo, S/O Parvaiz Ahmad Burhoo R/O Syed Karim Baramulla	12	Pellet injury Rt Arm	Treatment Given
69	22/3/2013	Mohd Zubair, S/O Peer Bahudin R/O Baramulla		Multiple Pellet injury face, neck and head	Treatment Given
70	22/3/2013	Abdul Gani Bhat, S/O Ab Razaq Bhat R/O Baramulla	48	Pellet injury Face and Both Legs	Treatment Given
71	22/3/2013	Mushtaq Ahmad Mir, S/O Nabi Mir R/O Baramulla		Pellet injury on body and Face	Treatment Given
72	22/3/2013	Abdul Gani Kanli, S/O Ab Razaq Kanli R/O Baramulla	48	Pellet injury Neck Left Side	Treatment Given
73	27/3/2013	Maqsood Mir, S/O Mohd Fazal Mir R/O Dani Sydan Uri	16	Explosive Injury right thigh and right leg	Admitted and discharged next day
74	29/3/2013	Shakeel Ahmad Lone, S/O Habibullah Lone R/O Kanil Bagh Baramulla	45	Pellet injury Left Eye	Treatment Given
75	29/3/2013	Parvaiz Ahmad Shiek, S/O Gh Mohd Sheikh R/O Tawheed Gunj Baramulla	20	Left Eye Lid Upper Medial Canthus	Treatment Given
76	29/3/2013	Taja Begum, W/O Late Mohd Rajab R/O Khawja Bagh Baramulla	58	Pellet injury Left Side Neck	Treatment Given

77	5/4/2013	Md Shafi, S/O Muhammad Sultan R/O Sopore	35	Pellet injury Rt. Fore Arm and forehead	Treatment Given
78	5/4/2013	Nisar Ahmad, S/O Md Shaban Malik R/O Baramulla	26	Pellet injury left toe	Treatment Given
79	5/4/2013	Mohammad Ashraf, S/O Md Ismaiel Dar R/O Baramulla	30	Pellet injury Scalp	Treatment Given
80	5/4/2013	Hilal Ahmad, S/O Gh Hassan Najar R/O Old Town Baramulla	21	Multiple Pellet injury bilateral leg and left clavick region	Treatment Given
81	5/4/2013	Suhail Ahmad, S/O Saif ud Din Malik R/O Drangbal	18	Pellet injury with Fire Arm	Treatment Given
82	5/4/2013	Moomin, R/O Old Town Baramulla	14	Pellet Injury Scalp	Treatment Given
83	5/4/2013	Umar Showkat, S/O Showkat Ahmad Sheikh R/O Kakar Hamam Baramulla		Pellet injury head right side face and Rt Shoulder	Treatment Given
84	8/4/2013	Sajad Ahmad, S/O Abdul Rashid R/O Old Town Baramulla	20	Pellet Injury Lt. side head	Treatment Given
85	8/4/2013	Nissar Ahmad, S/O Gh Mohd R/O Old Town Baramulla	18	Multiple Pellet injury left side head and nose	Treatment Given

86		Mudasir Ahmad Dar, S/O Abdul Jabbar Sar R/O Umbar Uri	30	Injury Lt. side Nose and Left Eye Brow, bleeding nose	Treatment Given
87		Sheikh Uzair, S/O Gh Mohd Sheikh R/O Sangri Colony Baramulla	18	Pellet Injury Rt. Eye	Treatment Given
88	10/4/2013	Shabir Ahmad Bhat, S/O Abdul Rashid Bhat R/O Anantnag	18	Pellet Injury Open Globe Injury	Treatment Given
89	11/4/2013	Showkat Ahmad, S/O late Md Sultan Lone R/O Azad Gunj Baramulla		Multiple Pellet Injury on Back	Treatment Given
90	11/4/2013	Tanveer Ahmad Pathan, S/O Mehboob ul Pathan R/O Kalayban Sheeri	25	Splinter both Thighs with populated injury with splinter abdomen	Treatment Given
91	11/4/2013	Firdous Ahmad Mir, S/O Muhammad Ramzan Mir R/O Azad Gung Baramulla	30	Splinter Injury Chest both sides with breathlessness	Referred to SMHS Srinagar at 2.15AM

In response to another RTI Application, the Medical Superintendent of District Hospital Baramulla, under No.DHB/538 dated 09-05-2015, reveals that from 15 December 2013 to December 2014, Five (05) patients with pellet injuries were treated in District Hospital Baramulla. Among these five patients 03 (Three) patients had pellet injuries in their left eyes and 01 (One) patient had pellet injury in his right eye. While as the fifth patient was received in the hospital for pellet injuries in his back and all the five patients were referred for advanced medical treatment to major hospitals of Srinagar.

District Hospital Shopian

From August 2010 to 31 December 2014, 179 patients with pellet injuries were admitted/ treated in District Hospital Shopian and 114 pellet injury patients were referred from District Hospital Shopian to major hospitals of the valley for advanced treatment. The total number of pellet injury patients who were received in the District Hospital is 293 (Two hundred and ninety three). This information along with the list of patients was provided, in response to RTI Application, by Medical Superintendent District Hospital, Shopian, under No. MS/DH- Spn/RTI/119-20 dated 20-04-2015.

Sub District Hospital Pampore

35 pellet patients were admitted and treated. (No. BMO/P/Est/958, dated 17-07-2014)

JLNM Hospital, Srinagar

05 patients with pellet injuries were admitted and treated in the Hospital, from 2010 to November 2013. (No. JLNM/H/RTI/PIO/3689-90, dated 20-02-2014)

Public Health Center Sheeri - Baramulla

03 patients with serious pellet injuries were referred from this health center to District Hospital Baramulla for advanced treatment. w.e.f. 2010 to November 2013. (No.Estt/BMOS/RTI/452, dated 30-06-2014)

Sub District Hospital Pattan

49 pellet injury patients reported to the Sub District Hospital Pattan from 2010 to November 2013 (No.BMO/P/470, dated 09-07-2014).

District Hospital Anantnag

O8 pellet injury patients were admitted and treated at District Hospital Anantnag, while as 01 Patient namely Irshad Ahmad Parray was referred to a Major Hospital of Srinagar because of serious pellet injuries. (Information provided by the Medical Superintendent, MMAB Memorial Hospital, Anantnag, in reference to CMO's letter No. EST/IV/Gen/RTI/7128-38, dated 10-12-2013).

Public Health Center, Vehil - Shopian

07 patients with pellet injuries were treated at this health center.(No. CMO-Spn/RTI/14/731-33, dated 16-07-2014)

Public Health Center, Burzahama – Ganderbal

01 patient with severe pellet injury was admitted in PHC Burzahama on 09-12 2012 and was immediately referred to SKIMS, Soura. (NO. ZMO/2/1611, dated 16-12-2013).

Block Medical Officer, Pulwama

15 pellet injury patients were admitted and treated at Pulwama, according to the information received from Block Medical Officer under No.BMO/Pul/Estt/1925, dated 22-12-2013.

Medical Research Articles

Pellet gunfire injuries among agitated mobs in Kashmir

Majid Mushtaque, Mohammad F. Mir,
Muneer Bhat, Fazl Q. Parray, Samina A Khanday,
Rayees A. Dar, Ajaz A. Malik

BACKGROUND

Pellet gunfire injuries inflicted while controlling agitated mobs has been studied.

METHODS

A total of 198 patients admitted to the Accident and Emergency Department with pellet gun injuries were studied in terms of anatomic site, severity and type of injury, treat- ment, and outcomes.

RESULTS

72.7% of patients were aged 16-25 years. The most common sites of injury were the extremities (47.9%), abdomen (36.3%) and chest (31.3%). 59.5% of patients were found to have minor injuries. Of the 80 patients admitted to the hospital for their injuries, 43 (53.7%)

required an operative procedure. Six deaths (3.03%) were observed.

CONCLUSION

While the pellet wound itself may seem trivial, if not appreciated for the potential for tissue disruption and injuries to the head, chest, and abdomen, there can be catastrophic results. Patients should be evaluated and managed in the same way as those sustaining bullet injuries.

An estimated 32,000 injuries attributable to non-powder firearms (i.e., BB gun, pellet gun, and air rifle) occur each year in the United States, most of which are seen in the pediatric population. Many case reports of serious and even fatal non-powder firearm injuries have been published describing ocular, intra-cranial, abdominal, and thoracic wounds, but there is no single data regarding the pattern, severity and outcome of pellet injuries inflicted while controlling agitated crowds in a defined population. A persisting problem is the lack of medical recognition of the severity of injuries that can result from these guns, including penetration of the eye, skin, internal organs, and bone. Injuries associated with non-powder guns should receive prompt medical management similar to that administered for firearm-related injuries.

MATERIALS AND METHODS

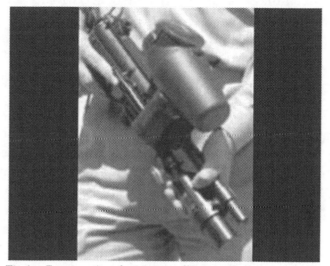

Fig 1. Pump action shotgun or pellet gun used to control agitated mobs

This study was conducted at Sher-I Kashmir Institute of Medical Sciences. The data were obtained during the period of social unrest from June 2010 to September 2010. A total of 634 patients were received in Emergency Reception (ER). Three hundred and twenty-five people sustained firearm injuries (88 bullet injuries, 39 tear gas shell injuries and 198 pellet gunfire injuries), Ninety-eight were injured by stone pelting and another 211 by alleged beating by the security forces. Our study included only those sustaining pellet gunfire injuries. The weapon is a pump action shotgun or pellet gun (Fig. 1), and

its single shot fires numerous pellets that can hit multiple targets at once. Abstraction of information included the following: patient age, gender, anatomic location, severity of injury, diagnostic studies, treatment, and outcome including morbidity and mortality.

Upon arrival to the ER, patients were examined, primarily treated with intravenous (iv) fluids, a dose of anti-tetanus toxin, and prophylactic iv antibiotic. They also underwent the obligatory scans including X-rays [cervical spine, abdominal, pelvic and chest] and focused assessment with sonography in trauma (FAST) ultrasound scan. They were then sent either directly to the operating room, observation/disaster ward, or for additional studies such as non-contrast computed tomography (NCCT), Doppler scan, or extremity X- rays, according to their condition assessment and diagnosis (Figs. 2-6). Patients diagnosed to have minor injuries were discharged within 12 hours.

RESULTS

During the study period of four months, 198 patients were identified as having sustained pellet gun- fire injury. Patients' ages ranged between 6-54 years.

Table 1. Age distribution

Age in years	Number of patients(n)	Percentage (%)
6-10	2	1.01%
11-15	14	7.07%
16-20	85	42.92%
21-25	59	29.79%
26-30	22	11.11%
31-35	6	3.03%
36-40	4	2.02%
41-45	2	1.01%
46-50	3	1.51%
≥51	1	0.50%
Total	198	100%

(Table 1). The highest prevalence of injury was observed in the 16-25 year age group (72.7%). The youngest patient was a six-year-old boy and the oldest was 54 years old, with pellet wounds in the face and abdomen, respectively. There were 192 males and six females. Most patients sustained multiple wounds, with up to 70 small wounds reported in one of them. The most common sites of injury were the extremities (47.9%), abdomen (36.3%) and chest (31.3%). Injuries to any of these sites were associated with a significant number of injuries involving other parts of the body (Table 2).

All patients were thoroughly examined and primarily treated with iv fluids, a dose of anti-tetanus toxin and prophylactic iv antibiotic. Obligatory scans including X-rays, FAST ultrasound scan, and additional studies including NCCT, Doppler scan or extremity X-rays were done according to the site of injury. A

total of 118 (59.5%) patients were found to have minor injuries and were discharged from the emergency department after antiseptic dressing or removal of the foreign bodies. Of the remaining 80 (40.4%) patients admitted to the hospital for their injuries, 43 (53.7%) required an operative procedure. The viscera damaged/injured site and the surgical procedures done are shown in Table 3. The most common sites of injuries requiring either hospitalization or operative intervention were the abdomen, chest and eyes. Operative procedures included exploratory laparotomy (20), intercostal chest tube (ICCT) drainage (9), thoracotomy (2), vascular repair/grafting (3), ophthalmic procedures (7), and exploration of neck wounds (2).

At exploratory laparotomy, the findings included isolated small gut perforations in four patients. Small gut perforation(s) were associated with large gut perforation(s) in two patients, retroperitoneal hematoma in two patients, and mesenteric hematoma, urinary bladder perforation, liver laceration, and splenic hilar injury in one patient each. Two patients had isolated colonic perforations, while another two had isolated mesenteric hematoma and gastric perforation, respectively. The operative procedures for small gut injuries included primary closure/ repair in seven, resection anastomosis in four, and ileostomy in one patient. Large gut perforations were managed with repair in two, colostomy in one, and resection anastomosis in one patient. Two patients with mesenteric laceration were treated by repair in one and resection anastomosis in another. Splenic hilar injury seen in one of the patients was treated by

splenectomy. Gastric perforations and liver laceration present in one each of the patients were managed by primary repair, while the urinary bladder injury was treated by primary repair with suprapubic cystostomy (SPC). No retroperitoneal hematoma was explored in our series. Four patients in our study had a negative laparotomy. One of these patients had postoperative fecal drainage via the pelvic drain on the 2nd day. Reexploration revealed a perforation in the posterior wall of the rectum above the peritoneal refection, which was managed with closure and proximal diversion colostomy.

Eleven patients were treated with ICCT drainage for hemothorax/pneumothorax/ hemo-pneumothorax, of which two required thoracotomy for their persistent drainage.

Seven of 11 patients with injuries to the eyes required operative intervention. A total of five patients were blinded in the involved eye. One patient had pellet injuries in both eyes, rendering him completely blind.

Three patients required vascular repair of femoral or popliteal vessels, and another two were subjected to exploration of neck hematoma revealing injury to the trachea and one of the carotids.

Mortality occurred in six patients (3.03%). Five of these patients died either in the emergency OT or in the immediate postoperative period. One died of sepsis on the 7th day. Wound infection was seen in eight of the operated patients (18.6%). Two patients had adhesion obstruction that was managed conservatively.

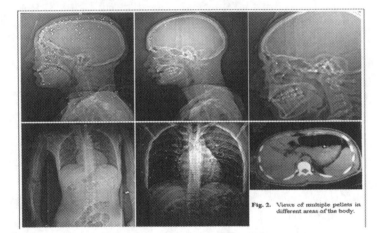

Fig. 2. Views of multiple pellets in different areas of the body.

Table 2. Anatomical site of injuries

Site of injury	Number of patients		Total
	Isolated to the site (single or multiple wounds)	Associated with injury to other sites	
Head and neck	31	11	42
Face and eyes	21	2	23
Chest	35	27	62
Abdomen	38	34	72
Extremities	72	23	95

DISCUSSION

A number of firearms have been used to disperse/ control violent mobs in Kashmir over the last 20 years. These include conventional bullets, rubber bullets, and tear gas shells. Pellet firearms have been introduced as the latest modality for crowd control, assuming to have lower mortality. There are two injury patterns that result from pellets: minor, requiring local care in the emergency department with subsequent discharge, and serious, requiring admission to the hospital and frequently operative intervention. Serious injuries occasionally cause long-term functional deficit. Non-powder firearms can generate muzzle velocities of 200 to 900 foot-pounds per second; skin penetration requires only 120 foot-pounds per second, while ocular penetration can occur at velocities as low as 130 ft/ second. Fortunately, the majority of these injuries are minor (59.5% in this series).

There is a potential for serious injury, which mandates that all non-powder firearm wounds be thoroughly evaluated to avoid missing underlying severe injury. This should include localization of the foreign body, if present, in three dimensions using imaging techniques (typically roentgenograms), determination of the trajectory to postulate the potential organs injured, and assessment of the need for operative intervention. Wounds determined to be minor should receive local wound care (irrigation, removal of foreign body if superficial), and tetanus prophylaxis. Antibiotics are not required routinely, but their use should be at the discretion of the treating physician. Antibiotics are typically reserved

for patients with additional risk factors for wound infection (i.e., tissue devitalization, delay in treatment, or gross contamination). All the patients in our series received prophylactic antibiotics, as most of them had contamination. Patients with potentially serious wounds should be admitted for observation, and if indicated, operative intervention.

In our series, the extremities were the most common site involved (47.9%), and only three patients required admission and operative intervention for vascular injuries. The majority of the extremity wounds required only local wound care, careful neurovascular evaluation, and tetanus prophylaxis. This is in accordance with the consequences of non-powder firearm injuries reported previously.

Abdominal injury occurred in 72 patients, of whom 20 (27.7%) required laparotomy for signs of peritonitis and/or hemoperitoneum. The small gut was the most common viscera injured. Four patients had a negative laparotomy. One of these patients had postoperative fecal drainage requiring re-exploration. We stress the importance of a thorough inspection of all the abdominal viscera in patients sustaining pellet wounds to the abdomen, as small perforations may be missed easily and present with complications. Bond et al. also described in their study that abdominal wounds were frequently associated with visceral injury and multiple perforations, usually of the small bowel, and peritoneal penetration was associated with a more than 80% chance of visceral injury.

Table 3. Showing various viscera damaged and surgical procedure done

Viscera damaged/Injured site	Number of patients	Surgical procedure
Small gut perforation	11	Repair in 7, resection anastamosis in 4, and ileostomy in 1 patient.
Large gut perforation	4	Repair in 2, colostomy in 1 and resection anastamosis in 1 patient
Mesenteric laceration	2	Repair in 1 and resection-anastamosis in 1 patient
Splenic hilar injury	1	Splenectomy
Urinary bladder laceration	1	Repair with SPC
Gastric perforation	1	Primary repair
Liver laceration	1	Primary repair
Negative laparotomy	4	Missed rectal perforation
Re-exploration	1	ICCT drainage only in 9,
Thoracic wounds	11	and thoracotomy in 2 patients
Vascular injuries in extremities	3	End to end anastamosis in 2 and vascular grafting in 1 patient
Ophthalmic procedures	7	
Neck wounds	2	Carotid a repair in 1, and tracheal repair in 1 patient

Thoracic injury occurred in 62 (31.3%) patients, of whom operative intervention was required in 11 (17.7%). Most of these patients were managed with ICCT drainage, while two required a thoracotomy for persistent drainage. No patient in our series had cardiac injury, which could be rapidly fatal. The potential lethal nature of these wounds is reported by Scribano et al., who evidenced a child sustaining right ventricular penetration and presenting with pericardial tamponade. Others reported similar experiences including cardiac penetration with pellet embolization and aortic penetration with delayed cardiac arrest and death.

Although 42 (21.2%) patients in our study had pellet wounds in the head and neck region, only two (4.7%) required operative intervention. None of the patients had intracranial penetration of the pellet, which is also a possibility, with its attendant risk of morbidity and mortality. Ocular and facial injuries, in contrast, occur less frequently, but were seen in 23 (11.6%) patients. Eleven of these patients had penetrating ocular injury, seven required operative intervention, and six (54.5%) had residual functional deficits. This is in accordance with the consequences of non-powder firearm ocular injuries reported previously.

Deaths attributable to non-powder firearms have been reported in previous case reports. Most of these studies have been done in the pediatric population and are the result of unintentional/sports-related non-powder firearms injuries. The lethal potential of these wounds is difficult to quantify due to the paucity of large reported series; however, this should

not diminish the concern in the evaluation of these patients. There were six deaths in this series. Pellet gun (pump action short gun), though considered as a new benign modality (non-lethal weapon) for controlling agitated crowds, is not really benign. It can cause serious injuries with morbidity and mortality.

Pellet guns either should not be used to disperse agitated mobs unless extremely necessary or the personnel using them might be better trained so that the people do not receive close hits. While the pellet wound itself may seem trivial, if not appreciated for the potential for tissue disruption and injuries to the head, chest, and abdomen, there can be catastrophic results. Patients should be evaluated and managed in the same way as those sustaining bullet injuries.

This study was conducted by the doctors, **Majid Mushtaque, Mohammad F. Mir, Muneer Bhat, Fazl Q.Parray, Samina A Khanday, Rayees A. Dar, Ajaz A. Malik** of Department of General Surgery, Radiodiagnosis & Imaging and Hospital Administration at SKIMS Srinagar, Kashmir and was published in Turkish Journal of Trauma & Emergency Surgery.

Pattern of ocular injuries in stone pelters in Kashmir valley

Shabana Khan, Akifa Maqbool, Nowsheen Abdullah, Manzoor Q. Keng

Abstract

Purpose: To describe the pattern and types of ocular injuries in stone pelters in Kashmir valley during recent turmoil. Design: Cross sectional study.

Methods: Sixty patients with different types of eye injuries were assessed between June–September 2010 and initial visual acuity was recorded. The injuries were classified according to Systems for Classifying Ocular Injuries (OTCS) and Ocular Trauma Score (OTS) was calculated in order to estimate the probability of follow-up visual acuity range.

Results: Most of the victims (75%) were young boys between 16–26 years with a mean age of 20.95, 95% of cases were males. The main cause of injury was stones (48.3%) and pellets (30%) besides rubber bullets, sling shots and tear gas shells.

Most of the open-globe injuries due to stones were of Type B and A, Grade E, Zone II and III with Afferent Pupillary Defect (APD) in 30% of the cases. Closed-globe injuries were mostly of Type A, Grade C and D and Zone II and III.

Most of the open-globe injuries due to pellets were of Type D, Grade D, Zone II and APD in 33.3%. Pellets Intra Ocular Foreign Body (IOFB) was in 41.6%. Most of the closed-globe injuries were of Type A, Grade D and E and of Zone III.

Overall OTS of 1 was calculated in 16.6% and 3 in 53.3% of the cases.

Conclusion: In stone pelting demonstrations eye injuries can result in visually significant trauma. Injuries due to pellets are mostly perforating and pellet IOFB, and both tend to have a very poor prognosis. OTS can be used to estimate visual prognosis.

Introduction

Ocular injuries pose a significant global health problem. It has been recognized that ocular trauma is a leading cause of mono ocular blindness. Annual incidence of ocular trauma is 55 million, of which 750,000 require hospitalization, including some 200,000 open globe injuries. 1 The pattern of ocular injuries varies from area to area depending upon the activities of people residing in a particular area.

Kashmir valley has been hit by a violent upsurge of civil un-rest for the last four months which has resulted in death of more than 110 people and injured more than 200 civilians and there has been a significant rise in the frequency of eye injuries as well due to the present turmoil, causing concern to Ophthalmologists

The Ophthalmology Dept. of Govt. Medical College Srinagar, which is the apex centre of Ophthalmology

in the valley has received many patients with eye injuries during this per-iod, a large number of which have been caused by stones and pellet guns. We report the pattern of eye injuries in 60 cases, who were referred to our Department of Ophthalmology, Govt. Medical College Srinagar, between 11th June 2010 to September 2010.

Patients and methods

60 patients who received different types of eye injuries were assessed and admitted in the hospital and managed accordingly. Patients were assessed and initial visual acuity was recorded. Injuries were classified according to BETT and Systems for classifying ocular Injuries. Ocular Trauma Score (OTS) was calculated in order to estimate the probability of follow up visual acuity range. We present the causes, pattern of eye injuries, initial visual acuity and the Ocular Trauma Score (OTS)

The study strictly adhered to the tenets of the Declaration of Helsinki for medical research involving human subjects, including research on identifiable human material and data.

Results

Age distribution

Most of the victims, 75%, were young boys of school and college going age (16–26 years), who were

pelting stones at security forces and got injured. Some of them were involved accidentally while going to and coming back from schools. The mean age was 20.95 years (Table 1).

Sex distribution

Overwhelming majority of the victims were males, there were only three females who got injured accidentally (Table 2).

Causes of injury

Majority of injuries were caused by stone pelting (48.33%). Next common cause was due to pellets fired from pellet guns (30%). There were 5 cases due to rubber bullets, 6 cases due to marbles fired from slings and from gas shells (Table 3).

Initial visual acuity and ocular trauma score (OTS)

The initial visual acuity was found to be between LP to HM in majority of about 43.3%, followed by 1/200 to 19/200 in 26.6%. NLP was found in 18.3% and P20/40 in only 6.6% of cases (Table 4).

OTS score was calculated. Most of the patients, 53.3% had OTS of 3, followed by OTS of 2 in 18.3%, followed by OTS of 1 in 16.6%. OTS score of 4 was found in 1.6% of cases and OTS of 5 in about 10% of cases (Table 5)

Table 1. Age distribution.

	5-15 years	16-26 years	27 years and above
Number of cases	6 (10%)	45 (75%)	9 (15%)

Table 2. Sex distribution

Gender	Number	Percentage
Males	57	95
Females	3	5

Table 3. Causes of injury.

	Stones	Pellets	Rubber bullets	Sling shots (marbles)	Tear gas
No. of cases	29 (48.33%)	18 (30%)	5 (8.33%)	6 (10%)	2 (3.33%)

Table 4. Initial visual acuity.

NLP	11	18.33%
LP to HM	26	43.33%
1/200 to 19/200	16	26.66%
20/200 to 20/50	3	5%
P20/40	4	6.66%

Table 5. Ocular trauma score.

OTS	No. of patients	Percentage
1	10	16.66
2	11	18.33
3	32	53.33
4	1	1.66
5	6	10

Table 6. Classification of injuries.

	Stones	Pellets	Slings	Rubber bullets	Tear gas	Total
Open globe	10	12	-	2	-	24 (40%)
Closed globe	19	6	6	3	2	36 (60%)

Pattern of ocular injuries in stone pelters in Kashmir valley

Table 7. Open globe injuries.

Open globe injuries	Due to stones		Due to pellets		Due to rubber bullets	
	Number	Percent	Number	Percent	Number	Percent
Type of injury						
A. Rupture	4	40	3	25	–	–
B. Penetrating	5	50	3	25	–	–
C. Intraocular Foreign Body	0	0	5	41.6	–	–
D. Perforating	0	0	6	50	–	–
E. Combined	1	10	–	–	2	100
Grade of injury (Visual acuity)						
A. P 20/40	0	0	–	–	–	–
B. 20/50–20/100	1	10	–	–	–	–
C. 19/100–5/200	2	20	3	25	–	–
D. 4/200–LP	2	20	7	58.3	–	–
E. NLP	5	50	2	16.7	2	100
Zone of injury						
I. Cornea	2	20	4	33.4	–	–
II. Limbus to 5 mm posterior into sclera	4	40	5	41.6	1	50
III. Posterior to 5 mm from Limbus	4	40	3	25	1	50
Relative afferent pupillary defect						
Abs.	3	30	4	33.4	2	100
Rve.	7	70	8	66.6	–	–

Classification of injuries

Most of the injuries i.e. 60% were of closed globe type and 40% were of open globe injuries. Stones were the leading cause of injury in closed globe type (52.7%), while pellets were the leading cause of open globe injuries (50%) (Table 6).

Most of the Open Globe Injuries due to stones were of Type B (50%) and Type A (40%), Grade E (50%), Zones II & III (40%), each with APD in 30% of the cases. Most of the Open Globe Injuries due to pellets were of Type D (50%), Grade D (58%), Zone II (42%) and APD in 33.3%. 41.6% of the cases were of pellet Intra Ocular Foreign Body (IOFB). Open Globe injuries due to rubber bullets were of Type E – 100%, Grade E – 100%, and Zones II and III – 50% each and APD present in all cases (Table 7). An X-Ray (Fig. 1) and a CT Scan (Fig. 2) show Intra Ocular Pellets.

Most of the Closed Globe injuries due to Stones were of Type A (79%), Grade C & D (42%) and Zone III (58%) with APD present in 10% of cases. Most of the Closed Globe injuries due to Pellets were of Type A (83%), Grade D (33%), and Zone III (50%) with APD present in 16.6% of cases. The Closed Globe injuries due to rubber bullets were of Type A – 100%, Grade D – 66.6%, and Zones III – 100% and APD present in 33.3% cases. Both Sling shots and Tear Gas caused closed globe injuries with most of them being Type A, Grade D, Zone III (Table 8).

Table 8. Closed globe injuries.

Closed globe injuries	Due to stones		Due to pellets		Due to rubber bullets	
	Number	Percent	Number	Percent	Number	Percent
Type of injury						
A. Contusion	15	78.94	5	83.3	3	100
B. Lamellar laceration	1	5.26	–	–	–	–
C. Superficial foreign body	0	0	–	–	–	–
D. Mixed	3	15.78	1	16.7	–	–
Grade of injury (Visual acuity)						
A. P 20/40	3	15.78	1	16.6	–	–
B. 20/50–20/100	0	0	1	16.6	–	–
C. 19/100 – 5/200	8	42.1	1	16.6	1	33.3
D. 4/200 – L P	8	42.1	2	33.4	2	66.7
E. NLP	0	0	1	16.6	–	–
Zone of injury						
I. External	3	15.78	1	16.6	–	–
II. Anterior Segment	5	26.31	2	33.4	–	–
III. Posterior Segment	11	57.89	3	50	3	100
Relative afferent pupillary defect						
Absent	2	10.52	1	16.6	1	33.3
Present	17	89.47	5	83.4	2	66.7

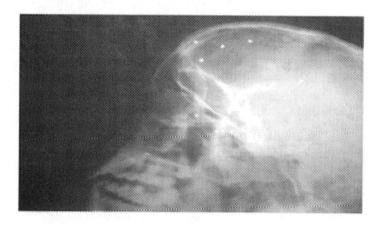

Figure 1. X-ray showing Intra ocular pellets.

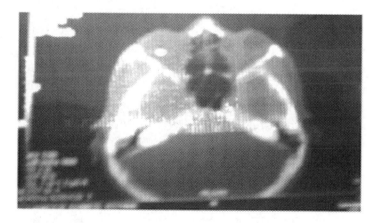

Figure 2. CT Scan showing Intra Ocular pellets.

Discussion

The causes of ocular trauma have changed continuously over the course of this century. Almost 100 years ago more than 70% of all serious injuries occurred in work places. 7 With heavy industry and no knowledge of protective devices, industrial accidents were common. In Kashmir there being hardly any heavy industries, the causes of eye injury are entirely different. 8 Kashmir valley has witnessed an unprecedented increase in violent demonstrations in the summer of 2010. The eye injuries resulting from violence are increasing in both civilians and wartime settings in recent years. 9,10 There were 60 patients who sustained eye injuries. Most of the patients (75%) were young adults between the ages of 16–26 years. The eye injury has been mostly reported in young adults in many studies.

The age distribution in the present study is seen mostly in young adults as is expected, as the stone pelting has been seen to involve young adults in the present turmoil. Over-whelming majority of the patients were males (95%) versus females (5%) as is expected, the stone pelters are only males. The three female patients who suffered eye injury were involved accidentally. This is consistent with previously reported series of ocular trauma.

Majority of the patients who suffered eye injury had the trauma due to stone pelting (48.33%). Stone pelting has gained importance in recent turmoil as the agitators were using only stones as a form of weapon as against guns which were in use some years back. This pattern of stone pelting is similar to that in the

study reported by Elder in Palestine. 14 The other causes of eye injury were due to Pellets (30%), rubber bullets (8.33%) and sling shots (10%)

In our study the most common cause of injuries was stones (%) which were mostly Closed Globe involving higher zones and are more likely to result in visually significant trauma 14 and most of the Open Globe Injuries were also posterior, thus portending a worse outcome. 14 Next common cause of injuries was pellets which caused mostly perforating injuries and pellet IOFB, and both tend to have a very poor prognosis. 14 All other injuries due to pellets, rubber bullets, tear gas shells and marbles were mostly closed globe injuries involving higher zones. The paramilitary force and the police use Rubber Bullets to control the violent mob. However, rubber bullets can cause severe dam-age to the victims. There have been few deaths also due to rubber bullets.

OTS was found to be three in majority which translates into final VA of >20/40 in only 44% patients and in-fact we even had patients with an OTS score of 1 in about 16% patients which translates to a final visual acuity of >20/40 in only 1%. This indicates that most of the injuries sustained by people during the turmoil were significantly visually disabling.

Conclusion

During any public demonstration, even with supposedly harmless forms of protests like stone pelting, eye injuries can result in visually significant trauma. Injuries due to pellets are mostly perforating

and pellet IOFB, and both tend to have a very poor prognosis. OTS can be used to esti-mate the visual prognosis.

Controlling violent mobs is a risky job, while it may restrict violence to some extent, at the same time it can cause serious damage to vital organs.

Given the seriousness of the damages caused by the methods used during such demonstrations, use of less lethal weapons by both mobs as well as combating forces, becomes imperative.

This study was conducted by the doctors, **Shabana Khan, Akifa Maqbool, Nowsheen Abdullah, Manzoor Q. Keng** of Department of Ophthalmology Government Medical College, Srinagar, Jammu and Kashmir. The study can be accessed online at: www.saudiophthaljournal.com and www.sciencedirect.com

Pattern, presentation and management of vascular injuries due to pellets and rubber bullets in a conflict zone

Mohd L Wani, Ab G Ahangar, Farooq A Ganie, Shadab N Wani, Gh Nabi Lone, Ab M Dar, Mohd Akbar Bhat, and Shyam Singh

INTRODUCTION

Historically, most patients who sustained serious arterial injury did not survive long enough to reach medical care providers. Those who did reach generally had minor wounds. With advancement in health care systems, and urbanization of the population, many seriously injured patients now arrive at hospitals. Even those with very serious vascular injuries (e.g., carotid vascular injury) may be salvaged.

The usual surgical approach to a major vascular injury was simply ligation of the vessel and amputation of the limb, e.g. during the American civil war popliteal artery injury resulted in a 100% amputation rate. In World War II, repair lowered the rate to 72%. During the Korean War, a policy of mandatory surgical exploration of all potential vascular injuries lowered the amputation rate to 32% for popliteal injuries. A policy of performing arteriography on all suspected vascular injuries combined with evolving vascular

repair techniques, during the Vietnam War, reduced the amputation rate of these injuries to 15%. With current diagnostic and vascular repair techniques, almost all of these injuries can be revascularized, although severely mangled limb may still need amputation. With an epidemic of vascular injury due to numerous causes (including Missile vascular injuries), this institute has got a vast experience in revascularizing such patients.

Non-lethal weapons used for dispersing the agitated mob during street protests are not supposed to cause lethal vascular injuries. However, during civilian unrest in 2010 in the Kashmir valley, these non-lethal weapons caused serious vascular injuries. These weapons were used to disperse the unruly mobs in street protests during this period. The present study was undertaken to analyze the pattern and presentation of these injuries.

PATIENTS AND METHODS

This was a prospective study of patients from 1st June 2010 to 30th November 2010. All patients with features of vascular injuries due to pellets and rubber bullets were included in this study. On arrival, patients were attended in the Accident and Emergency Department and were resuscitated as per the vital status of the patient. Initial resuscitation was started by basic A, B, C, (airway, breathing and circulation). Pressure bandaging and clamping of vessels by bulldog clamp was done to achieve control over bleeding vessel in case of obvious vascular injury. I/V fluids,

e.g., crystalloids, colloids and blood transfusion after cross-matching through two wide bore cannulae at the available sites were given as per patient requirements. Urinary catheterization was performed in every patient. Associated injuries were addressed by the respective colleagues. Patients with vascular injuries were categorized into two categories depending on the clinical status.

Category 1 (Hard signs)

These include pain, pallor, pulselessness, parasthesias, paralysis, pulsatile bleeding and large or expanding hematoma. A patient who shows these signs will have a > 90% chance of vascular injury.

Category 2 (Soft signs)

These include a relatively diminished but palpable pulse, a non-expanding hematoma and peripheral nerve injury. Thirty percent to 35% of these patients will have vascular injury.

Patients in whom vascular injury was obvious and those who were hemodynamically unstable were directly transferred to the emergency theater and explored. Others were investigated by vascular Color Doppler before exploration. All patients received preoperative antibiotic, a combination of third-generation cephalosporin and an aminoglycoside. We used these antibiotics because there was improper asepsis and contamination at the site of injury. All associated fractures (when associated) were fixed in the same

sitting. The various surgical procedures performed were:

1. End to end repair (after debridement of the ends)
2. Use of reverse saphenous venous graft (segmental loss of > 2 cm)
3. Lateral repair (in case of lateral tear only).

All vessels were repaired by using continuous monofilament 6/0 prolene sutures. Venous graft whenever needed was taken from the saphenous vein of a non-injured limb. No temporary shunting was used. Fasciotomy was done as and when needed to relieve either existing compression or to avoid this from occurring in the post-operative period. Nerve injuries were assessed for immediate or delayed repair. Proper debridement of muscle tendon units was done and the repaired vessel was covered by a viable soft tissue cover in all settings. All patients received heparin intraoperatively. Heparin was continued in the post-operative period, which was followed by antiplatelet therapy. Venous injuries whenever identified were repaired after initial arterial repair. Patients were transferred to the Surgical Intensive Care Unit or the Postoperative Ward, where strict monitoring of vital signs was performed. On the second post-operative day, patients who made good progress were transferred to the main ward. All patients underwent Doppler studies before discharge. All patients were regularly followed-up in the outpatient department on a weekly basis for the first month, fortnightly for the next 3 months and 3-monthly thereafter.

The following were excluded from the study:

1. Patients with vascular injury other than that caused by pellets and rubber bullets
2. Vascular injury below the radial/ulnar and tibial arteries.

Finally, the entire data set was compiled and analyzed statistically.

RESULTS

A total of 35 patients were enrolled in this study. All of them were males. The mean age was 22 years. Popliteal artery was the most common vessel, followed by femoral artery [Table 1]. Sixty percent of the patients presented within 6 h of injury, while 40% presented after 6 h of injury. Contusion was the most common type of injury, followed by transaction. Lateral tear was present in three patients, one of whom had a carotid artery injury. Associated injuries were present in 57% of the patients [Table 2]. Long bone fractures were present in 40% of the patients. Reverse saphenous vein graft was performed in 54% of the patients. Fifteen patients underwent end to end anastomosis. Lateral repair was performed in one patient. He had a carotid artery injury. Venous injury was present in 11 patients. Nerve injury was identified in 11 patients. Wound infection was the most common complication, followed by graft occlusion (thrombosis). Wound infection occurred in 40% of the patients. Three patients developed graft occlusion. They were

re-explored and thrombo-embolectomy was done. One of them ultimately ended up in amputation. The type of procedure (whether primary anastomosis or vein graft) did not influence the amputation rate. Amputation rate was 6%. The amputation rate was significantly higher in patients with long bone fractures and in those who reached the hospital after more than 6 h [Tables [Tables33 and and.

Table 1

Distribution of arteries involved

Artery involved	No. of patients	Percentage
Popliteal artery	16	46
Brachial artery	4	11
Femoral artery	9	26
Tibial artery	3	9
Radial/ulnar artery	2	6
Carotid artery	1	3

Table 2

Associated injuries

Associated injury	No. of patients	Percentage
Abdominal injury	2	6
Chest injury	2	6
Venous injury	11	32
Nerve injury	11	32
Long bone fractures	14	40

Table 3

Outcome as per timing of repair

Time of repair	No. of cases	Amputations	Deaths	No. of limbs salvaged (%)	P value
<6 h	21	0	0	100	0.074
>6 h	14	2	2	85	

ONE DEATH WAS DUE TO CAROTID ARTERY INJURY AND ANOTHER HAD POPLITEAL ARTERY BLOW OUT

Table 4

Effect of associated fracture on outcome of limb salvage

	No. of limbs injured	Amputations	No. of limbs salvaged (%)	P value
With fractures	14	2	85	0.081
Without fractures	20	0	100	
Total	34	2	94	

CAROTID ARTERY INJURIES WERE EXCLUDED FROM THE ABOVE DATA AS THEIR INJURY DOES NOT POSE A THREAT TO LIMB SURVIVAL. OUR LIMB SALVAGE RATE WAS 94%, AS SHOWN IN THE ABOVE TABLE

DISCUSSION

The study was performed keeping in view the civil war-like situation of Kashmir valley, in which there has been a steep rise in usage of rubber bullets and pellet guns. This study was undertaken to evaluate the pattern, presentation, management and outcome of these injuries in our hospital, the Sheri-Kashmir Institute of Medical Sciences Srinagar, the only tertiary care centre in the whole state of Jammu and Kashmir for management of such injuries. Keeping in mind the nature and severity of these injuries, that not only can they disable but also kill a patient if not treated immediately, the study was performed

to analyze the management profile of these injuries. All patients were young males involved in these street protests. Popliteal artery was the most commonly affected vessel, followed by the femoral artery. The distribution of arterial injury in our series was comparable to that in other series. These series also had an almost similar arterial distribution.

Contusion was the most common type of injury, followed by transaction. This was probably because of the low velocity impact of the pellet and rubber bullet. Others had similar results in their series. However, all these types of comparisons depend upon the mechanism of trauma, whether it was high velocity or low velocity trauma. In our series, most of the patients were injured by low velocity trauma.

Most patients were diagnosed by careful clinical assessment. In doubtful cases, pre-operative vascular Colour Doppler studies aided the diagnosis. Doppler study is easy and quick to perform in doubtful cases without much delay in treatment. We did not perform angiography because of its invasiveness and time consuming process; its use in this type vascular injury is limited as first-line investigation. However, it is a useful tool for the diagnosis of delayed vascular injuries (missed injuries). Facility of on-table angiography is not available in our setup. In most of the series, careful clinical assessment was the most common method of diagnosis. Patients with vascular injury were most often treated with reverse saphenous venous graft or end to end anastomosis. We performed end to end anostomosis only in those patients where the two ends could be approximated easily after proper mobilization and debridement of the two ends. End to end anastomosis

was fashioned in 42% of the patients while vein graft was used in 54% of the patients. With advanced techniques of vascular repairs and understanding the pathophysiology of vascular injuries, end to end anastomosis is the preferred treatment provided conditions are favourable. However, it is customary not to perform anastomosis under tension, and the saphenous venous graft must be used to bridge any segmental loss.

Associated skeletal trauma presents a challenge to the surgeon because skeletal trauma increases the morbidity rate such as amputations or even mortality. Injury caused by high velocity trauma is usually associated with soft tissue loss, damage to the collateral circulation and venous injuries as well. Longer surgery as well as excessive manipulation of tissue due to fixation of bony fragments adversely affects the outcome. During bony stabilization, due respect should be given to the surrounding tissue and the cold ischemia time should be calculated accordingly. In our series, associated fractures have a significant impact on limb salvage. Those without fractures had limb salvage of 100% versus 85% of those with fractures. Associated skeletal trauma, particularly femur and tibial fractures, were major causes of morbidity in our series. We made fixation of fracture mandatory in the same sitting. Any vascular injury with concomitant skeletal trauma should be considered as a very high risk for limb loss and hence should be dealt with very meticulously and carefully, especially in those with associated spinal injuries such as cord compression, contusion or laceration. Internal fixation was done in four patients while external fixation was done in the remaining of the 10 patients.

There were 11 patients having associated venous injuries (32%). Venous injuries are mostly diagnosed on exploration of the wound. Venous injury should be repaired unless the situation demands otherwise. Ligation works on the principle of collateral channels, but, when in doubt, every attempt should be made to restore the continuity of the vessel. Our series had 32% associated venous injuries correlating very well with reports of other centers. We always ensured repair of any major vein, as ligation alone would jeopardize arterial perfusion because of Compartment syndrome.

Nerve injury was an associated injury in 11 patients. Seven of them were repaired primarily. Nerve repair was done using 8/0 prolene by a plastic surgeon. In the remainder of the patients, the cut ends of the nerves were identified and tagged with prolene and approximated as much as possible to avoid retraction and for later identification of the nerve. Our results were comparable to those of other series.

Vascular injuries were defined as early or late depending on whether they presented before or after 6 h post injury, resulting in a delay in revascularization from the time of trauma. This is the cold ischemia time, which is important with regard to the viability of the tissue, thrombus formation and distal patency of the vessel. Also, it indirectly affects the hemodynamic stability of the patients. In our study, 14 patients (40%) had a time lag of > 6 h and 21 patients (60%) were revascularized within 6 h or less. This is a reflection of early transportation and efficient management with increasing facilities and technology. In cases where blood flow was re-established within 6 h, 100% of the limbs were salvaged, while only 86% of the limbs

could be salvaged in case of delay of > 6 h. Vascular repair should be attempted in every case, whether early or late. With meticulous repair, proper use of fasciotomies and proper wound care, the results may be satisfactory. Of course, proximal and distal thromo-embolectomy are a necessity, and more so is clearly defining the injured sites of these vessels by deskeletonizing the proximal and distal stumps or the site of lateral trauma before any repair is attempted.

Of the 34 limbs injured in this series, 32 were salvaged (94%), which is comparable to the results of other series.

CONCLUSION

Early intervention and prompt resuscitation should be done. No time should be wasted for time consuming investigations. Associated trauma to bones, lag time > 6 h and hemodynamic instability should be considered high risk factors among vascular injuries. The technique of reconstruction, whether primary anastomosis or saphenous vein graft, should be meticulous and fastidious, without any amount of tension on the anastomosis site. Tissue coverage of anastomosis by muscle, rotation flap, etc., prophylactic

fasciotomy when indicated and good post-operative care are keys to success.

This study was conducted by **Mohd L Wani, Ab G Ahangar, Farooq A Ganie, Shadab N Wani, Gh Nabi Lone, Ab M Dar, Mohd Akbar Bhat, and Shyam Singh** the doctors of Department of Cardiovascular and Thoracic Surgery, SKIMS Soura, Srinagar, Jammu & Kashmir and was published in Journal of Emergencies, Trauma, and Shock.

Pellet Gun Fire Injuries in Kashmir Valley – Cause of Ocular Morbidity

Wasim Rashid, Nusrat Shaheen, Imtiyaz A. Lone, Sheikh Sajjad

ABSTRACT: OBJECTIVE: To study the type and severity of ocular injuries in gun pellet victims.

METHODOLOGY: It was a retrospective case series. The study was conducted in the department of Ophthalmology, SKIMC Medical College Bemina Srinagar. The study included gun pellet victims admitted in our department between January 2010 to September 2013. RESULTS: Total number of patients were 20 with 19 males and 1 female. Mean age of the subjects was 21.45 years. Ocular injury was unilateral in 17 cases and bilateral in 3 cases. The most common type of injuries encountered were hyphaema in 82.60% of eyes, followed by corneoscleral tear in 78.26% and vitreous hemorrhage in 47.82% of eyes. Out of the 23 eyes, 18 eyes (78.26%) had an open globe injury, while only 3 eyes (13.04%) had closed globe injury at presentation in our hospital. The most commonly performed surgery was corneoscleral repair in 18 eyes. Final corrected visual acuity remained unchanged in 34.78% and improved in 65.22% of eyes. About 47.83% of eyes had final visual acuity < 6/60.

CONCLUSION: Gun pellet related ocular injuries are becoming increasingly common in Kashmir valley. In severely injured eyes the visual prognosis remained poor despite development of advanced micro-surgical techniques. The best preventive measure for such injuries involve reducing the level of violence in our society.

KEYWORDS: ocular injuries, hyphaema, corneoscleral tear.

INTRODUCTION: Ocular trauma once described as the neglected disorder1 has recently been highlighted as a major cause of visual morbidity. Worldwide there are approximately 1.6 million people blind from eye injuries, 2.3 million bilaterally visually impaired and 19 million with unilateral visual loss, making ocular trauma the commonest cause of unilateral blindness.

Etiologically ocular injuries can be classified in to domestic, occupational, sports, road traffic accidents, iatrogenic, fights and assaults and war injuries.3 Almost 100 years ago more than 70% of all serious ocular injuries occurred at workplace.4 In the 1960s and 1970s road traffic accidents became the most common cause of serious ocular injuries.5 In the 1980s sports and leisure activities became common cause of severe eye injury.6,7 The home is now the most common location for eye injuries.8 However bomb blast and battle field ocular injuries are becoming increasingly common in different parts of the world.

Ocular injuries following pellet gun fire has assumed alarming significance in Kashmir valley (India) over the past few years. To curb agitated

mobs, the security forces fire pellet gun cartridges, considered to be a non-lethal weapon.

A single pellet gun cartridge upon fire from pellet gun breaks into more than 500 small iron pellets which can penetrate any body tissue including eyes. An eye can thus receive one or multiple pellets and depending upon its velocity and distance can cause both penetrating and non-penetrating injury to the eye.

The study assumes significance as no such work has been reported in the literature.

MATERIAL AND METHODS: The present retrospective study was conducted in the Department of Ophthalmology, SKIMS Medical College, Bemina Srinagar. The purpose of our study was to evaluate the type and severity of ocular injuries in gun pellet victims. The patient population was defined by reviewing the admission records of the hospital data base. We retrospectively reviewed the clinical files of 20 patients who suffered eye injury from gun pellets. All patients were admitted in the department of Ophthalmology, SKIMS Medical College Bemina Srinagar between January 2010 to September 2013.

The presenting case records, theatre notes and outpatient follow up of each of these patients were obtained and analyzed with regard to age and sex of the patient, circumstances surrounding the injury, presenting ocular signs subsequent management and final visual outcome. There was no subject with a pre-injury history of ipsilateral amblyopia or previous ocular trauma. All patients were victims of gun pellet injuries and all of them belonged to Kashmir valley.

The terms used in the description of ocular injuries conform to the recommendations of Birmingham Eye Trauma Terminology System (BETT) 11 which is an unambiguous, consistent, simple and comprehensive system to describe any type of mechanical globe trauma.

RESULTS: Twenty patients were included in this study. All ocular injuries were due to gun pellet made of iron. Review of the age and sex of these patients demonstrates that typical gun pellet casualties were young males (Fig. 1). The mean age of our study group was 21.45 years. The youngest patient in our study was 14 years old and the eldest patient was 32 years of age, notably 75% of those injured were below the age of 23 years. The 19 males and one female represent a 19:1 male to female ratio.

Ocular injuries were unilateral in 17 cases and bilateral in 3 cases. In the 23 eyes of 20 patients whom we studied a wide spectrum of anterior and posterior segment injuries were encountered as shown in table 1.

The most common type of injuries encountered were hyphaema in 82.60% of eyes, followed by corneoscleral tear in 78.26% and vitreous hemorrhage and iridodialysis in 47.82% each.

Out of the 23 eyes, 18 eyes (78.26%) had an open globe injury, while only 3 eyes (13.04%) had closed globe injury at presentation in our hospital. Two eyes had injury to ocular adnexa alone without injuring the eye ball.

Intraocular penetration by gun pellets led to scleral tear in 8 eyes (34.78%), tears involving both sclera and cornea in 5 eyes (21.74%), and corneal tear

alone in 5 eyes (21.74%). Vitreous hemorrhage was encountered in 11 eyes (47.83%). Retained IOFB was seen in 6 eyes (26.08%), confirmed on B-Scan USG and one patient developed features of siderosis bulbi due to retained IOFB. Traumatic cataract developed in 7 eyes (30.43%). Retinal detachment in 4 eyes (17.39%) and macular scar in one eye were as other posterior segment injuries encountered in our study.

Five cases had a lid laceration with the pellet traversing the lid to reach the globe or become lodged in the orbit. Out of these five cases, two patients had lower canalicular tear. Moreover only two of these cases had injury to ocular adnexa alone without any injury to the eye ball.

The treatment varied according to the type of injury. 3 cases were managed conservatively with closed globe injury. Rest underwent single/ multiple surgical procedures. Corneoscleral repair was the most commonly performed surgery. Sclera autografting was done in one patient because of tissue loss. Seven patients needed cataract extraction with intraocular lens implantation. Vitreo-retinal surgery was performed in patients who had non-resolving vitreous hemorrhage, retinal detachment or retained post segment IOFB. Canalicular tear repair with silicon tube implantation was done in two patients (table 2).

The visual acuity on admission and final corrected visual acuity are shown in table 3 and figure 2.

About 52.17% of the eyes had only perception of light (PL +) at the time of presentation in the hospital, reflecting the severe nature of trauma caused by gun pellets. The final corrected visual acuity remained

unchanged in 34.78% and improved in 65.22% of cases. About 47.83% of the cases had final corrected visual acuity less than 6/60.

Final corrected visual acuity in open injury group was worse than closed globe injury group. In open globe injuries 61.11% of the eyes had a final corrected visual acuity < 6/60, whereas in closed globe injury group all patients had a final corrected visual acuity of > 6/12.

Factors that were associated with poor prognosis include poor visual acuity at presentation (< 6/60), penetrating injury, delayed presentation in the hospital (more than 10 days), presence of relative afferent papillary defect (RAPD), retinal detachment, retinal IOFB and macular scarring. Factors that were associated with better prognosis were small wound and wound location anterior to the insertion of rectus muscles.

DISCUSSION: Ocular injury is an important and potentially preventable cause of ocular morbidity.12 Even though the eye comprises only a small part of the surface area of the human body, 8 despite being well protected from all sides except one, it is injured quite frequently.

Over the past few years security forces in Kashmir valley have been using pump action shot gun or pellet gun to disperse violent mobs. Pellet fire arms have been introduced as the latest modality of crowd control considered to be non-lethal weapon.

Review of the age and sex of these patients demonstrates that the 'typical' gun pellet casualties are young males. Out of the 20 patients 19 were males

and one was female; notably 75% of those injured were below the age of 23 years. This was due to the fact that these agitated mobs comprised primarily of young males. The only female patient in our study was hit by the pellet while looking out of the window of her house. Both hospital and population based studies indicate a large preponderance of ocular injuries affecting young males14-17 as was the case in our study.

The spectrum of ocular injury in this series is similar to other studies, but perhaps the most important feature to appreciate is the severity of this type of injury. We noted that hyphaema to be the most common manifestation of gun pellet injuries (82.6%). This is in accordance with the consequences of non-powder fire arm injuries reported previously.

In our study we found that majority of the injuries (78.26%) were open globe penetrating type. This pattern could be explained by the fact that non powder fire arms can generate muzzle velocities of 200 to 900 foot pounds per second20 whereas ocular penetration can occur at velocities as low as 130 foot pounds per second21. Moreover from a single cartridge, more than 500 pellets can be fired, thus accounting for the high incidence of penetrating trauma in our study.

The prognosis for penetrating eye injury is poor; in our study we found that the most important factor predictive of a poor visual outcome is poor visual acuity at presentation (< 6/60).

This is in agreement with other studies.22-24 Other factors that were associated with a poor visual outcome included delayed presentation in the hospital, presence of RAPD, retinal detachment, retained IOFB and macular scarring. Wound location anterior to the

insertion of rectus muscles and small wound were favorable prognostic factors. These findings are in agreement with other studies.

In our study we found that retained IOFB was seen in six eyes (26.08%), out of these six eyes one had IOFB in anterior segment and rest were present in posterior segment. One of the eye developed features of siderosis bulbi in which the IOFB had been missed on presentation in the hospital. Siderous bulbi developed because the gun pellets used were made of iron. Retained gun pellets are best localized by plain x-rays of the orbit, although in selected cases additional information can be obtained from CT scans and B-scans.

The final corrected visual acuity also depended on the type of injury.26 In patients with closed globe injury (3 eyes) all had a best corrected visual acuity of > 6/12, whereas in those with penetrating eye injury about 61.11% had a final corrected visual acuity of < 6/60. The commonest cause of permanently reduced visual acuity were severe perforation of the globe, retained IOFB and retinal damage.

The final visual acuity is a significant indicator of the extensive, disruptive nature of these ocular injuries, and despite improved micro surgical techniques, in the present study 47.83% of the injured eyes had a final corrected visual acuity of < 6/60. Earlier authors18, 19, 27 have reported 29-42% of cases in poor acuity category, again reflecting the severe nature of trauma caused by these gun pellets.

CONCLUSION: Our study conclusively proves the severe nature of ocular injuries caused by pellet guns.

Their use should not be encouraged and some other non-lethal weapon should be used for controlling agitated mobs. Visual prognosis is often poor, but prompt recognition and treatment should improve outcome. Presence of hyphema, visual acuity worse than 6/60 or an abnormal pupil are particularly important clinical findings suggestive of penetrating eye injury.

The high frequency of penetrating eye injuries among young adults (nearly 75% of the injuries occurred below 23 years of age) underscores the economic and social casts of severe eye trauma. The best preventive measure for such injuries involve reducing the level of violence in our society.

Figure 1: Bar graph illustrating the age distribution (years) of gun pellet injury to the eye.

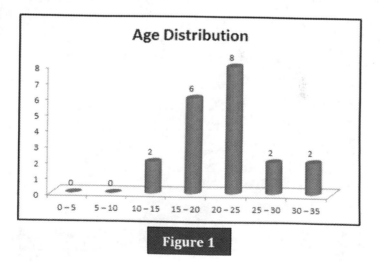

Type of Injury	No. of Eyes	Percentage
Ocular adnexal injury +	5	21.73
Hyphaema	19	82.60
Iridodialysis	11	47.82
Corneal/ sclera tear*	18	78.26
Traumatic cataract	7	30.43
Vitreous hemorrhage	11	47.82
Intraocular foreign body (IOFB)#	6	26.08
Retinal detachment	4	17.39
Macular scar	1	4.34

Table 1: Type and number of eye injuries

+ out of the five cases two had lower canalicular tear and only in 2 cases ocular edema alone was involved.

* including corneal tear in 5 eyes, sclera tear in 8 eye and corneoscleral tear in 5 eyes.

5 eyes had posterior segment intraocular foreign body (IOFB), and one eye had anterior segment IOFB.

Type of Surgery	No. of Surgeries
Corneal/sclera repair	18
Canalicular tear repair	2
Vitrectomy with IOFB removal	5
Cataract extraction	7
Sclera autograft	1
Removal of F.B. from anterior chamber	1
Retinal detachment surgery	4

Table 2: Type and number of surgeries

Visual acuity	Initial BCVA		Final BCVA	
	No. of Eyes	%	No. of Eyes	%
PL (-)	1	4.35	1	4.35
PL (+)	11	47.83	5	21.74
HM	3	13.04	1	4.35
CF	4	17.39	4	17.39
6/60 to 6/18	2	8.69	7	30.43
6/12 to 6/6	2	8.69	5	21.74

Table 3: Initial and Final Best Corrected Visual Acuity (BCVA)

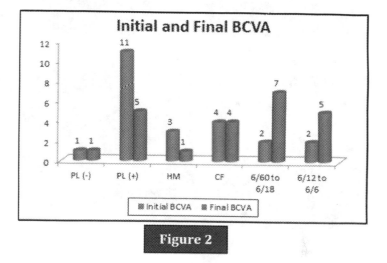

Figure 2

Figure 2: Bar graph showing initial and final BCVA.

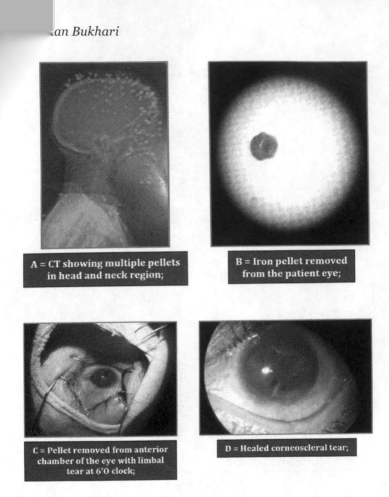

A = CT showing multiple pellets in head and neck region;

B = Iron pellet removed from the patient eye;

C = Pellet removed from anterior chamber of the eye with limbal tear at 6'O clock;

D = Healed corneoscleral tear;

This research article was prepared by the Doctors, **Wasim Rashid, Nusrat Shaheen, Imtiyaz A. Lone, Sheikh Sajjad** of Department of Ophthalmology, SKIMS Medical College, Bemina, Srinagar, Kashmir and was published in Journal of Evolution of Medical and Dental Sciences 2014; Vol. 3, Issue 29, July 21; Page: 8015 – 8058.

Profile and Outcome of Violence Related Injuries of Patients during Civilian Unrest in a Conflict zone

Syed Amin Tabish, Rauf A Wani, Mushtaq Ahmad, Natasha Thakur, Yatoo GH and Shadab Nabi Wani

Introduction

Violence is a phenomenon intrinsic to class based society which are inherently unequal, apprehensive and oppressive. Violence is a dynamic process. Large scale violence may take the form of mass uprising against oppression of dominant class. Such types of violence has recently surged in many conflict zones across the Asian and African continents.

An armed conflict that erupted in Indian Kashmir since 1989 left tens of thousands killed and many more injured. This has now been replaced in recent years by mass street protests which at times become violent. The response from the government has been to control these protests, often resulting in mass casualties. The patterns of injuries encountered by health authorities are different depending upon the type of weapons used by security forces to quell the protesters. Initially conventional bullets were used, followed by rubber bullets, tear gas shells, and the latest introduction was pallet guns.

Civil unrest is a form of protest against major socio-political problems; the severity of the action coincides with public expression(s) of displeasure. Subsequent clashes between security forces and civilian populations can lead to injuries.

The situation in Kashmir can best be described as a "low-intensity conflict". Kashmir witnessed a fresh spate of protest and violence as a result of death of a teenager school boy in the month of May 2010 reportedly at the hands of security forces. What predominates in such conflicts is the use of terror to exert social control, frequently by disrupting the social, economic and cultural relations. Kashmir is not merely a law and order problem but there are social, emotional, political and psychological aspects involved. Traumatic events can have a profound impact on the behavioral and physiological functioning of an individual and society at large.

The costs of violence

Violence exacts both a human and an economic toll, and costs economies many billions of US dollars each year in health care and lost productivity. Understanding how the complex interplay of individual, relationship, social, cultural and environmental factors is related to violence is one of the important steps in the public health approach to preventing violence.

Methodology

The present study was conducted for five months from May to September 2010, at Sher-i-Kashmir Institute of Medical Sciences (SKIMS), Srinagar (India), a 700 bedded tertiary care medical centre with a modern Accident and Emergency Department backed by well organized and dedicated diagnostic and therapeutic service. The hospital has four levels of emergency care: Level I (Filter Clinic) acts as a triage area and mostly deals with Ambulatory cases; Level II consists of assessment, evolution and resuscitation wherever necessary, Level III acts as a holding area for emergency admissions up to 24 hours. Level IV houses medical emergencies who need to be observed beyond 24 hours. The department has a 20 bedded Disaster Management ward attached to it for catering to causalities arising out of major incidents etc. It has also a 4 bedded Isolation facility. SKIMS hospital has a dedicated ambulance service. However, Ophthalmic, ENT and Orthopedic emergencies are referred to SKIMS affiliated Medical College Hospital. Although fully equipped with all the facilities; the resources of the hospital and the blood stocks get depleted very quickly in such situations and sometimes can't be replenished effectively due to disturbed situation and strict curfew. In such situations the local voluntary and social organizations are of immense help in getting blood donors, volunteers, medicines and surgical disposables available.

Six hundred and thirty consecutive patients who presented to the Emergency Department were included in the study. The injured patients were

assessed in relation to age, sex, anatomic location of injury, type of injury sustained (blunt or penetrating), treatment received and final outcome. Patients were initially resuscitated, their apprehensions allayed, thorough clinical examination done especially for neurological and loco motor functions. Scout radiographs were obtained in the areas of visible pellet marks. CT Chest and or abdomen performed were performed in multiple pallet injuries of abdomen& chest. Laparotomy was done in case of pellets injuries with pellets having breached peritoneum as these could cause late perforation, if lodged on gut wall. Ocular injuries were other clinically important bullet related events. The medical and medico-legal records were also consulted for complete information.

Results

Violence affected 630 patients received during the study period required hospitalization for treatment for 393 (62.38%) patients and emergency outpatients treatment for 237 (37.61%) who were sent home after receiving the treatment. A predominance of injuries was found among younger population. The age group involved mostly was between 13-24 years comprising 204 (51.90%) out of 393 patients admitted (Table 1).

Amongst the 393 patients admitted in SKIMS during the period, 300 (76.33%) were literate and out of 300 literate patients 125 patients were high school students. Of the 393 studied by profession, 180 (45.80%) were students.

Sixteen females (4.1%) were injured due to violence related episodes and one female suffered permanent disability due to paraplegia resulting from spinal cord injury. 62.08% patients were managed conservatively, 23.91% required surgical intervention and, 6.10% needed life support and 7.88% received other treatments (Table 2).

After treatment, 324 (82.44%) recovered fully, 10 (2.54%) were disabled due to different nerve injuries, 22 (5.59%) were referred to other hospitals and 28 (7.12%) expired in the hospital during the course of treatment (Table 3).

Of the 393 patients studied, 138 (35.11%) had bullet injuries, 60 (15.26%) pellet injuries (Figure 1-3), 57 (14.50%) had injuries due to stone pelting, 50 (12.72%) had tear gas shell injuries and 88 (22.34%) had history of assault.

Highest incidence was seen in the month of August 2010. Of the 393 patients admitted, 157 (39.94%) had head injuries, 131 (33.33%) had limb injuries, 28 (7.12%) had chest injury and 24 (6.10%) had abdominal injuries and 43(10.94%) had got multisystem injuries.

Treatment modality	Number of patients N=	Percentage (%)
Conservative	244	62.08
Surgical	94	23.91
Other procedures	31	7.88
Life support	24	6.10

Table 1: Treatment recourse to determine hospital resource N= 393 100.06%.

Outcome	Total number of patients	Percentage
Recovered fully	324	82.44
Recovered partially	9	2.29
Disabled	10	2.54
Expired	28	7.12
Referred to other hospitals	22	5.59

Table 2: Treatment Outcome.

Mode of injury	Head	Neck	Chest	Abdomen
Bullet	27	8	18	12
Pellet	11	2	3	6
Stone	53	2	1	-
Teargas	26	-	4	4
Assault	40	-	2	2
Total	157	10	28	24

Table 3: Type and mode of injury.

Figure 1: X-Ray Chest showing pellets.

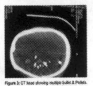

Figure 2: Radiograph of pelvis showing multiple pellets.

Figure 3: CT head showing multiple bullet & Pellets.

Of the 393 patients, 159 (40.44%) were having major clinical findings and underwent different surgical procedures. Fifty-nine patients had received head injuries, of which 38 (64.4%) had cerebral contusions, 11(18.60%) had fracture of skull bones mostly temporal or frontal bone and 10 (16.94%) had mutilated compound fracture skull bones and brain lacerations.

Out of 159 patients, 24 (15.09%) had chest trauma, of which 13 (54.16%) had lung contusions and 11 (45.84%) had hemothorax. Seventeen patients had abdominal trauma, out of which 5 (29.41%) had liver tear and 16 (66.70%) had gut perforations. Fifty-one (32.07%) had limb injuries of which 30 (58.82%) had blood vessel injuries and 21 (41.17%) had fracture long bones.

Discussion

Globally, violence pervades the lives of many people, permeates every aspect of life for those living in conflict zones and touches all of us in some way or other. One cannot stay out of harm's way by closing one's eyes and avoiding dangerous places. Escape is not possible for others. The threat of violence is behind those doors—manifest or veiled.

Many faces of interpersonal, collective and self-directed violence, as well as the settings in which violence occurs are exposed by the human toll of violence that occurs every year throughout the world. Health is seriously compromised where violence persists.

During the last five decades public health has made a significant contribution, particularly with regard to reducing rates infectious diseases and many other major health problems that used to take a huge toll of human lives. Life expectancy has increased, many childhood diseases are controlled and mortality rates have declined particularly the infant, childhood and maternal. However, saving our children from these diseases only is not enough. They have to be saved from falling victim to violence, to the savagery of war and conflict; otherwise it would be a failure of public health. Public health has an important responsibility in the prevention of violence worldwide.

Violence has been part of the human experience in all parts of the world. It is among the leading causes of death worldwide for people aged 15-44 years. It has an adverse effect on the economy as well. It costs of billions of US dollars in annual health care

expenditures worldwide. Moreover, it costs billions more in terms of days lost from work, law enforcement and lost investment.

It is very difficult to calculate the human cost in grief and pain as much of it is almost invisible. Some causes of violence are easy to see while others are deeply rooted in the social, cultural and economic fabric of human life.

Public health efforts can prevent violence to a great extent and reduce its impact, in the same way that public health efforts have improved the human health by sustained improvements in hygiene, safe drinking water and immunization. The factors that contribute to violent responses (attitude and behavior or related to larger social, economic, political and cultural conditions) can be changed by concerted and continued efforts of governments which need a strong political will.

Public health interventions include: Primary prevention- (approaches that aim to prevent violence before it occurs), Secondary prevention (approaches that focus on the more immediate responses to violence, such as pre-hospital care, emergency services) and Tertiary prevention (approaches that focus on long-term care in the wake of violence, such as rehabilitation and reintegration, and attempts to lessen trauma or reduce the long-term disability associated with violence).

Today, the health sector is a key ally in the global response to violence because of its closeness to, and therefore familiarity with the problem. The healthcare professionals dedicate a great amount of time to the victims of violence. Moreover, the health sector has

at its disposal information to facilitate research and prevention work as such the sector is uniquely placed to draw attention to the health burden imposed by violence.

Huge database with health sector can be a powerful tool both for advocacy and for action: for creating and implementing an action plan for violence prevention, defining priorities for research on, the causes, consequences, costs and prevention of violence, promoting and strengthening primary prevention responses for victims of violence.

Violence is not inevitable. A lot can be done to address and prevent it. Those whose lives each year are shattered by violence can be safeguarded, and the primary causes of violence tackled to produce a healthier society for all.

Economic Dimensions

In order to ensure faster and sustainable growth, it is important to identify critical areas where the existing policies and programmes need to be strengthened or even redesigned.

Empowerment through human development

Development of human resources through education, training and health care is vital for enhancing the quality of life. In the last twenty

three years of turmoil, the functioning of democratic institutions responsible for providing services like education and health care have got a major setback. Hence the quality and quantity of services rendered by such institutions in Kashmir have not been satisfactory compared to other States of India.

The security scenario has gradually improved in the state with the dawn of twenty-first century due to perceptible decline in insurgency and militancy, it is imperative to initiate such policy measures as are critical for providing competent human resource for raising productivity particularly the education and health sectors.

The people have been denied peace and economic security in Kashmir, which their counterparts in the rest of the country enjoyed in the last twenty-three years. The civil unrest, militancy and turmoil have not only jeopardized the functioning of democratic institutions but also disrupted normal life and eroded governance systems, including delivery of essential services to the community. The Government has over time taken various initiatives to ameliorate the sufferings of the people, the outcomes of which may be gauged from the improvement in indicators of development.

Security concerns are amongst the dominant themes in the minds of people living in Kashmir. This owes to the fact that death, injury, destruction of property is the notable features of life here due to conflict, disturbances and turmoil for the last 21 years. Many have suffered tragic incidents of a war-like situation, which by their nature are beyond the endurance of common man. Many are witness to

bloodshed that is characteristic of such situation. Thousands of people have lost their lives or limbs, and thousands have been rendered orphans and widows. Scores have disappeared. Moreover, with disruption of development works consequent upon war-like situation, added concerns are unemployment, poverty, relationships etc. A vicious circle of events has been created comprising torture, disappearances, displacement, killings, ballistic trauma, etc. paralleled by a state of mind wherein grieving, insecurity, oppression, poverty, uncertainties of career and relationships etc. are the major themes. Unemployment, poverty, political oppression is the main factors which predispose to violence.

People of Kashmir feel alienated and ignored. Much of this sentiment can be traced to an aspect of the conflict generally overlooked: economic opportunities lost because of misguided development policies in the region during the last six decades.

The continued restrictions, curfews and shutdowns during these disturbances have dealt a heavy blow to the private enterprise and the tourism industry in Kashmir. The exact estimates of unrest-generated economic loss (that are of high magnitude) are difficult to assess.

It is estimated that globally, over 500,000 injuries are sustained annually from the use of firearms; 300,000 or more relating to those occurring in situations of armed conflict, with the remainder of 200,000 or more being sustained in non-conflict situations. According to reports from the World Health Organization in 2001, these injuries represent roughly a quarter of the estimated 2.3 million deaths which

have occurred due to violence; 42% being suicides, 38% homicides, and 26% related to war and armed conflict. Although violence against civilians has become a global phenomenon, Palestine, Afghanistan and Iraq are the conflict regions in West Asia which have witnessed decades of conflict and violence. In contemporary times, a new surge in violence caused by mass uprisings against their governments have surfaced across the globe particularly in Asian and African countries like recent Middle East uprisings. Kashmir has also witness a fresh spite of civil unrest during 2008-2010.

Although there are several causes for ballistic trauma depending upon the situation in which they occur, priorities for healthcare professionals lie in ascertaining the likelihood of survival for the patient based upon damage caused by the bullet on entry- whether a bullet strikes or shatters a bone, and if shattered bone or shrapnel has punctured vital organs or has damaged the spinal cord of the patient. Estimation of the patient's survival is essential. An important determinant is if the future health of the patient dependent upon the severity of the injury so that preventative measures can be approximated, due to the benefits of preventing death or injury outweighing those of a purely treatment based approach.

Conventional ammunition (bullets, pellets, rubber bullets, and tear gas shells) were used by Police in Kashmir in crowd control during the 2010 civil unrest. There were also stone pelting incidents causing injury to some of the patients. The latest addition was the pellet guns. This leads to a real challenge to the

treating physicians. When assessing the likely severity of gunshot wounds, numerous variables that affected management of trauma include: the particular type of weapon used, the caliber of the weapon, the type of the bullet and its propellant charge (i.e. a standard velocity), the range at which the victim was shot (i.e. wounds inflicted), the site of injury and the number of wounds inflicted. Frequently, victims of gunshot wound in Kashmir (during 2010 AD) have been hit several times. An individual shotgun pellet is comparatively small, though victims are usually hit by large numbers of pellets simultaneously; the degree of injury is severe, particularly when the wound is inflicted at close range. The patients present with multiple pellets, sometimes hundreds causing diagnostic difficulties to the treating clinicians. We gradually developed protocols for such patients.

The effects of prolonged turmoil have had an effect on social fabric also. The role of social and voluntary organizations cannot be over emphasized. Such organizations provide the much needed volunteers, blood donors, medicines, surgical disposables at a very short notice.

Our study shows that young people were injured during violence suggesting that majority of victims were males who were involved in the street protests, most of them in the age group of 13 to 25 years and many were students by profession. Patients admitted in SKIMS were injured on streets in different localities and districts while protesting against security forces. Hamblen and Schnurr conducted studies on violence affected persons in Middle East found that civilian stressors lead to violence on streets.

Wright and Kariya in a study found that the mean age of violence victimization is 28 years. They also found that 80 percent of the victims were males clearly resembling to our studies. The leading causes of Traumatic Brain Injury (TBI) - related deaths differed among age groups. Among youths aged 0–19 years, motor-vehicle-related TBIs were the leading cause; among persons aged 20-74 years, firearm related TBIs were the leading cause; and among persons aged >75 years, fall-related TBIs were the leading cause. Adekoya et al., found highest percentage of deaths in traumatic brain injuries and mostly male and rural residents.

Tabish and Yattoo in a retrospective study in 2004 found highest incidence of traumatic brain injuries in age group 21-30 years, 18% were males and most of them were rural.

Tabish and Yatoo in a study in 2004 found that age group 0-10 was the most vulnerable. Males with rural background were mostly involved in traumatic head injuries. Most of the patients (58%) reached to hospital within 3 hours and ambulances (66%) were the mode of transport utilized by the patients referred from peripheries to SKIMS hospital. Average death rate was 6.4 % of the total traumatic brain injury patients.

Sivarajasingam and Shepherd in a study found that 45% patients came from the age group of 18-30 years. The findings of our study resembled the previous studies with respect to the age group violence.

Tabish et al., in a study in 2004 found that some patients who expired were brought in a critical condition to SKIMS, either in coma or in shock. Delay in transporting the patients to hospital, lack of

Emergency Medical Services System, non availability of First Aid, loss of a Golden Hour, loss of blood, improper transportation, etc were the factors that were beyond the control of doctors at SKIMS thus resulting in death of some patients. However, once the patients were received at SKIMS, prompt and quality care was provided to them by the multidisciplinary teams.

Even non-fatal wounds caused by gunshot, teargas and pellets frequently have severe and long-lasting effects, including disfigurement and/or permanent disability. All such wounds are surgical emergencies which require immediate hospital treatment.

The immediate damaging effects of the missile on the victims, observed in the current study, include: loss of blood and the hypovolemic shock. In a few cases, immediate effects resulted in death due to exsanguinations, hypoxia caused by pneumothorax, heart failure and brain damage. Non-fatal gunshot wounds resulted in serious disability in few cases.

The essential trauma care facilities should be available to people to assure optimal care of the injured patient in all the Districts, from Primary Health Centers, to District Hospitals, to provincial Teaching Hospitals, to Tertiary care medical centers. There is also a strong need to promote standards including training, quality improvement and trauma team organization. The mechanisms for needs assessment that helps to define priorities for affordable and sustainable improvements in trauma care need to be devised.

Decreasing the burden of injuries is among the main challenges for health care delivery system

in the twenty-first century. To promote low-cost improvements in injury care, in both the pre-hospital and hospital-based arenas needs serious consideration of health planners and policy-makers. The benefit of such improvement is evidenced by the gross disparities in outcome between low- and middle income countries on one hand and high-income countries on the other. Persons with life-threatening but salvageable injuries are more likely to die or develop disability if proper trauma care is not available.

The essential trauma care facilities can realistically be made available in all parts of the State. The resources that would be necessary to assure such care include human resources (staffing and training) and physical resources (infrastructure, equipment and supplies). The improvements in organization and planning can result in improvements in trauma treatment services and hence saving scores of lives and limbs and prevention or reducing the consequent disability.

Conclusion

Unemployment, poverty and political oppression are the main factors which predispose to violence. Males are more vulnerable. The age group between 13-24 years is the period when young people face the realities of life and strive to make their own political existence. During young adulthood, violence as well as other behaviors is often given heightened expression. Both quantitative as well as qualitative information is required to plan for intervention and construct

policy. Complications from head injuries are the single largest cause of morbidity and mortality in patients who reach hospital alive.

The establishment of physical infrastructure is necessarily crucial. There has to be a rational policy for evacuation of injured as sometimes even the health professionals and hospital vehicles (including ambulances) are not allowed in these areas for evacuation. The role of social and voluntary organizations in such situations is of paramount importance. Reduction in morbidity and mortality associated with severe head injury has been achieved with aggressive management protocols at SKIMS.

Solving the problems of poverty, unemployment and other political aspirations can go a long way in preventing the violence and civil unrest in societies. Commitment of violence prevention and peace building requires proper assessment of all forms of violence and its uses and impact.

This research article was prepared by the doctors, **Syed Amin Tabish, Rauf A Wani, Mushtaq Ahmad, Natasha Thakur, Yatoo GH** and **Shadab Nabi Wani** of Accident & Emergency, Department of General Surgery and Hospital Administration at SKIMS Srinagar, Kashmir and was published on June 18, 2013 in Emergency Medicine journal.

Printed in the United States
By Bookmasters